Camera Man's *Journey*

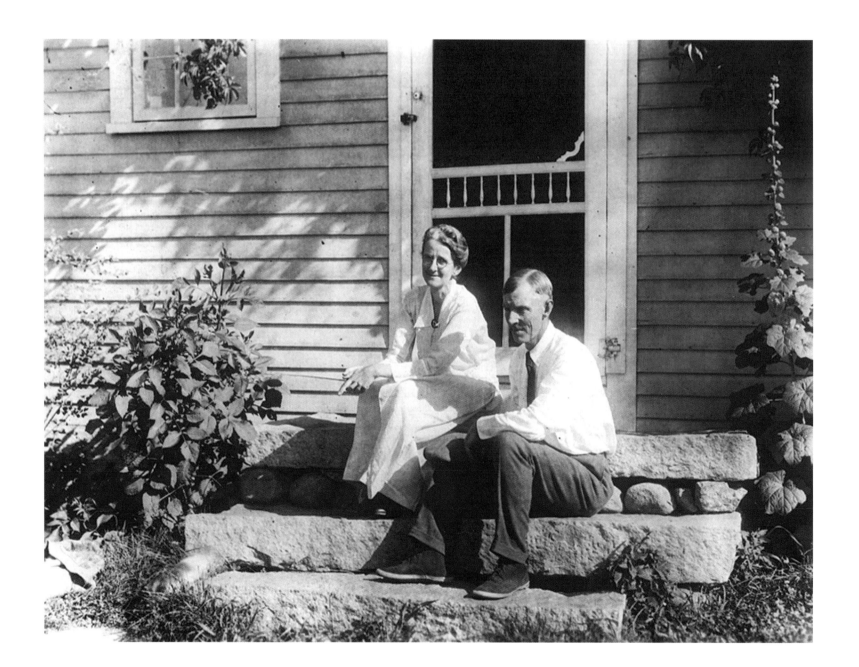

Camera Man's *Journey*

JULIAN DIMOCK'S SOUTH

Edited by Thomas L. Johnson & Nina J. Root

The University of Georgia Press *Athens & London*

Publication of this book was supported by the
Hilton Head Island Foundation, Inc.

Designed by Sandra Strother Hudson
Printed and bound in Korea through Pacifica Communications
The paper in this book meets the guidelines for permanence
and durability of the Committee on Production Guidelines for
Book Longevity of the Council on Library Resources.

Printed in Korea
06 05 04 03 02 C 5 4 3 2 1

Library of Congress Cataloging-in-Publication Data

Frontispiece: Annette and Julian Dimock.
Courtesy of the Vermont Historical Society.

Dimock, Julian A. (Julian Anthony), 1873–1945.
Camera man's journey : Julian Dimock's South / edited by Thomas L.
Johnson and Nina J. Root.
 p. cm.
Includes bibliographical references.
ISBN 0-8203-2424-8 (alk. paper)
1. African Americans–South Carolina–Columbia Region–Social conditions–
20th century–Pictorial works. 2. African Americans–South Carolina–
Beaufort Region–Social Conditions–20th century–Pictorial works.
3. Working poor–South Carolina–Columbia Region–History–20th century–
Pictorial works. 4. Working poor–South Carolina–Beaufort Region–
History–20th century–Pictorial works. 5. Columbia Region (S.C.)–Social
conditions–20th century–Pictorial works. 6. Beaufort Region (S.C.)–Social
conditions–20th century–Pictorial works. I. Johnson, Thomas L., 1935– II.
Root, Nina J. III. Title.
F279.C7 D56 2002
975.7'00496073—dc21 2001054187

British Library Cataloging-in-Publication Data available

Leaving, then, the white world, I have stepped within the Veil, raising it that you may view faintly its deeper recesses.

—W. E. B. Du Bois, *The Souls of Black Folk*

All photographs are courtesy of the Department of Library Services, American Museum of Natural History, New York.

Photographic prints by the Photography Studio, American Museum of Natural History.

Contents

Foreword
Dori Sanders
ix

Preface
Cleveland L. Sellers Jr.
xi

Acknowledgments
Nina J. Root and Thomas L. Johnson
xv

Julian Dimock: Reluctant Camera Man
Nina J. Root
3

Mr. Smalls's and Mr. Dimock's South Carolina
Thomas L. Johnson
15

JULIAN DIMOCK'S PHOTOGRAPHS
(following page 32)
Columbia and Environs
Beaufort: Town and County

Afterword
Leon F. Litwack
179

Bibliography
187

About the Authors
191

Foreword

DORI SANDERS

In Julian Dimock's extraordinary photographs, the camera's eye captured real people, places, and situations with sharp detail. The pictures not only reveal defining aspects of predominantly black Carolinians in two distinct communities near the turn of the last century, they also document the look and feel of the towns of Columbia and Beaufort and their rural neighborhoods. Dimock has caught the essence of both the town and country scenes of the day: the architecture of the city and the farm, the downtown street and the county road, and even the seasonal change of light and climate—the ice-laden trees of a South Carolina Midlands winter day, the blinding sun of the Lowcountry spring.

For the most part, however, the collection focuses on the hardships and poverty of marginalized African American families trapped in the abysmal economic and social circumstances of the South in the Jim Crow era. This is not to say that in 1904 and 1905 all African Americans in these parts of South Carolina were saddled with desperate circumstances, exhibited here in a way reminiscent of persons and conditions encountered in some Charles Dickens novels (Dimock, too, had the honest and incisive eye of a compassionate narrator whose object is to uncover local truth about human experience in all of its cruelty, injustice, and deprivation—as well as its moments of pleasure, joy, and satisfaction). Nevertheless, the photographs here seem to reflect a determination to concentrate primarily on the lives of average black Carolinians, the working poor, rather than on those of the communities' small, rising middle class. However, more in Beaufort than in Columbia, Dimock does include some of the latter, represented, for instance, by the portraits of Robert Smalls. (One can only hope that a corresponding publication eventually will be produced featuring Dimock's images of the Florida Seminoles, another group that has been preserved in the photographer's archive at the American Museum of Natural History in New York.)

That Dimock did for the most part choose to photograph the poor during this period is fortuitous. These people were the ones least able to have had their pictures taken using their own resources and therefore those least likely to have left for posterity any visual record of their lives and circumstances.

Dimock showed great sensitivity in photographing his subjects. He skillfully used the camera to depict individuals and situations that appear to be hopeless. Yet his subjects' faces are characterized by strength, determination, and will—the will to make do, to carry on, and to persevere under the most formidable conditions. And, most importantly, they are characterized by hope. The obvious delight mirrored in many of the photographs of family life, despite the clearly portrayed conditions of deprivation, cannot be denied.

Children, especially, are strong and compelling subjects in many of Dimock's pictures. Apparently unaware of the dark clouds of hardship and uncertainty that loom over the heads of their elders, youths are caught on film in realistic ways: at work, at play, laughing and smiling, using their creative skills, making and flying kites.

For many, Dimock's seemingly sudden renunciation of his photographic vocation continues to tantalize. Did he give it up because after the death of his father, with whom he had partnered on journalistic forays, there was no longer any reason or desire to continue? Or did he give it up principally because he could no longer endure seeing and recording through his lens the human suffering, hardship, and poverty that so often defined his subjects' lives? In this regard he did indeed speak of having the very life ground out of him and of seeing his self-respect vanish. At the same time, the very adversity that he photographed seems to have been the necessary ingredient of his art, as is often the case for many truly talented artists: he gave witness to a burden he could neither bear nor remove.

In the end, this collection presents a vivid, moving story wherein the images bring to life unspoken words that strongly remind us that this world of downtrodden and oppressed people whose spirits did not break was never meant to be silent. For me, Dimock's South Carolina photographs evoke the haunting memory of stories passed down orally about those who came before, of those who endured the dark and dangerous days of the early twentieth century. The memories come flooding back, making the familiar new and the unfamiliar, familiar. Camera Man's pictures teach us a history we did not quite know and remind us of a past we should never forget.

Preface

CLEVELAND L. SELLERS JR.

Dark complexion, wide forehead, high cheekbones, wide lips—the Columbia nurse very easily could have been a high priestess, goddess, or queen in Senegambia.

A young woman with her head wrapped in a towel, wearing a soft, gentle smile, reminds us of Nefertiti.

A profile of a young Angolan girl conveys a strength and beauty like that of so many of her people.

An old man and a child—the past so close to the future.

The subjects of Julian Dimock's newly discovered photographs are reflections of a people torn by their ancestral might and their bleak present situation. W. E. B. Du Bois, in his classic *The Souls of Black Folk,* assesses the African American's dilemma with the veil that covers reality:

> the Negro is sort of a seventh son, born with a veil, and gifted with second-sight, in this American world—a world which yields him no sure self-consciousness, but only lets him see himself through the revelation of the other world. It is a peculiar sensation, this double-consciousness, this sense of always looking at one's self through the eyes of others, of measuring one's soul by the tape of a world that looks on in amused contempt and pity.

Dimock's images peer behind the veil and provide us a glimpse at a uniquely African and American people. His photographs capture the strength and determination that carried a people through the virtual nightmare of the Middle Passage, the cruelty and inhumanity of slavery, the violence during the deconstruction of Reconstruction, and the separation with racial prejudice and segregation. Dimock destroys myths, stereotypes, and misconceptions with his images of a spirited and persevering people. From the lawyer to the farmer, peddler, woodsman, fisherman, cotton picker, mother, father, and child, Dimock captures a wide range of activities carried on by a besieged, downtrodden, but still resilient people.

The photographs of Robert Smalls illustrate. Dimock's portrait of a pensive and stately Smalls is a testament to the sensitivity and compassion displayed throughout his work. The image of Smalls, the "Gullah Statesman," is powerful and full of pride—not the condescending and unflattering image that old conventions and distorted representations of history have given us. Taken in the wintering of the hero's life, the photo captures the glimmer of satisfaction and resolve in the elder statesman's eyes. Smalls's story is a remarkable one, just as are the stories of his people.

At the beginning of the Civil War, Smalls commandeered a Confederate gunboat, the *Planter,* guided it past the garrisons at Fort Sumter, and delivered it to Union forces. Smalls, disguised as the captain by adorning himself with the captain's straw hat, jacket, and pipe, piloted the boat in a remarkable act of courage, determination, and patriotism. It was all the more daring when you consider that his family and friends were aboard during his leap for freedom. In 1863, Smalls piloted the Union's *Keokuk* as a part of the flotilla that bombarded the Confederate stronghold at Fort Sumter. The *Keokuk* was sunk in this attack. During the

period of Reconstruction after the war, Smalls became a major figure in the Republican Party (the party of Lincoln), serving as a member of South Carolina's constitutional convention as well as in the state legislature and the U.S. House of Representatives.

Though his feats were more noticeable and his life events more widely shown, Smalls, like all of the subjects in Dimock's collection, has depth that is too often overlooked, but always present. That Dimock would chronicle the magnitude of such depth—stretching from cultures in Africa to the communities of South Carolina—speaks to Dimock's talents and value as an artist.

Historians constantly research old materials, papers, books, and other artifacts and images to provide society with accurate records of the past, clues about evolving humanity. Much of the work is slow, methodical, and tedious, but on occasion we are rewarded with new material collections or images that can be considered treasure troves. Sometimes the findings are so valuable, so rare, so beautiful—they are truly gems of knowledge. The discovery of Dimock's extensive collection of photographs of African Americans in South Carolina at the turn of the twentieth century has revealed just such a treasure trove.

This discovery adds to the rich collection of new resources on the history, evolution, and culture of the African American in both South Carolina and America. As we see in the photograph of Robert Smalls, the Dimock collection provides images that challenge the old white conventions and stereotypes of African Americans, displaying the resilience, fortitude, and determination of a people long ago separated physically from their homeland but bent on establishing a home in a land soaked with tears, toils, and triumphs. Dimock's pictures capture the true essence of African Americans and how it has contributed to the creation of the American mosaic.

South Carolina and the African American community share a unique and extensive history and relationship. The slave trade, which began in the Americas in the sixteenth century, would continue for three centuries, and South Carolina would be the primary port of entry. Between 1700 and 1775, some 40 percent of the Africans imported into North America came through Sullivan's Island in Charleston Harbor. Unlike on Ellis Island, where the immigrants were considered human, the Africans who came through Sullivan's Island were considered wretched, uncivilized, and without culture.

Those Africans came from Senegambia, the Windward Coast, the Congo-Angola, the Gold Coast, Benin, and Biafra—regions with histories and traditions that far outdate and surpass those of the fledgling land that sought successfully to steal not only human resources but also generations of pride and progress. These Africans brought with them cultures and ideals, ethos and ingenuity, music and methods, and a spirit that could not be broken despite all attempts. From the auction block to the fields of the plantation, the institution of slavery lasted well into the nineteenth century and suppressed, but could not destroy, the spirit of this vibrant people. Despite their achievements, contributions, and sacrifices, African Americans were not given their due, as Frederick Douglass sadly acknowledged. He observed that

> while we are plowing, planting and reaping, using all kinds of mechanical tools, erecting houses, constructing bridges, building ships, working in metals of brass, iron, copper, silver and gold; that while

we are reading, writing and ciphering, acting as clerks, merchants and secretaries, having among us lawyers, doctors, ministers, poets, authors, editors, orators and teachers; that while we are engaged in all manner of enterprises common to other men digging gold in California, capturing the whale in the Pacific, feeding sheep and cattle on the hillside, living, moving, acting, thinking, planning, living in families as husbands, wives and children, and, above all, confessing and worshipping the Christian's God and looking hopefully for life and immortality beyond the grave, we are called up to prove that we are men.

At the close of the nineteenth century, a new method of repression became a part of the everyday life of the African American. The majority of the southernmost states had not recovered ideologically or physically from the spiritual devastation and tangible destruction of the Civil War. The southern economy sputtered as a result of the absence of free slave labor, and crops failed because of drought. An entire system had been overthrown, and beginning anew did not imply becoming better. In 1895, South Carolina governor Ben "Pitchfork" Tillman initiated a constitutional convention that adopted the new state constitution.

This new constitution included an "understanding clause" designed to disenfranchise the African American and the poor and completely silence the black voter. At the time, blacks were the majority population in South Carolina. In the 1896 *Plessy v. Ferguson* case, the U.S. Supreme Court ruled that "separate but equal" was the law of the land, which permitted states to pass laws forcing blacks and whites to use separate public facilities. This ruling effectively undermined the Fourteenth Amendment to the U.S. Constitution, which protected civil rights. "Jim Crow" legislation, forcing legal separation of the races, was passed across the South, and many southern states adopted the Mississippi Plan (a strategy designed by Mississippi citizens to disenfranchise and oppress African citizens). Lynchings became commonplace and racial violence accelerated. It is amid this turmoil, when African Americans had no friend in law or countryman, no escape in their southern "home" and no means of financial improvement, that Dimock takes his pictures.

There are black soldiers pictured in regiments, symbolizing the patriotism of all great Americans who chose to serve their country, like the legendary Smalls and Nathan Hale. Within those ranks of comrades, behind the lines of soldiers, stand men who often were not treated as such, men who were willing to die for a country that knowingly refused them the right to vote and subjected them to apartheid because of the color of their skin.

The Angolan hairstyle on the Columbia child speaks of the process and depth of transport.

The bright eyes and smiles of the children could not be dulled by the tattered and worn clothing that hangs from their bodies.

The expressions of steadfastness and nobility on the faces of the old man and woman could very easily have been taken in the Precolonial rule in the western Senegalese Empire of Mali.

The facial expressions bespeak a very able-bodied, determined people with no signs of inferiority or absence of hope or faith.

The children, like the boy standing on his head and those fly-

ing a kite, display innocence with no resolve of subservience. Their hopes, their forefathers' hopes, all soaring as high as the cloth on a string with which they entertain themselves.

For many black people, becoming American has been an extremely elusive enterprise. The effort to gain inclusion has been arduous. The group's understanding of itself, the sensitivity, the hopes, the determination can be pointed out only when there is a discovery like the Dimock collection and a community to sense what is actually being experienced. Dimock's pictures weave a collective tapestry in the lives of African Americans. It is crystal clear that the African American struggle to become equal participants as Americans has been littered with opposition and resistance. The inhumane nightmare of the Middle Passage, slave codes, chattel/colonial slavery, the Fugitive Slave law, the Three-Fifths Compromise, the Dred Scott decision, *Plessy v. Ferguson,* Jim Crow, and segregation—all of which treated blacks as less than human or as second-class citizens at best—could easily have destroyed these African people. But as social scientists are beginning to find out, many of the African cultural values (such as determination, thrift, faith) were not destroyed in the arduous process. That African Americans retain these values is reflected in their talk, walk, and achievements.

Dimock does history well because he has captured much of what makes African Americans African. Truly, each picture speaks thousands of words and for thousands, indeed, millions, of African people.

Acknowledgments

NINA J. ROOT & THOMAS L. JOHNSON

Nina Root wishes to thank a number of people who were of considerable assistance and support: the now defunct U.S. Department of Education Title II C grant program for research libraries that provided the funds to sort and catalog the vast AMNH Photographic Collection; Dr. Enid Schildkraut, Anthropology Department, American Museum of Natural History, who supported this project; Jeremy Hinsdale and Donald Clyde, Interlibrary Loans, AMNH, who borrowed all the articles and books written by the Dimocks; Matthew Pavlick of the Photographic Collection, who located the negatives and kept track of requested prints; and the Photography Studio, AMNH, which made the prints, often from fragile glass plates. And thanks to contributors Fred Lantz, who generously shared his research on the Dimocks; Paul Carnahan, Vermont Historical Society, who remembered an old inquiry about the Dimocks and years later found important biographical material; and Carolyn Morrison, Blake Memorial Library, East Corinth, Vermont, who also provided significant data. My friend Edward McCartan, as usual, read, edited, and offered suggestions and support throughout the years of the biographical project. Jenny Lawrence of *Natural History* saw the genius of Dimock's work and shepherded the articles about him, which led to this project. My coeditor, Tom Johnson, was a joy to work with: courtly and with a ready sense of humor. He became a good friend.

Thomas L. Johnson's first word of gratitude goes to South Carolina photographic historian Harvey S. Teal, who in 1996 called his attention to the article "Legacy of a Reluctant 'Camera Man'" published in that year's August issue of *Natural History* and written by Nina J. Root (then AMNH library director) about the work of Julian Dimock. This fortuitous discovery led to an exploration of the unit of South Carolina photographs in the museum's Dimock archive and to the collaboration with Ms. Root as coeditor of this book. In addition to expressing his appreciation to Nina Root, Johnson wishes to thank the following persons and institutions: Malcolm Call, senior editor at the University of Georgia Press, who on first viewing the Dimock material indicated a serious interest in publishing it; the Hilton Head Foundation (in particular, its board of directors and associate Eleanor LaBorde) for providing a grant to help assure both the quality of the book and its distribution within Beaufort County; Leon Litwack, Dori Sanders, and Cleveland L. Sellers Jr. for their incomparable contributions to the effort; Hillary Barnwell and her staff at the Beaufort County Library for their generous assistance with research questions; and Allen Stokes, director of the South Caroliniana Library, for his constant professional and institutional support. These friends and associates demonstrated an early interest in the project and provided persistent encouragement toward its completion: Eric Holowacz, Eugene Norris, and Carol Tuynman (Beaufort); Elaine Nichols (Columbia); Wilhelmina Roberts Wynn (New York); and Vertamae Grosvenor (Washington, D.C.).

The editors also wish to thank Jennifer Reichlin and Sandra Hudson of the Press for their essential technical and creative contributions to this endeavor.

Camera Man's *Journey*

Julian Dimock:
Reluctant Camera Man

NINA J. ROOT

In 1920 Julian Anthony Dimock, a much-published photographer, donated some six thousand images with negatives to the American Museum of Natural History, hung up his camera, and never took another photograph. Why would a man who called himself a "Camera Man" and who traveled throughout North America capturing the Everglades, Seminole Indians, former slaves and descendants of South Carolina slaves, cowboys, northern logging activities, and scenes of New York suddenly give up his profession?

Julian Dimock, the fifth of six children, was born in Elizabeth, New Jersey, to Anthony and Helen Weston Dimock on August 8, 1873. Only two children, Julian and his older sister Mabel, survived to adulthood. He was educated at the Pingry School in Elizabeth. (The school was founded by Dr. John Pingry to provide a moral as well as a strict classical education.) For a short time after graduation, young Julian was a member of the New York Stock Exchange. Unspecified ill health forced him to retire and become a photographer for his father, a wealthy financier and noted sportsman, who wrote articles and books about outdoor adventures.

The Dimocks lived in Elizabeth, where the father was instru-mental in the city's development, building streets and residential and public buildings. They then moved to Peekamoose (or Peekamose), New York, in the middle of the Catskill preserve. When the Peekamoose house burned, the family moved to Happy Valley on the Hudson, where Anthony devoted himself to beautifying the estate, writing, and traveling with his son. Anthony was widowed in 1901 and married Leila Bayliss Allen in 1909.

The Dimocks knew many of the wealthy and influential people of the time, such as Gifford Pinchot, the first chief of the U.S. Forestry Service; William Hornaday, director of the New York Zoological Park; Robert Roosevelt, uncle of Theodore Roosevelt, author, politician, and conservationist; the naturalist and neighbor John Burroughs; Henry Ford; and authors Walt Whitman and Owen Wister. Julian was privileged to know these people from an early age, but he was seemingly unimpressed by their status. The conservationist views of his father and his associates, however, did influence Julian to embrace the movement and to become an active conservationist.

By the end of the nineteenth century, a wealthy class had emerged, looking for leisure activities and beginning to take an interest in the condition of the poorer classes. This was also the era when the fields of anthropology and sociology were being institutionalized, and photography became an important documentation tool. By 1880, glass plates with a dry gelatin-bromide that permitted exposures of $1/1000$ of a second were produced, and by the turn of the century, smaller, more portable cameras, ideal for amateurs, were introduced. The lighter camera and emerging interest in social/anthropological trends produced wealthy amateur photographers eager to record images.

With the advent of the Industrial Revolution, a burgeoning middle class was also eager for affordable pastimes suitable for self-improvement. Commercial book and magazine publishing developed to fulfill this need, providing a socially acceptable, educational, and inexpensive outlet for the middle and wealthy classes. The precursors to *National Geographic* and *Field and Stream,* such as *Outing, Country Life, American Magazine,* and *Today's World,* were eager to publish adventure, nature, and socially relevant articles illustrated with photographs.

Anthony Dimock turned his camera to conservation, a growing concern in America, and his pen to social commentaries. The elder Dimock was a pioneer amateur photographer of wildlife and is credited with being the first man to photograph a live wild elk. He often used the baby Julian as a subject, paying him "a cent a sit." The father wrote of his son, "He had his own ideas of art even then and after I had placed him he usually insisted on introducing his toys to give a human interest to the picture."[1] When a fire at Peekamoose destroyed all of Anthony's glass plate negatives, lantern slides, and other photographic equipment, he gave up photography and devoted himself to writing and his travels. "Julian began to do so much better work than I that I laid the camera aside and tried to make pictures with my pen," Anthony wrote.[2] After a life of hunting, he had become a conservationist and an advocate of hunting with a camera. In 1890, he published one of the first articles on the subject: "Camera vs. Rifle," in *Mosaics.*

Julian became a professional photographer and eventually began writing articles and illustrating them with his own photographs. He was also commissioned by magazines and authors for special assignments. He used a 6½ x 8½ Reflex camera for most of his work and a folding-tripod view camera for landscapes and portraits; the same lens and plate holder served both cameras. He did his own developing and printing. Glass plates, the cameras, developing and printing equipment, and chemicals were heavy, cumbersome baggage but were transported through the Everglades, the Arizona desert, the frozen Canadian and New England woods, and South Carolina.

The social concerns at the beginning of the twentieth century became Julian's concerns and are evident in his photographs. In a book on photography he writes: "Make your picture tell a story, whether it is of the quietness, even the solemnity of an evening subject, or the joy in the life of a child" and "Humanity in the mass is a subject for science, for sociology; the individual is a person to love, to hate, to fear, to pity."[3] This advice is clearly visible in his potent images, although love is the principal emotion he demonstrates. None of his six thousand photographs shows fear or hate, even of a trussed-up crocodile in a skiff headed for a zoo. There is compassion in the photo of the now defenseless animal trying to escape. Dimock's writings and powerful photographs show his empathy for the poor and the defenseless and his talent for finding the inherent strength and dignity in his subjects. He also seems to have been drawn to children, perhaps because of their vulnerability and undaunted spirit. Although his landscapes are aesthetically pleasing, beautifully composed, and technically correct, it is his images with people and animals—which reveal his interest in the individual and his compassion for the underdog—that are elevated to art. Dimock identifies with his subjects, for there is not only pathos in his compositions, but also romance and humor.

Julian traveled with his father, photographing fishing trips,

expeditions, rodeos, local residents, and scenery for his father's publications. In his articles, Anthony refers to his son as the "Camera-man" (a commonly used term in the early part of the century for photographers) who always wanted human interest, which the father usually provided, sometimes with discomfort. "When a coiled rattlesnake needed stirring up, I shook a short stick in its face. If we caught a big 'gator or crocodile on a bank I was the one to keep between it and its home. . . . I was expected to hypnotize any bird from a tern to a turkey buzzard, while the Camera-man got in his work."[4] Julian, too, suffered the discomfort of tropical heat, mosquitoes, ants crawling up his leg as he endeavored to steady the heavy camera on swampy soil, and the freezing Canadian winter that stiffened his fingers as he set up his shot.

From 1904 to 1905 father, son, and a Miss Dimock, undoubtedly Mabel, visited Beaufort on the South Carolina coast, where Julian took the opportunity to photograph local residents, including former slaves and their descendants. While Anthony was writing an article on the former glory and Confederate history of the area, Julian photographed the black inhabitants. Here he recorded the grinding poverty evidenced by threadbare and much-mended clothes and the careworn faces and hands, but what he really captured is the subjects' extraordinary dignity and strength of spirit. Children in his photographs are mischievous and playful, not yet betrayed by poverty. Only a few of the six hundred South Carolina photographs were published in Anthony's two articles on the South. This book is the first opportunity to show the best of Julian Dimock's images from his southern sojourn.

In 1906, the Dimocks went to Alabama for Tuskegee Insti-

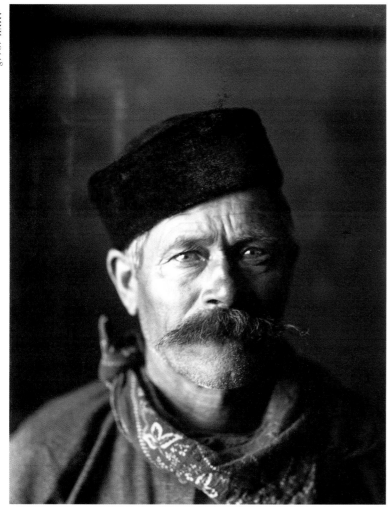

tute's twenty-fifth anniversary. Tuskegee was founded in 1881 as a Normal School and Industrial Institute for colored people by Booker T. Washington, who sought "to hold up the future of the American Negro in its most attractive aspect and to emphasize the virile philosophy that there is a positive dignity in working with the hands, when that labor is fortified by a developed brain and a consecrated heart."[5] At the Institute the Camera Man successfully caught the nobility of Dr. Washington; the elegance of Emmett Scott, his executive secretary; and the neatness, cleanliness (a precept insisted upon by Washington), and determination of the students so evident in the photographs of 1906 for an article by Washington. Peculiarly, Washington used some of Julian's South Carolina photographs of destitute and elderly African Americans to juxtapose against those of his students. He labeled the impoverished as "shiftless and improvident" and "addicted to snuff."[6] The captions provided by Dimock identify these people as mammies, sawyers, field hands, and fishermen. One wonders how Julian reacted to Washington's appellations. Although Julian uses the common terminology of the beginning of the twentieth century, such as "pickaninny," "old mammy," "Israelite," and so forth, one does not detect animus or prejudice in his writings or his photographs. Rather, one sees his understanding in the compassionate images.

The lower East Side of New York, the home of newly arrived poor immigrants and Ellis Island, the gateway to America, attracted Julian. A 1908 article in *World To-Day*, "Ellis Island as Seen by the Camera-Man," is Julian's tribute to new immigrants to America. He spent ten days on Ellis Island observing and photographing the immigrants and immigration officials: "I devoted myself to typical people without regard to character, but

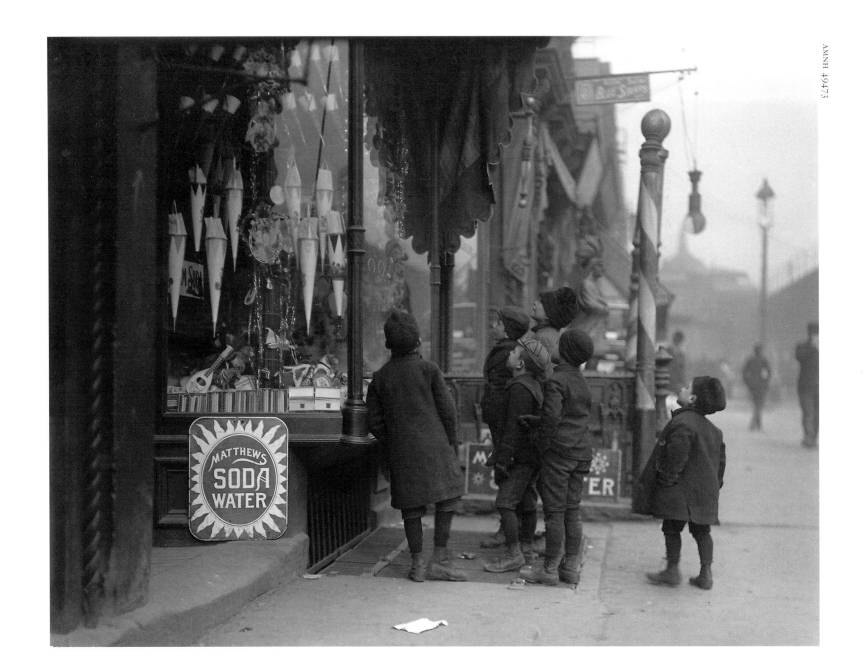

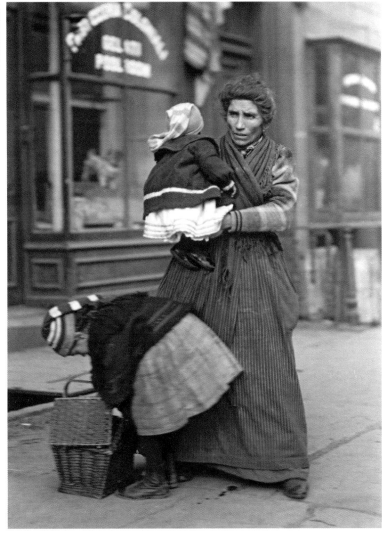

always I avoided the best looking ones lest the result compare too favorably with the work at a Fifth Avenue studio," Julian wrote, revealing an early hint of his feelings about his role of Camera Man.[7] His sympathy for the perplexed, frightened, and hopeful is evident in the portraits from Ellis Island.

In lower Manhattan, Dimock photographed the newly arrived foreigners: street vendors on a gray winter day, disheveled mothers sheltering their children under thin shawls, and raggedy children with wistful looks and noses pressed against a Woolworth's window with a bright Christmas display. Here again he captured the impoverished, overworked adult as well as the irrepressible spirit of children playing in the dirty snow on a busy tenement street.

The Dimocks were early proponents of the preservation of the Everglades and its fauna and flora. As early as 1907, Anthony Dimock lamented the "Passing of a Wilderness" in *Scribner's Magazine:* "The fauna of South Florida is passing away. The habitat of the disappearing Florida crocodile has shrunk to a narrow strip of land. . . . Alligators are being slaughtered so rapidly. . . . The egret and long white [heron] . . . the curse of their plumes clings to them and they will soon be classed with the dodo. Of the plume-bird rookeries which I visited a year ago, every one has since been destroyed."[8] Julian Dimock photographed the vanishing Florida wilderness and published articles in 1907 in *Country Life* on "Egret Murder: A Protest and a Crusade" to enlist the aid of the general public to stop the slaughter of plumage birds for ladies' hat decorations. As a result of his upbringing and, in his youth, watching the slaughter of alligators, manatees, plumage birds, and other creatures, Julian became an ardent conservationist. In 1906, he wrote, "As a child,

the camera man used to shoot the wild things, but the feeling of brotherhood with all of Nature's creatures which had become more apparent with each generation, in him came early to the surface."[9] Here again his sympathy for the underdog and defenseless is expressed in words and photographs. For example, three heron chicks standing on a branch looking ungainly, disheveled, and confused are photographed with humor and heart. "Approach these wild creatures as you would your other friends, with neither murder in your heart nor a gun in your hand, and you will meet a grateful response that will warm the cockles of your heart," Julian wrote.[10] He loved Florida, especially Marco Island, and in 1908 published a book, *Florida Enchantments,* which was reprinted in several editions, the last in 1975, long after his death.

Julian and Anthony accompanied Alanson Skinner, curator of anthropology at the American Museum of Natural History, to Florida in 1910 to visit Seminole Indians living in the Everglades and Big Cypress Swamp. Because father and son had explored much of the area, they were ideal companions for guidance and photography. Julian's photographs illustrated Skinner's article in *American Anthropologist.* In "Professor and the Prairie Schooner," in *Outing* magazine, Dimock senior pokes fun at Skinner: "The Professor represented a great museum which had commissioned him to make collections of specimens—anthropological, biological, entomological, zoological—or of anything else that was logical."[11] Throughout the article he refers to Skinner variously as "the Wise Man of the Museum," "the Collector of Specimens," "our Chaser of Bugs," and "Bug Collector."

Skinner's 1913 article "Notes on the Florida Seminole" is a straightforward scientific report on Seminole costumes, village life, social organization, and religion. It is Anthony Dimock who in his 1911 article "A Despoiled People," in *New Outlook,* decries the government's policy toward the Seminole. "To a wrongful policy, long continued, we are in the way of adding inhumanity. In their shrinking domain these Indians are realizing the condition of Poe's prisoner within iron walls that contracted daily. Already their food is insufficient and famine not impossible. Egret plumes are contraband, and besides, the birds are nearly extinct. Otters are very, very scarce. White hunters have slaughtered the deer, and little stands between the Seminole and starvation but the few remaining alligators." He describes one Indian: "The Seminole strode . . . with an erectness of carriage and a mien worthy of, say, the President of the

Chemical Bank, although his bare legs—I mean the Indian's—impaired the realism of the illusion."[12] It is this nobility of manner that Julian captured in his extraordinary images of a people on the brink of extinction.

In 1911, Julian went to Vermont to photograph maple sugaring for a magazine article by Helen Dodd. He was enchanted with the beautiful countryside and the New Englanders, and in 1912 he bought an apple orchard on a hilltop in Topsham, although his post office address was in the neighboring town of East Corinth. Since he knew nothing about farming and apple growing, he enrolled in a summer course at Massachusetts Agricultural College in Amherst. There he met Annette Follette Chase of Chaseville, New York, a nutritionist and teacher. Annette and Julian were married on July 27, 1912, in Oneonta, New York, by the Reverend T. F. Hall. The Dimocks began to farm their orchard, but Julian continued to travel with his father, as well as alone, on various photographic assignments. Julian wrote and illustrated a series of articles, "True Tales of the Northern Frontier," in *Country Life* in 1913-1914, and another series in 1916, in *Travel,* on Gloucester fishermen, Canadian loggers, dog sledding in Hudson Bay, and his honeymoon trip. It wasn't until 1914 that Annette and Julian finally set out on a "belated honeymoon journey in a sleigh through the snowbound hill country of Vermont. . . . It was a perfect winter's morning when Eve and I, in a little old sleigh drawn by a little old horse, started out on our wedding journey. The mercury marked eighteen below zero, but the morning was still and clear and the sunlight glistened and smiled at us from millions of snowy crystals."[13]

Anthony Dimock died in 1917, and Julian promptly quit

photography. He became a successful orchardist, planting an additional sixteen hundred trees, mostly Macintosh, Fameuse, and Bethels. He was instrumental in developing the seed potato as an important Vermont crop and also participated in the state's reforesting project of planting red and Scotch pines. He served as town auditor for sixteen years and was known as the best apple grower in the area. Today his farm is still known as the "Dimock Orchard."

Julian continued to write for a while, but now on farming, and illustrated his work with someone else's photographs. In a 1918 article in *New Country Life,* "Why I Turned Farmer," Dimock confessed his unhappiness as a photographer. "Photographing leaping fish had always seemed like a waste of a man's time, while photographing the accomplishments of other men made me feel like a useless spectator, a hanger on, a dead weight in the universe. . . . all those years that went before my appearance on the farm were years of slavery. . . . It ground the very life out of me. . . . Self respect vanished. . . . Magazine work had made me a publicity agent." The article ends, "I find joy in my farm. It has been my salvation. It has saved my reason and my health. It has brought hope into my life and with it all, came happiness, for Cupid works on the farm as in the city."[14]

The orchardist, however, did not give up his interest in others. For example, he was active in the World War I Women's Land Army and postwar farmerette movement. Two young women worked summers digging potatoes and harvesting apples on Dimock's land. In my conversation with her, one of the farmerettes remembered, "It was my good fortune to live and work there." When the season was over, she needed another job, so Julian contacted Henry Ford, who owned a resort in Eustis,

Florida. The farmerette ended up running the country store at Ford's historic preservation and restoration project. Annette Dimock did her share of outreaching as well. She wrote regularly for the *Burlington Free Press* under the name Aunt Serena, and she served in the state legislature in 1925.

Because of his previous association with the American Museum of Natural History, Julian deposited six thousand of his photographs along with the glass plate negatives in 1920. He was pleased when the museum honored him by electing him a patron for his important donation. Julian must have felt sufficiently connected to the institution to write to museum director Roy Chapman Andrews in 1941 requesting assistance in pricing "a necklace of alligator teeth made by Tiffany. It is a beautiful piece of workmanship, of course, but quite a barbaric ornament."[15] Dimock had a buyer for the necklace, but Andrews could suggest only that a jeweler appraise it.

Julian Anthony Dimock died of a heart attack on September 22, 1945, finally a contented man. The Topsham Annual Report honored him with a full-page, black-bordered memorial to their friend, neighbor, and auditor. In the registry of deaths, it says: "Sept. 22. Julian A. Dimock, 72y, 1m, 13d." His ashes were interred in the Chase family vault in Shevunus, New York. Annette died in 1953.

This early-twentieth-century reluctant photographer has left a legacy of sympathetic images of New York's lower East Side and Ellis Island immigrants, Florida's Seminoles on the verge of extinction, impoverished South Carolina former slaves, Gloucester fishermen, Navaho poverty, and Canadian loggers. He captured scenic beauty as well: the despoiled Everglades and their endangered flora and fauna, the romance of New England winters, and the grandeur of Canadian snow-covered forests. The photographs, taken with a sympathetic and discerning eye, are a record of a now-vanished America that we are fortunate to have preserved at the American Museum of Natural History.

NOTES

1. Anthony W. Dimock, *Wall Street and the Wilds,* 439.

2. Ibid., 454.

3. Julian A. Dimock, *Outdoor Photography,* 82, 83.

4. Anthony W. Dimock, "Camera Adventures," 371.

5. Booker T. Washington, *Tuskegee and Its People* (New York: Appleton, 1905), 3.

6. Washington, "Twenty-five Years of Tuskegee," 7433–50.

7. Julian A. Dimock, "Ellis Island," 395.

8. Anthony W. Dimock, "Passing of a Wilderness," 361, 362.

9. Julian A. Dimock, "Crocodiling with a Camera," 269.

10. Julian A. Dimock, "Egret Murder," 420.

11. Anthony W. Dimock, "Professor and the Prairie Schooner," 387.

12. Anthony W. Dimock, "Despoiled People," 202, 205.

13. Julian A. Dimock, "Following the Winter Road," 13.

14. Julian A. Dimock, "Why I Turned Farmer," 56.

15. Julian A. Dimock to Roy Chapman Andrews, 1941, American Museum of Natural History Archives.

Mr. Smalls's and Mr. Dimock's South Carolina

THOMAS L. JOHNSON

Columbia and Environs

For several days near the end of January 1904, sixty-five-year-old black Republican ex-congressman Robert Smalls from the coastal town of Beaufort, South Carolina, and a thirty-one-year-old white New Jersey–born photographer named Julian Dimock happened to wind up simultaneously in the state's capital city of Columbia.

Smalls was there for a meeting with other Republican party leaders. Dimock had arrived with his father, the wealthy amateur journalist-historian Anthony W. Dimock, to begin taking pictures of black South Carolinians in and around Columbia, presumably in preparation for a joint publishing project with his father. The Dimocks were in the city at least by January 18, which is the earliest date assigned to a picture in the Columbia unit of photographs housed in the American Museum of Natural History in New York.

Whether Smalls and Dimock ever actually met each other in Columbia during the few days their sojourns there overlapped is not known. There may not have been any special reason for them to have met at this point. Even so, they were mutual ob-

servers of troubling events, practices and attitudes that were a gauge of the discordant times in which they lived.

For instance, both men would have heard or read about the lynching that had taken place just a few days earlier, on January 13, in the town of Reevesville, in Dorchester County, not far from Charleston. They would have read in the January 18 issue of *The State,* Columbia's daily newspaper, that it was difficult to get particulars of "the affair at Reevesville in which a negro perhaps unoffending and inoffensive had his life taken by a mob because it was alleged that he had knocked on the door of the house of an unprotected woman."[1] No official report had been sent from the county officers to Governor D. C. Heyward, the well-liked, mild-mannered state executive who decried the lynching.

They also would have seen the latest reports on the controversy surrounding President Theodore Roosevelt's nomination of a black Charlestonian, William D. Crum, to be the port city's collector of customs. Nor could they have helped but notice a prominent headline in *The State* on January 20 that read "Education Makes Negro Criminal" and covered an article reporting on a "New View of the Race Problem," in which Mississippi governor James K. Vardaman claimed in a speech that "the growing tendency of the negro to commit criminal assault on white women" was "but the manifestation of the negro's aspiration for social equality, encouraged by the character of free education in vogue which the State is levying tribute upon the white man to maintain."[2]

Then young Dimock would be reading about Smalls himself in the pages of *The State,* and from accounts published between January 25 and 30, 1904, the photographer could piece together

the puzzle of a racial incident in which the senior ex-congressman was targeted for Jim Crow humiliation in corridors of the capital city of his home state.

Dimock would have learned that between 10:30 and 11:00 A.M. on Wednesday, January 20, Robert Smalls arrived at the Columbia Hotel to keep an appointment with some Republican colleagues. Smalls would later remember the exact hour he entered the hotel lobby, because that morning he needed to catch the 11:45 train from Columbia south to Allendale, where he would then make the connection with the Charleston and Western Carolina Rail Road for the rest of the trip home to Beaufort.

Accompanying Smalls was ex-congressman Jonathan A. Baxter of Georgetown, another small seaport on the Carolina coast. These two longtime Lowcountry Negro Republican leaders had been asked to meet with two white Republicans, Loomis Blalock and John G. Capers, in Room 99, on committee business—presumably in anticipation of the state Republican convention scheduled to be held in Charleston on February 24.

Smalls walked up to the desk where the clerk was writing in a book on the counter and said to him "in as polite a manner as any one could" that he wished to see Mr. Blalock. Another white man standing by with his hat on and a lighted cigar in his hand said to him "in a very abrupt manner," "Pull your hat off." Smalls, "in the same tone and manner," said, "You have yours on." The white man declared after a few seconds, "You cannot see him." Smalls replied in a mild manner, "Well, sir, he wants to see me." He and Baxter then turned and walked out of the hotel.[3]

In a letter to the editor of *The State,* written from Beaufort on January 27 and published on January 30, Smalls stated that he never knew it was a rule of etiquette or of any hotel that any man was required to take off his hat in going into the corridor of a hotel. Had a notice been posted to the effect "that all persons entering the corridor of this hotel must take off his hat and had he his off, or the other gentlemen sitting and standing around had theirs off, I certainly would have taken mine off without his ordering me to do so, whether in the corridor of a hotel or anywhere else," wrote Smalls. He went on to state that he did not believe there was a gentleman in South Carolina who knew him or of him who would speak of him as being offensive. "I am a man," he declared, "and intend to be one, whether it takes me three or five seconds to get out of where I am not wanted. In getting out of this particular hotel, it took me just about as long to get in as it did for me to get out, as I had no reason to particularly hurry."[4]

Smalls wrote his account in response to a story about the incident that had appeared in *The State* on January 25 under a headline that read "Color Line Drawn at Columbia Hotel," with a subhead declaring "Ex-Congressman Smalls Ordered Out of Lobby." Proprietor S. F. Wheeler, the writer observed, was one southern hotel man who would not tolerate even the semblance of color in his business, "a fact illustrated in his hotel a few days ago when he had occasion peremtorily [sic] to order ex-Congressman Smalls from his lobby."[5]

Smalls, identified as collector of the port of Beaufort and referred to as "very black," was described as having "floated in with his silk hat on." When Wheeler reportedly called out sternly to Smalls to "Take that hat off" and Smalls rejoined with his "You have yours on," the journalist hastened to register the

perceived racial effrontery of the ex-congressman, who generally had "shown sense enough to know and keep his place in South Carolina."[6]

When Smalls was then told to "get out of here quick"—followed by "some stronger language which Smalls did not fail promptly to appropriate"—it was insinuated that his retreat had been a cowardly one: "The estimates of time Smalls required to reach the pavement vary between three and five seconds. The clerk's estimate is less than five seconds."[7]

The writer then proceeded to reveal some of the purported fallout from the incident and to give an account of the conversation reportedly held the following day between Wheeler and one of the white Republicans with whom Smalls was to have met in the hotel. Wheeler was said to have told the white politician that he was welcome to receive "whatever negroes it gave him pleasure to entertain, but that they must be received as other negroes who come into the hotel." Furthermore, Wheeler wished the Republican to understand, he would not be responsible "for promiscuous negroes coming into the hotel and would not allow any general conference in his lobbies between black and tan and lily white guests; that if a negro caller wished to see any of his white guests he would insist upon his being accompanied to the room by one of the hotel's representatives."[8]

Further telling comment appeared on the editorial page of the newspaper on January 26. In "The State's Survey," a compilation of briefly stated opinions and observations on a variety of current subjects, the "Smalls Hotel Episode" was directly or indirectly alluded to in two separate entries. "The colored politician may call on his white confederates in their room[s] in the Columbia hotels," one of them read, "but to ensure good faith

and portable furniture the politician must be escorted to and from the said rooms by a trusted colored porter." The other one stated simply, "Columbia is so big and busy these days that old Bob Smalls thought he was in the national capital until ordered to 'uncover' in a hotel lobby."

Perhaps it should not be surprising that such an incident of racial humiliation and degradation should occur in South Carolina's capital city in 1904 and that it should be publicly reported and widely broadcast, especially as it related to a prominent black citizen. The memory of the city's having been burned during Sherman's victorious sweep through South Carolina fewer than forty years earlier—at the end of a conflict in which the Negro stood at the center—was still fresh on the minds of its citizens in 1904. And as the center of restored white political power, the city was aware that only three decades earlier it had been the seat of black leadership during Reconstruction. Summarily ordering a black patron to leave a hotel lobby for perceived racial insolence would have been considered necessary to "draw the line," to refuse to tolerate "even the semblance of color" in a business, to make sure that black people "kept their place" in South Carolina. Such lapses in the region's traditional good manners would have been justified in the interest of maintaining "good sense and good faith."

Such an incident probably would not have surprised the Dimocks, either, who as northern observers and reporters may have come south for the very purpose of surveying and recording the conditions of the place and people a generation after the sectional conflict. It is unlikely that they would have been shocked to find blatant references in the newspapers to "the negro problem" and to discover racial identification as part of

normal journalistic practice—"A White Man and Twenty-Two Negroes Arrested by the Police," "A Colored Business Man's Experience"—and to encounter such racial sarcasm as the following, which appeared on the editorial page of *The State* on January 8, 1904:

> The north and west, being somewhat worried about the treatment accorded the negro in the south, the south is more than willing to get relief from part of its responsibility by trading, say, 250,000 negroes for an equal number of whites from those sections each year. And, if it would be any inducement, we might give two for one.

Although in 1904 South Carolina was governed by the lovable, genial, aristocratic Duncan Clinich Heyward (1903–7), the state was still living largely in the political and demagogical shadow of Benjamin R. ("Pitchfork") Tillman. Tillman, who served twice as governor (1890–94) and later three terms as United States senator, was responsible for the state's repressive and exclusive "new" 1895 constitution, which effectively disfranchised black South Carolinians. As historian Leon Litwack points out in his book *Trouble in Mind,* Tillman in his racist rhetoric extolled the virtues of "the old Negro," the former slaves, while vilifying and demonizing the new generation—their sons and daughters—as "inoculated with the virus of equality" and responsible for "all the devilment of which we read every day." "We took the government away," Tillman once boasted to his fellow senators. "We stuffed the ballot boxes. We shot them. We are not ashamed of it."[9]

Certainly symptomatic of one aspect of the times was the fact that on January 15, 1903, the year before the Dimocks arrived in Columbia, Tillman's nephew, the volatile lieutenant governor James H. Tillman, shot at close range, within a block of the state capital and in the presence of several witnesses, *The State* newspaper's editor in chief, N. G. Gonzales, as the latter was walking home for lunch. Tillman felt that Gonzales's editorial criticism of him had caused him to lose in the primaries in his race for governor. And while the evidence shows that Gonzales himself had been a racist in his personal views, nevertheless he had supported Negro suffrage and opposed Jim Crow laws and lynchings. Many had credited Gonzales as having been the catalyst in changing Columbia from "muddy town to budding metropolis." One Columbian, Edward B. Taylor, characterized 1904 as "at the very beginning of our most hopeful era of prosperity."[10]

And, to be sure, Columbia was not without some opportunities for its African American citizens, represented in the existence of a small black middle class and its accompanying leadership. Its nucleus was largely to be found in the communities associated with its churches and schools, especially Benedict College and Allen University. There were also a few black doctors, lawyers, merchants, skilled laborers, and artisans whose presence contributed to the complexity of the interracial situation—in some ways acting to buffer, soften, and defuse its volatility, and in other ways fueling it.

There were in Columbia, for instance, such educators as Celia Dial Saxon (1857–1935), who had attended the University of South Carolina during the period in the 1870s when it was open to black students, and Nathaniel J. Fredrick, the young principal of Howard School, who went on to become one of the city's most prominent black lawyers. By 1901 Dr. Matilda

Evans, a graduate of Oberlin College and the Women's Medical College of Pennsylvania (1897), had opened her Taylor Lane Hospital and Training School for Nurses.

And then there was the Reverend Richard T. Carroll, the outspoken Baptist minister who had been born into slavery in Barnwell County in 1860 but who, as an educated man, rose to a position of real power and influence in Columbia and Richland County and probably would have been considered the most prominent black spokesman of his era in the region. By 1899 he had opened his South Carolina Industrial Home for Negro Children in Columbia, and soon he "was in the forefront of virtually every local gathering dealing with racial matters and, in fact, did much to shape attitudes shared by both races."[11] An advocate of education and self-reliance, Carroll became known as "South Carolina's Booker T. Washington," and his occasional letters and comments were published without hesitation by *The State*.

The State also gave space to the occasional African American voice raised in testimony to interracial harmony and opportunity in Columbia. Among the rising black entrepreneurial class there were a few who could seize an advantage within the socioeconomic power structure and make it work to their benefit. In a letter that appeared in *The State,* one I. J. Miller, who identified himself as having recently moved to Richmond, paid a tribute to the "Friendly Support He Received at the Hands of Both Races in Columbia." He had been a resident of Columbia for twenty-seven years and a successful merchant for nineteen and was thankful that he had enjoyed "the respect, esteem and hearty support of both white and colored." His store, he claimed, "met with very little discrimination on the part of the white people, both from the country and in the city, and it was this that kept me in business there so long." During his nineteen years in business, having "made strong friends among the most influential white business men of the city," he had "never seen the day when I wanted for a dollar or a favor." He claimed to have "many warm friends among the white people of dear old Columbia; I feel proud of them and shall ever cherish them and speak in the highest praise of them wherever I go and as long as I live."

Miller went on to assert that there was "a more friendly relationship between them and the better element of colored people than in any city that I know of." The white people of Columbia were "always willing and ready to extend a helping hand to any self-respecting and honest colored man. I venture to say that there is not a city in the union where the colored people have had freer access to their money drawers, their banks, their grocery stores and other business concerns."

"Mr. Editor," Miller continued, "I take the liberty to say that the colored people in and around Columbia ought to be in better condition, financially and otherwise, than the colored people in any other part of the State, on account of the liberality that has been shown by the kindhearted white people of our city in the way of trying to help them; and I am sorry to say that the most of them have slept upon their opportunities and I fear that the chances which they once had will never return again, for that old-time confidence which they once had is now lost." Miller finally advised "my people of Richland county . . . to be honest, upright, industrious, saving, and above all things to be true to their promises and obligations."[12]

Furthermore, according to John Hammond Moore, there

were during this period some other positive interracial associations and genuine opportunities for black Columbians. He goes so far as to claim that Columbia and its environs "created a racial climate that some communities must have envied."[13] He points out that Richland County apparently was free from lynch-mob violence during the half century from 1890 to 1940, that whites and blacks were brought together in frequent conferences focused on significant issues, and that the leaders of both races knew each other. He mentions, for instance, the cordial treatment and reception by white Columbians of Booker T. Washington when he visited the city in 1898. In May 1903 a black lawyer from Darlington, S. S. Davis, argued a case before the South Carolina Supreme Court in Columbia, apparently without incident. And in February of that year, white guests were among those who attended a black society wedding at Sidney Park Church, with nine or ten pews reserved for them. And when a paid fire department was organized early in 1903, black drivers were retained in three companies.

Moore concludes that Columbia and Richland County blacks, who made up almost half the population at the time, were very much a part of the day-to-day world as insiders in the sense of being an integral part of the essential routine and activities—but principally as maids, laborers, and sharecroppers.

And, no doubt, there had to have been some genuinely cordial and sincerely felt, if guarded, ties of affection between white Columbians and their black maids, servants, and hired helpers, both male and female—the principal subjects of young Julian Dimock's photographs. There must have been at least some slight continuation of the tradition that even W. E. B. Du Bois speaks of in *The Souls of Black Folk* when he attests that before

and directly after the Civil War, "when all the best of the Negroes were domestic servants in the best of the white families, there were bonds of intimacy, affection, and sometimes blood relationship, between the races."[14]

But Moore's chapter on the African American experience in Columbia and its surrounding county of Richland is entitled "Blacks: Outside Looking In," and he begins it by pointing out that one rebuff after another dominated the years at the turn of the century "as legal segregation à la Jim Crow became a fact of life on trolleys and railroads and in city parks." The years from 1890 to 1905, he states, were unusually difficult.

In 1900, for instance, soon after witnessing a fracas that broke out in front of the State House involving the black Capital City Guards—Columbia's last black militia company—and whites who drove a buggy into their drill formation, Governor Miles B. McSweeney disbanded the Guards. And while there may not have been any lynchings in Columbia technically, its black citizens were subject to violence visited upon them because of their race. A story entitled "The Coroner Out Making Business," which appeared in *The State*, tells of coroner Will Green's shooting, "on Gervais street, in the fashionable portion of the city," of Bingley Gary, a fisherman and hunter who was well known to everyone in Columbia as "one of the most harmless yet most privileged negroes in the city." The reason was for a supposed insult to a white woman of whom he had asked which streetcar to take out to the shooting range where he was to meet with a party of gentlemen—one of whom had sent him to carry a gun for him. Thinking that Gary had at one point raised the gun to a firing position, Green shot him with a .44-caliber revolver. Assuring readers that Gary's wounds were for-

tunately "not at all serious," the journalist concluded by saying that the whole affair was "a most regrettable one."[15]

Just a few months prior to the Dimocks' arrival in Columbia, the city council had established Jim Crow seating on the local trolley system. *The State* "expressed regret," wrote Moore, "that the 'best' element of the black population was being forced to the rear, but whites, 'by far the largest patrons,' had to be protected."[16] The result, he revealed, was a brief black boycott, followed ten months later by the adoption of a scheme for complete racial separation. And in 1904, Moore points out, the Columbia city directory introduced a "colored" section for the first time.[17]

While he was in South Carolina during the winter and spring of that year, Julian Dimock might have read such open insults as those that appeared in Charleston's *News and Courier* of March 5, in which the editor referred to "the millions of Southern people who have the negro at their very doors and who have to meet from day to day the problems that his presence there raises," lamenting "the situation in which the white people of the South find themselves in consequence of the negro's presence among them."[18] Or he might have seen spelled out the conditions under which black Carolinians were to be found acceptable, as in the "special" that was published in the *News and Courier* four days later. "Little complaint is made of the negro, especially the plantation negro, being in the way these days," wrote a correspondent from Spartanburg. "The negro is not such a terrible savage as he is supposed by some to be. The fact is he is now a very desirable member of society, especially if he owns a mule and a good batch of hoe hands."[19]

The desperate plight of most of Columbia and Richland Counties' black citizens was caused not only by legally imposed or privately sanctioned restrictions placed upon them by the majority white population. Natural conditions also sporadically wrought havoc in their lives. During the same week in which he read of the public humiliation of Robert Smalls by the proprietor of the Columbia Hotel, Dimock would have seen the plea for relief measures on behalf of "the destitute people of lower Richmond." Repeated disasters caused by floods and hail the previous spring had destroyed the crops of the tenants and prevented the landlords from proffering "that aid which they would otherwise have given." Hundreds of Negroes around Congaree, Hopkins, and Weston were reportedly almost starving and nearly naked.[20]

Young Julian Dimock, then, happened to arrive in South Carolina precisely in the middle of the period that Leon Litwack characterizes as "the most repressive period in the history of race relations,"[21] an era in which the average black person was trapped in circumstances of desperate poverty, illiteracy, exploitation, and powerlessness. And Dimock came into an area of the state in which the conditions of dire limitation were exacerbated by natural disaster. At least in his Columbia photographs, he chose not to capture the lives and the experience of the small black middle class or of its leaders. He determined, rather, to depict the average black person caught on the cusp and to portray the conditions of the majority of African Americans in this place at this time who lived out their lives in poverty and isolation—marginalized, degraded, segregated, reduced to debt peonage, socially and economically and politically deprived.

Incidentally, we do not know whether Dimock read W. E. B.

Du Bois's book *The Souls of Black Folk,* published just the year before he and his father made their foray into South Carolina. But what his photographs made there during 1904 and 1905 do is to provide a cohesive visual counterpart to Du Bois's 1903 work—South Carolina being the regional sample—as well as to Litwack's *Trouble in Mind,* published ninety-five years later. Du Bois stated in his book: "We seldom study the condition of the Negro today honestly and carefully. . . . how little we really know of these millions—of their daily lives and longings, of their homely joys and sorrows, of their real shortcomings and the meaning of their crimes!"[22] All of this could only be learned, he said, by intimate contact with them. And the genius and value of the photographs Julian Dimock took in South Carolina in 1904 and 1905 is found precisely in the nature of his intimate revelations of average black men, women, and children in the routine confines of their lives at work, at play, at home, on the road.

Beaufort: Town and County

By the fourth week in March 1904, Julian and his father had arrived in Beaufort County, apparently to observe this isolated, southernmost region of the state as their next objective. There are no known photographs in the Dimock collection of any of the other counties or towns that lay on either of the two rail routes they would have taken on their trip south to Beaufort.

The first photograph identified with Beaufort County is dated March 23, 1904, and shows several black persons waiting for the ferry at an unspecified location. Two photographs taken on March 24 of a man plowing with an ox are followed by a dozen pictures made at Tomotley Plantation. Located in the northwestern section of the county, some seventeen miles from Beaufort, historic Tomotley was a sprawling seventy-five-hundred-acre rice plantation that was the heart of an original thirteen-thousand-acre barony laid out in accordance with a patent granted Landgrave Edmund Bellinger by the Lords Proprietors in 1698. Dimock's photographs document—in addition to the black field workers themselves—the general look of the place and the agricultural methods employed at the time. This was prior to the purchase of Tomotley by Robert H. McCurdy and his construction, circa 1910, of a hunting lodge, the present "Big House," or "bungalow," on the property.

Dimock's Tomotley photographs reveal both a continuity and a discontinuity within his South Carolina images. They show his continued general preoccupation with the black population and the centrality of African Americans to the region's productive life—their daily routine, their backbreaking labor. But the pictures also present, unlike the Columbia photographs, the lush setting of the Lowcountry landscape, which—ironically, alongside the reality of its exactions upon the human workforce charged with wrestling a living from it—lends itself to breathtakingly beautiful works of art.

External evidence for the Dimocks' sojourn in the town of Beaufort in the spring of 1904 is found in the town's newspaper, the *Beaufort Gazette,* which twice carried mention of their presence. In the *Gazette* supplement of March 31 "A W and Julian A Dimock, New York" are shown as "registered during the past week" at the Beaufort House. And in the April 24 issue they were listed among the hotel's guests, along with a "Miss

Dimock, New York." Further evidence in Dimock's own photographic archive records at the American Museum of Natural History indicates that Julian took some 136 pictures in and around Beaufort between March 26 and May 7. Additional notations reveal that Julian, probably along with his father, returned to South Carolina in November 1905 to further photograph the Lowcountry.

Why would the Dimocks have come to Beaufort in the first place? To be sure, as an extension of a reportorial survey trip that began in Columbia, the capital of the first southern state to effect the dissolution of the federal union only four decades earlier, and therefore one upon which the heaviest hand of retribution had been felt. What were conditions like there now—for the conquered peoples, but especially for those who had been set free, the majority black population?

Furthermore, within South Carolina, Beaufort and its island realm held special interest because of their own peculiar history within the state's experience in the Civil War. Before the war, Beaufort and the Lowcountry had been part of that narrow strip of South Carolina coast that for two hundred years—with its rich and various supplies of indigo, tar, pitch, turpentine, resin, timber, furs, rice, and Sea Island or long-staple cotton—had been the economic mainstay of the whole state. Beaufort itself, next to Charleston, the second oldest town in South Carolina, had also been its wealthiest. Historian Edward McCrady once referred to Beaufort as "the wealthiest, most aristocratic, and cultivated town of its size in America; a town which, though small in number of inhabitants, produced statesmen, scholars, soldiers, sailors, and divines whose names and whose fame are known throughout the country."[23]

Then, in November 1861, everything changed. That month, in a surprise attack on Confederate Fort Walker on the northern end of Hilton Head Island, some twelve thousand Federal marines landed from a Union armada, beginning what was to be a four-year occupation of the Beaufort and Port Royal area from which the Federals' island-based Department of the South could blockade southern ports and, in particular, challenge Charleston and Savannah. The white families fled their island plantations and Beaufort townhouses, and their property was confiscated and bought by the government at modest prices or sold to soldiers or local African Americans.

Meanwhile, the area's black population, already distinguished by its African and West Indian roots and by independent mindedness (fostered by its relative physical isolation and traditional "task" system under slavery, whereby workers were able to attend to their own business after they accomplished assigned tasks on the plantation), was further able to acquire some education and assume some power of their own. Profiting by Reconstruction programs, largely educational and economic, which began years earlier than those that were created only after 1865 elsewhere in the South, black Lowcountry Carolinians were able to demonstrate some leadership and to claim some political power in this region.

Chief among these, of course, was Robert Smalls (1839–1915), who, as we have seen, appeared in Columbia in January 1904 on political business. A native Beaufortonian, Smalls had been born into slavery in a cabin behind the big house on the Point, the residence at 511 Prince Street that he was able to purchase at a land tax sale during the Civil War with money he received for his daring escapade of abducting the armed Confed-

erate steamer *Planter* with a cargo of unmounted guns and delivering it into the hands of the Union blockading squadron off Charleston in May 1862. Thinking that the vessel might be of some service to "Uncle Abe," the twenty-three-year-old slave stole the wooden side-wheeler from directly in front of the home and office of Brigadier General Roswell S. Ripley, commander of the Second Military District of South Carolina.

Smalls went on to serve five terms as a U.S. congressman. He eventually became customs collector for the port of Beaufort, a post he held sporadically from 1889 until his death. Although lacking formal education himself, Smalls championed free, universal, and compulsory education and helped establish South Carolina's first public school. Smalls's biographer Edward A. Miller Jr., in *Gullah Statesman: Robert Smalls from Slavery to Congress, 1839–1915,* claims that General Smalls was "unquestionably the longest serving and possibly the foremost ethnic leader in the history of the state." Described as "a major participant in every important event from the beginning to the end of black political participation in South Carolina," Smalls, though not a revolutionary, "never failed to protest injustice and sought constantly throughout his life to improve social, political, and economic conditions for black South Carolinians." This black hero of the *Planter,* federal congressman, customs collector, landowner, and Republican party leader "rose above his beginnings and reached as high in public accomplishment as has any black citizen of his state."[24]

Whether or not young Julian Dimock met Robert Smalls in Columbia three months earlier, he certainly did so in Beaufort that spring. He made at least four photographic portraits of the ex-congressman, two of which are dated—April 15 and April 23, 1904—in Dimock's records. The portraits were made both outside and inside, the interior shots presumably taken at Smalls's collector's desk in his office at the customs house along Beaufort's main commercial thoroughfare, Bay Street (now the Abram Cockroft Building). The portraits of the then sixty-five-year-old Smalls provide some evidence of the impaired eyesight that had been plaguing him, along with rheumatism, for many years. They also suggest something of the inherent dignity of "the old veteran, General Robert Smalls," who in 1904 was elected vice chairman of the South Carolina Republican Party.

Dimock's portraits of African Americans in the Beaufort area, in both town and country, differ from those taken earlier in Columbia by their obvious socioeconomic range and by the number of those identified by name. In addition to the heretofore unknown or forgotten portraits of Robert Smalls is a picture—the only known surviving one—of former state representative Hastings Gantt. Julian's father would later refer to Gantt in his article "The South and Its Problems," published in the *Metropolitan Magazine* of October 1907. "If you chance to travel the mail wagon from Beaufort to Frogmore," Anthony Dimock wrote, "the driver may mention that he is the Honorable Hastings Gantt, late member of the Legislature of South Carolina, now retired to his Before-the-War occupation of driving a team."

Julian's notes on his portraits of African Americans in the Beaufort area identify by name such individuals as John Smith, Matt Jones, Maria Grant, John Ford, Nancy, Mother Margaret, Tamar Blythwood, and Bailey. And his pictures portray the socioeconomic range within the black community, everyone from the politicians mentioned to the skilled and unskilled

workers of both sexes, day laborers, tenant farmers, and field hands.

In another of his articles, which was probably the immediate purpose for the Beaufort sojourn in the spring of 1904, Anthony uses four of his son's portraits of Lowcountry blacks and, in the parlance of the day, labels them "Types of Sea Island Negroes."[25]

The range of Julian's work in the Beaufort area, however, is not only socioeconomic in scope and caste inclusive; it is also geographically widespread. Not only does he depict African Americans in the agricultural interior of the country, specifically in his representation of Tomotley Plantation, as well as the town dwellers of Beaufort itself, he also shows individuals engaged in the maritime pursuits that characterized the life of the region: fishing, the manning of boats, waiting for ferry transportation, gazing toward the river or the sea.

While Anthony mentions or alludes to St. Helena Island in his magazine articles of 1905 and 1907—in the first historically, in the second with reference to Hastings Gantt's mail wagon—the island is not named in Julian's chronological list of photographs taken on the Lowcountry trips of 1904 and 1905. One cannot be certain, therefore, that any St. Helena islanders are represented in the collection beyond the photograph of the Honorable Mr. Gantt. Nor do we know whether Dimock was familiar with the photographic work of another white Yankee sojourner to the region: the Connecticut-born artist Leigh Richmond Miner (1864–1935). Miner came down to St. Helena from Hampton Institute in Virginia to visit his former students at Penn School and, "fascinated by the people and the beauty of the island," to take the now-famous photographs collected in the late Edith M. Dabbs's book *Face of an Island* (1970). Miner's records show that his St. Helena's pictures also date from at least as early as 1904, which means that his work coincided with Dimock's that year. Miner returned to St. Helena each year from 1906 to 1909 and again in 1923.

Whether or not Julian Dimock took photographs on St. Helena, it is certain that he made some on Hilton Head. His inventory list indicates thirty-nine pictures taken on the latter island between April 6 and 10. In fact, Dimock's Hilton Head unit constitutes one of the most interesting and unusual in the collection. For, whereas a photographic archive does exist for St. Helena Island and its well-documented Penn School in the work of Leigh Richmond Miner, no known equivalent exists for Hilton Head from this early-twentieth-century period. In this group of pictures is revealed the look of the historic, isolated island that, like the other sea islands, was reachable only by boat at this time. Its agricultural life is portrayed in photographs of the black laborers planting and plowing the fields; its river and maritime pursuits in pictures of fishermen shoveling and opening oysters.

Hilton Head is given as the place of identity for pictures of one Matt Jones, posing in his regimentals, and of old John Ford and young Albert Singleton. There are photographs of the William Graham house, which Anthony says in his 1905 *Outlook* article is the only remaining one of the twenty-three plantation houses that existed on this island "when South Carolina passed its ordinance of secession."[26]

Other particularly rare images associated with Hilton Head are the only known surviving photographs of one of the island's—and Beaufort County's—most colorful white citizens,

Dr. Francis E. Wilder (1837–1924). A native of Massachusetts, he had come to Beaufort in 1865 and, locating on Hilton Head, had formed, along with several associates, a partnership known as the Sea Island Cotton Company, which engaged in raising long-staple cotton. He also practiced medicine continuously from that time and became "known and loved" by the island residents. Active in the area's political life, he served as both a county commissioner and a school commissioner. In a 1903 *Beaufort Gazette* column reporting on recent activities and events on the island—which included items relating to the lighthouse and its keeper, the removal of a detachment of soldiers, the attraction of "our grand surf bathing," and the raising of funds for a church building—"our popular and well-known Doctor, F. E. Wilder," is mentioned three times: as meeting and guiding a large fishing party, as hosting visitors from Savannah for a "big old time" at his "delightful cottage," and as being a member of the church fundraising committee.

Anthony Dimock also mentions Dr. Wilder in his Sea Islands story, identifying him as "the oldest white resident of the island." Dimock claimed that the doctor's influence so dominated the island's large black population during and following Reconstruction—and "the mutterings of war between the races"—that it "maintained peace on the island and saved life on more than one occasion."[27]

There is, in fact, more of a white presence among Dimock's Beaufort pictures than among those taken in Columbia. In addition to the candid outdoor action portraits of Wilder and some architectural shots of white residences and landmarks are the pictures of a white gentleman-proprietor in profile, taken inside before his fireplace, and of white infants and children with their black caregivers. There are more than a dozen of these "Mauma and child" depictions—the genre studies that, more than any other images in the collection, suggest the complex interracial associations and socioeconomic caste system found in the South during this time. These portraits of elderly black nursemaids with their young white charges convey the reality of the continuation of a fixed class system, with blacks and whites within the first half century following slavery and Reconstruction shown in their traditional servant-and-master (or -mistress) roles. But besides the suggestion of social and economic determinism and entrapment evident in such pictures—as well as the literal interracial closeness—these genre portraits also reveal ties of mutual responsibility, dependence, and even affection.

And there were such ties in Beaufort, South Carolina, at this time, providing the foundation that would shape later white descriptions of the area's Gullah descendents. N. L. Willet, in a 1926 booklet, speaks of coastal life for the Gullahs as "easier and more to their liking here than in any other portion of the country." He characterized them as "just as expert as were the old Indians in all matters pertaining to salt waters." "Than this Gullah Negro," he declares, "no laborer in America, for so many hundreds of years, has stood so bravely and faithfully by this task."[28]

Furthermore, a few years after the Dimocks' visit to the area, an expatriate white native of Beaufort, Frederic Chisholm, writing in the *New York Sun* in 1908, described Beaufort as a "black belt" South Carolina town of "about 1,500 white and 3,500 colored persons" and made these observations about its black residents:

I get fresh meat and vegetables from a clean shop owned and run by a very dark negro, where I meet with prompt and polite service, in which there is not a trace of subservience. Every negro whom I have seen or to whom I have talked has impressed me as polite, accommodating and self-respecting. I have not seen any one under the influence of liquor nor heard any profanity or loud talking in the streets.

Chisholm quotes Robert Smalls, who "seems to [have] spoken the sentiment of the colored people when he said lately: 'Thank God that in Beaufort a white lady can walk the streets alone in safety at any hour of the day or night.'" Chisholm continued, "Little quarrels may sometimes arise between the whites and negroes, but the outsiders should avoid taking sides, for if he does both parties will unite in resenting his interference." He concluded, "The condition of affairs here has been very gratifying to me, and the race problem seems to have been solved here at least."[29]

And, indeed, there were shaping forces and influences in Beaufort's history before and since 1861 that gave expression to Lowcountry African American self-awareness as well as definition to local black power and positive race relations there. The recent *History of Beaufort County*, for instance, documents the phenomenon of the antebellum development of "a significant internal plantation economy managed by the slaves for their own sustenance and profit and rarely interfered with by a wise master." The use of slave time "for their own planting and craftmaking over many years allowed for the accumulation of wealth within the slave community." Their property rights within the plantation community, the book claims, were almost universally accepted by owners and overseers. So that while they endured insult, hardship, and abuse within the system, nevertheless "with perseverance, enterprise, and imagination, they seized their own time, preserved what they could of their African heritage, adopted what they wanted from white society, and forged the unique world of the Gullah."[30]

Then, with the occupation of the Port Royal area by Federal forces early in the Civil War, Lowcountry African Americans had the distinction of serving in the military. The tradition of a proud local black martial identity continued to be honored on into the twentieth century, evidenced here in Dimock's photograph of the "Beaufort Colored Troop" and in the portrait of one Matt Jones, presumably dressed in the regimentals of his South Carolina Volunteers unit, listed among the photographer's Hilton Head pictures.

In addition to sympathetic transplanted northerners like Dr. Wilder on Hilton Head and the Penn School teachers on St. Helena—Ellen Murray, Laura Towne, Alice Lathrop, and Rossa Cooley—there were such families as the Christensens in Beaufort. Danish-born Niels Christensen Sr. had come South as a Federal soldier and had stayed on after the war as superintendent of the United States Cemetery in Beaufort. He became one of the town's leading businessmen. His wife, Massachusetts native Abigail Holmes Christensen, was committed to education and the preservation of Gullah culture. Her collection of local stories written in dialect, *Afro-American Folklore,* was published in 1892. She was instrumental in the founding of the Port Royal Agricultural and Industrial School, located a few miles west of Beaufort and established with northern financial help just two years prior to the Dimocks' visit in 1904.

A typed account found among the Christensen family papers in the South Caroliniana Library at the University of South Carolina—written on the school's letterhead (with the name of the black principal, Edinburgh Mahone, printed at the top) during or after 1902—reports conditions in Beaufort County during this period. After providing a brief geographical description of the county and noting population statistics—"35,495 inhabitants according to the last census, about 31,000 being Negroes"—the writer goes on to single out the county's "possibilities": its agriculture, harbor, phosphate beds, tourist attractions, and development of a naval station. The report goes on to mention the devastating Hurricane of 1893 and the cyclones of a few years later that wrought economic havoc in the area. "Since '98 the recovery has been gradual and must be very slow as long as farmers work after antebellum methods," it continued. "The hope of our section is in improved methods in farming—no, that statement is too narrow. IT IS IN THE EDUCATION OF THE NEGRO ALONG LINES MORAL INTELLECTUAL AND INDUSTRIAL."

The town of Beaufort was reported to have a population of 4,151, about 1,000 of whom were white. A water system supplied excellent water, its principal streets were paved, its buildings were in better condition than ever before, and its ice and electricity were supplied by a local plant. Two graded schools—"one for whites and one for blacks"—accommodated some 500 students through a nine-month term. Pay for the four white teachers ranged from thirty to one hundred dollars a month; for the six black teachers, twenty-five to fifty. Two-thirds of the total number of pupils were black, and the funds apportioned to each school were about the same.

Niels Christensen Jr., who would gain a reputation for being a remarkable state senator with wide influence, was editor and then publisher of the *Beaufort Gazette* from 1903 until 1921. During much of that time the newspaper with some regularity featured a column variously headed "Of Interest to Our Colored Readers" or "Colored News." Written and submitted by members of the black community, the column covered the whole range of events and occasions of interest to the area's African American community: engagements, marriages, births, illnesses, deaths and burials, school and church happenings, meetings of all kinds, parties, special celebrations and occasions, excursions and fairs, concerts and lectures, sports events, crimes and imprisonments, accidents and injuries, business and political visits.

The comings and goings of prominent members of the black community were also reported in the column—including, of course, those of General Robert Smalls, who, as one could have discovered in the *Beaufort Gazette* of June 16, 1904, left that morning for Chicago, where he was to attend that year's Republican National Convention as a delegate. This was a short time after the Dimocks' presumed departure from Beaufort in early May.

In this column, persons were referred to by the conventional personal or professional titles of address: "Miss," "Mr.," "Mrs.," "Rev.," "Dr.," "Gen." The *Gazette*'s "colored column" was scarcely different in tone or written style from any other feature in the paper. And Christensen's persistent inclusion of it in the paper for many years was a tribute to his tradition of positive paternalism, as well as to his astute business and political sense.

Like most other southern newspapers of the day, however, the *Gazette* in its general reporting did occasionally resort to the

use of racially pejorative and stereotypical headlines: "Colored Minister in Trouble" (13 August 1903), "Bad Negro Captured on Paris Island" (13 September 1906). And, like virtually all regional newspapers of the era, there were headlines and stories on "The Race Problem" (29 October 1903).

And black Beaufortonians, no less than other southern African Americans, were subject to the effects of heightened discriminatory practices instituted by custom and by law during the twenty-year period starting in the mid-1890s—with South Carolina's prospective constitution of 1895; the Supreme Court's Separate but Equal decision of 1896, which weakened the protection offered by the Fourteenth Amendment; and the state's Jim Crow enactment in 1898 of laws governing equal access to railroad accommodations. As elsewhere in the South, chronic tensions would persist between Beaufort's blacks and whites over such matters as land ownership and control of local politics.[31]

One particularly volatile manifestation of the tense racial climate that at times prevailed even in Beaufort was reported in the *Charleston News and Courier* less than a year before the Dimocks arrived in town. An article entitled "The Negroes in Beaufort" revealed that at a mass meeting of "the colored people of Beaufort," resolutions were adopted charging that conditions in the jail and the poor house and on the chain gang demanded "a searching investigation." The resolutions charged that black convicts and paupers were treated with gross brutality and urged that such intolerable conditions be made known to the public and investigated.

The *Courier* article quoted the *Beaufort Gazette* as saying, "the greatest emphasis in the resolutions was laid upon the disenfran-chisement of the negro in general, and in this county in particular." The *Gazette* article continues, "Why is it that . . . leaders among our colored citizens do not hold mass meetings to encourage industry and education? All the political meetings held here during the last twenty years have not benefited conditions in the least." The *Gazette* editor is quoted as concluding, "It would seem wise to lay emphasis on the most important matters and leave the others for the future to settle."[32] The *News and Courier* would have "the Negro question"—"big as it is and tremendous as are the issues involved"—settled by the white people of the South.[33]

In Beaufort, as elsewhere across the South, at least these two interracial questions would continue to be at issue for many years to come: Who, in fact, should determine what the principal questions are for the whole community to address? And whose power should shape the answers to those questions?

Meanwhile, in 1904 and 1905, the lens of the northern "Camera Man," Julian Dimock, constitutes its own power, does its own questioning and answering. It of course reveals the quality of his own sensibility as a human being and his exceptional talent as a photographer. The breadth and depth of his work is everywhere manifested, from his portraits and genre scenes to his spontaneous reportorial shots and dreamy landscapes. Dimock captured the look of this particular place at this particular time in history—the inland and quasi-urban Columbia and its environs, and the Carolina Lowcountry, interior, and coast—in a way never before seen. The style and the condition of housing and clothing are revealed in all of their raw or appealing authenticity. Here is the land, seen exacting its agrarian toll in the backbreaking labor of those whose principal job it is

to till it. The evidence of work is captured throughout, whether it is that of the field hand, the skilled and semiskilled laborer in both town and country, or the women attending to the domestic responsibilities of their own homes—sewing, washing, negotiating with the itinerant tradesman, tending the children. Children are everywhere among Dimock's pictures.

But the principal power of Julian Dimock's lens lies in its revelation of the character of the subjects he photographed in all of the stark—often harsh and desperate—circumstances of their lives. What prevails, whether in Columbia or in Beaufort or on Hilton Head, is an indomitable sense of self, of pride and dignity, that no external limitations can smother or erase. If this young northern photographer came south to capture and expose something of the marginalized existence of an exotic community of survivors living out their lives on the periphery of the American dream soon after the turn of the century, what he found, in addition—and captured for all time—was the phenomenon of a rare expression of human strength and beauty in the faces and forms of a people who could demonstrate in themselves the American experience at its most profound and the country's lesson at its hardest: that of lives of unmistakable grace lived out under horrendous pressure.

NOTES

1. "The Reevesville Lynching," *The State,* 18 January 1904, p. 8.

2. "Education Makes Negro Criminal," *The State,* 20 January 1904, p. 5; "The Committee Stands by Crum," *The State,* 19 February 1904, p. 5.

3. "The Smalls Hotel Episode," *The State,* 30 January 1904, p. 6.

4. Ibid.

5. "Color Line Drawn at Columbia Hotel," *The State,* 25 January 1904, p. 8.

6. Ibid.

7. Ibid.

8. Ibid.

9. Litwack, *Trouble in Mind,* 189, 206.

10. "The Holly Hill Murder," *The State,* 5 March 1904, p. 5.

11. Moore, *Columbia and Richland County,* 373.

12. "A Colored Business Man's Experience," *The State,* 15 January 1904, p. 7.

13. Moore, *Columbia and Richland County,* 274.

14. Du Bois, *Souls of Black Folk,* 205.

15. "The Coroner Out Making Business," *The State,* 7 September 1900, p. 8.

16. Moore, *Columbia and Richland County,* 286.

17. Ibid., 369.

18. "Not a Fool Friend," *News and Courier,* 5 March 1904, p. 4.

19. "Spartanburg Needs Negroes," *News and Courier,* 9 March 1904, p. 5.

20. "Destitution in Lower Richland," *The State,* 28 January 1904, p. 4.

21. Litwack, *Trouble in Mind,* 278.

22. Du Bois, *Souls of Black Folk,* 163–64.

23. Edward McCrady, *The History of South Carolina under the Proprietary Government, 1670–1719* (New York: Macmillan, 1897).

24. Miller, *Gullah Statesman,* 250.

25. Anthony W. Dimock, "Story of the Sea Islands," 297.

26. Ibid.

27. Ibid.

28. Willet, *Beaufort County,* 16.

29. Frederic Chisholm, "Solving the Race Problem," *New York Sun,* 1908, Christensen Papers, South Caroliniana Library, Columbia, S.C.

30. Rowland, Moore, and Rogers, *The History of Beaufort County,* 353, 365.

31. See Miller, *Gullah Statesman,* 129.

32. "The Negroes in Beaufort," *News and Courier,* 6 July 1903, p. 4.

33. "Studying the Negro Question," *News and Courier,* 12 June 1903, p. 4.

SELECTED BIBLIOGRAPHY

Dabbs, Edith M. *Face of an Island.* [Columbia, S.C.]: R. L. Bryan Co., 1970.

Dimock, Anthony W. "The South and Its Problems." *Metropolitan Magazine* (October 1907): 1–11.

———. "A Story of the Sea Islands." *Outlook* (4 February 1905): 291–98.

Dimock, Julian A. *Outdoor Photography.* New York: The Book League of America, 1929.

Du Bois, W. E. B. *The Souls of Black Folk: Essays and Sketches.* Chicago: A. C. McClurg, 1903.

Litwack, Leon F. *Trouble in Mind: Black Southerners in the Age of Jim Crow.* New York: Alfred A. Knopf, 1998.

Miller, Edward A., Jr. *Gullah Statesman: Robert Smalls from Slavery to Congress, 1839–1915.* Columbia: University of South Carolina Press, 1995.

Moore, John Hammond. *Columbia and Richland County: A South Carolina Community.* Columbia: University of South Carolina Press, 1993.

Rowland, Lawrence S., Alexander Moore, and George C. Rogers Jr. *The History of Beaufort County, South Carolina, 1514–1861.* Vol. 1. Columbia: University of South Carolina Press, 1996.

Willet, N. L. *Beaufort County, South Carolina: The Shrines, Early History and Topography.* Augusta, Georgia: Commercial Printing Company, [1926].

The images reproduced here were printed from Julian Dimock's original glass plate negatives. Some plates show the telltale signs of age—flaws that are the result of scratches in the gelatin emulsion, cracks in the glass, or foreign matter imbedded in the emulsion.

That the images have survived in such a remarkable condition for 95 years is in great part due to the conservation efforts of the Department of Library Services of the American Museum of Natural History. The excellent prints were produced by the expert photographers of the Museum's Photography Studio.

Bracketed material in the captions represents the editors' emendations to the original descriptions found on the inventory list housed with the Dimock negatives.

Columbia and Environs

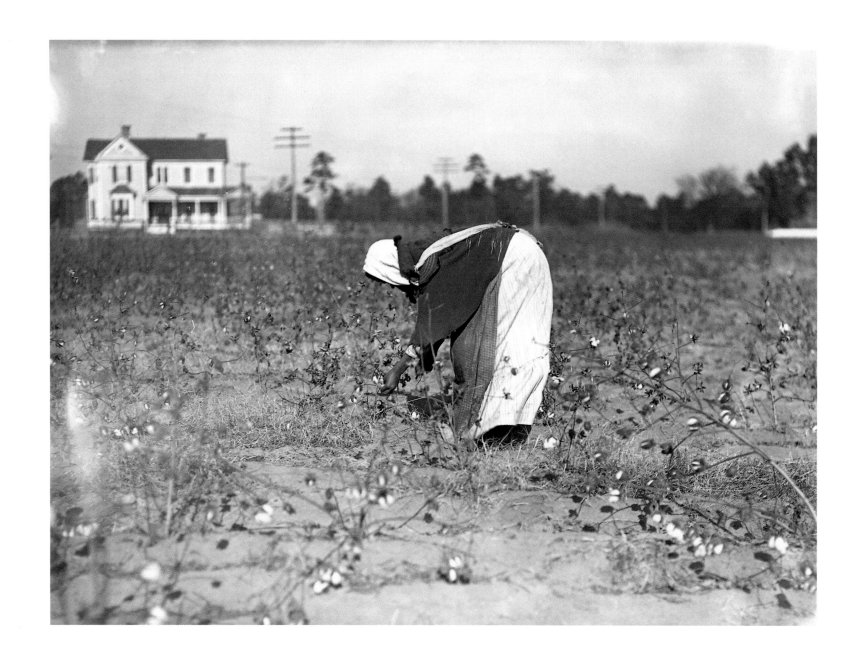

[Woman] picking cotton. Columbia, January 19, 1904. (AMNH 47867)

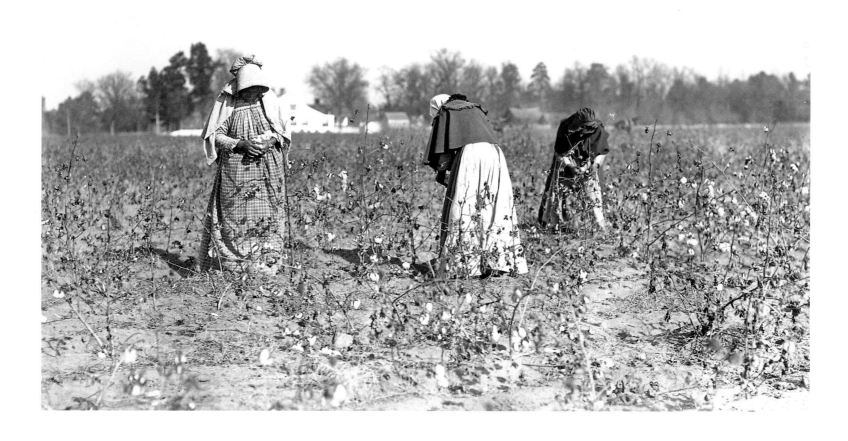

Women picking cotton. Columbia, January 19, 1904. (AMNH 47866)

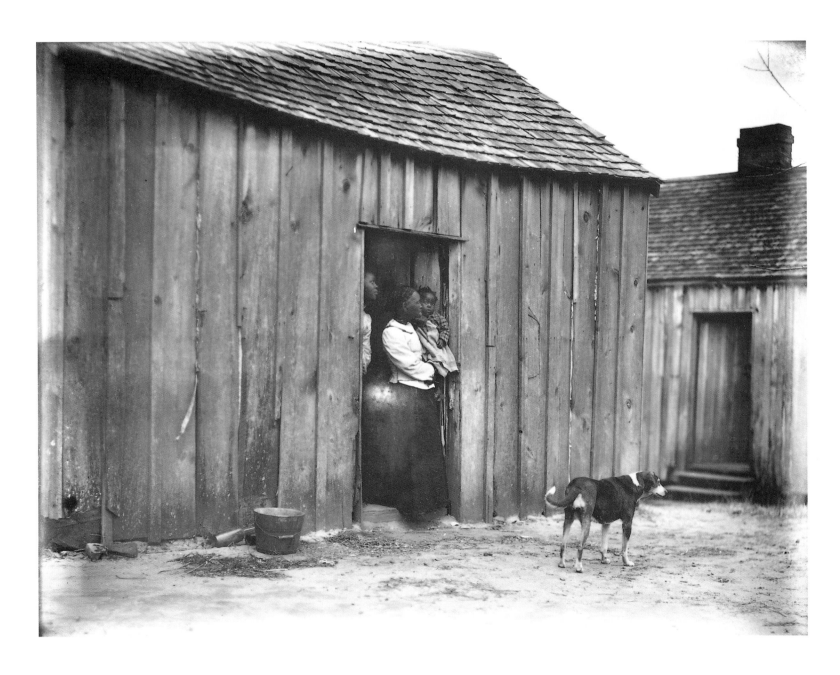

Granny and [child]. Columbia, January 22, 1904. (AMNH 48040)

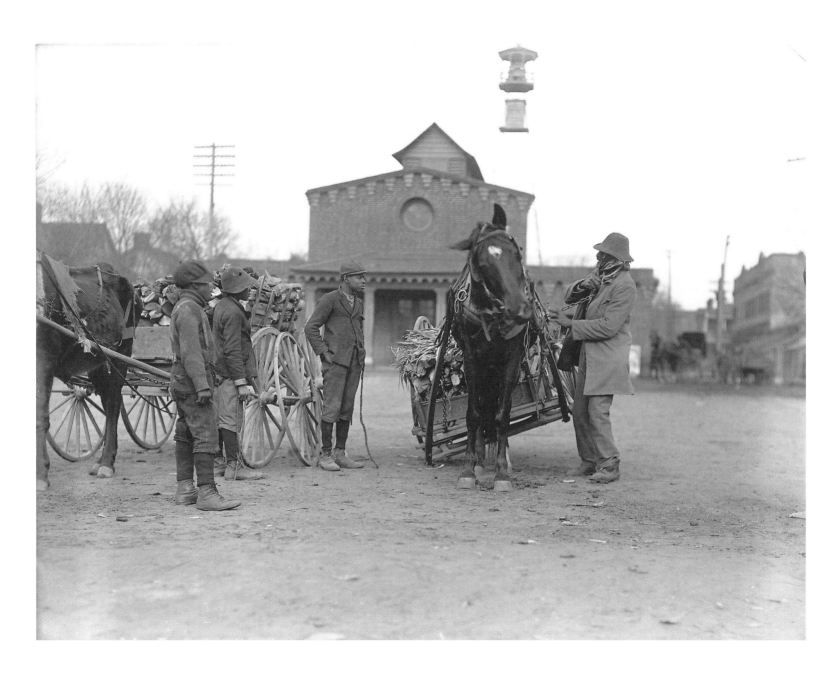

[Group] with load of wood and broken wagon. Columbia, January 21, 1904. (AMNH 47870)

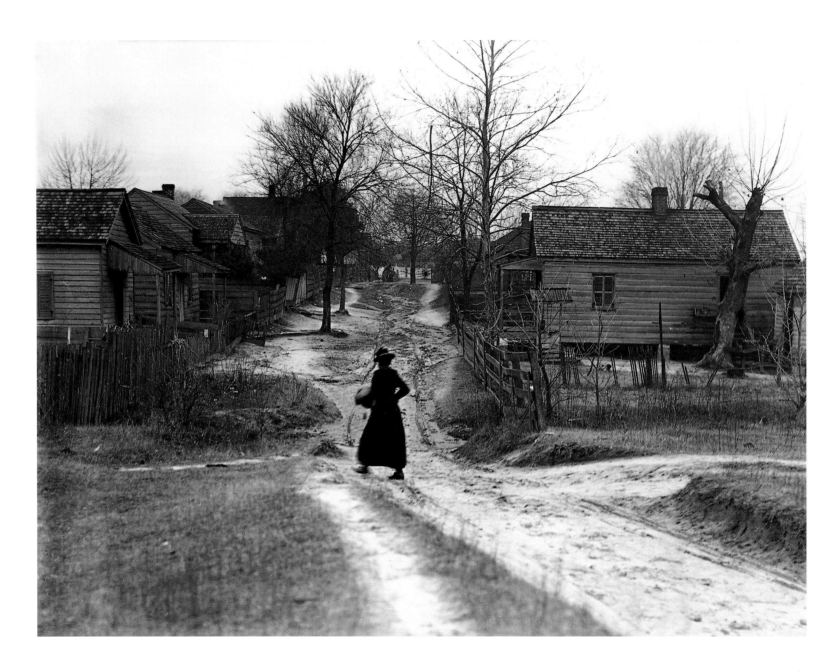

Houses, [woman] in foreground. Columbia, January 23, 1904. (AMNH 48051)

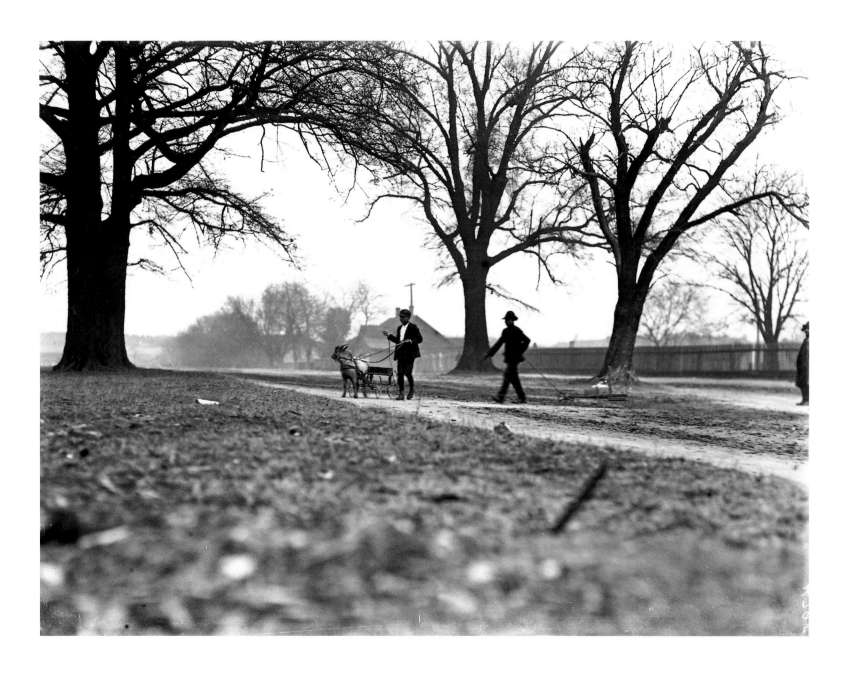

Road, trees and boys. Columbia, January 25, 1904. (AMNH 47957)

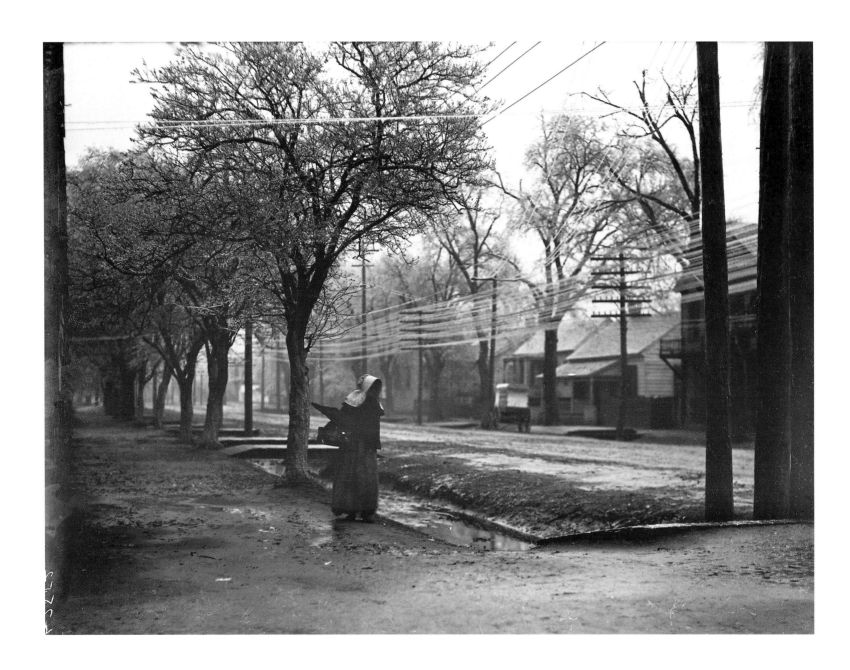

Trees, ice laden, and figure. Columbia, January 29, 1904. (AMNH 47852)

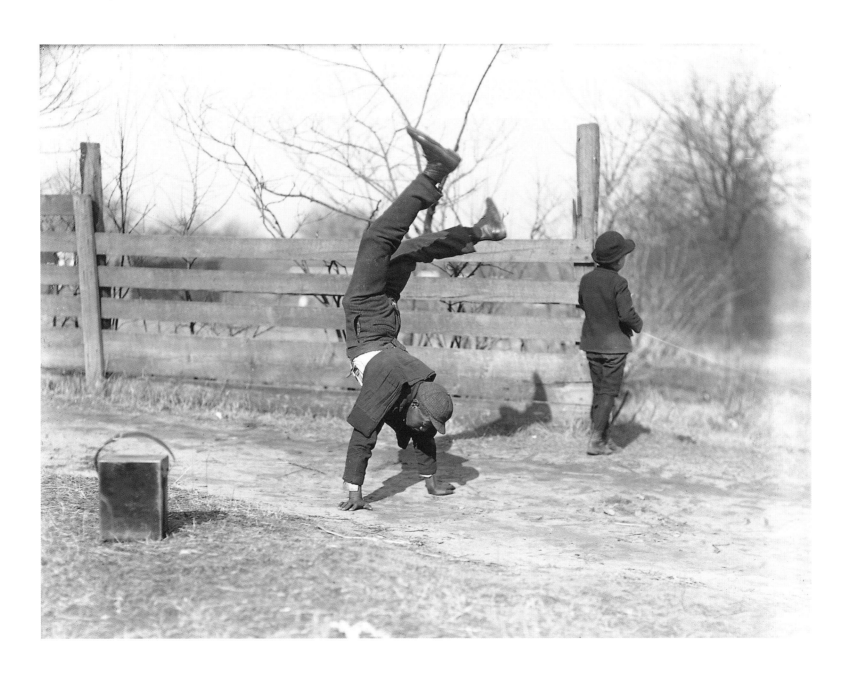

Boy standing on his [hands]. [Columbia], February 2, 1904. (AMNH 47958)

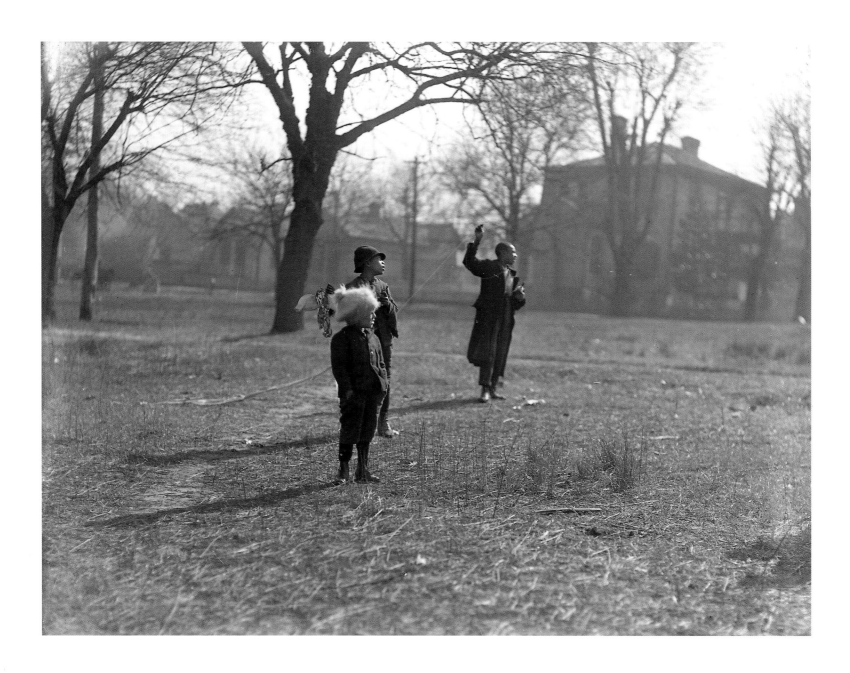

Boys kite flying. Columbia, February 2, 1904. (AMNH 47963)

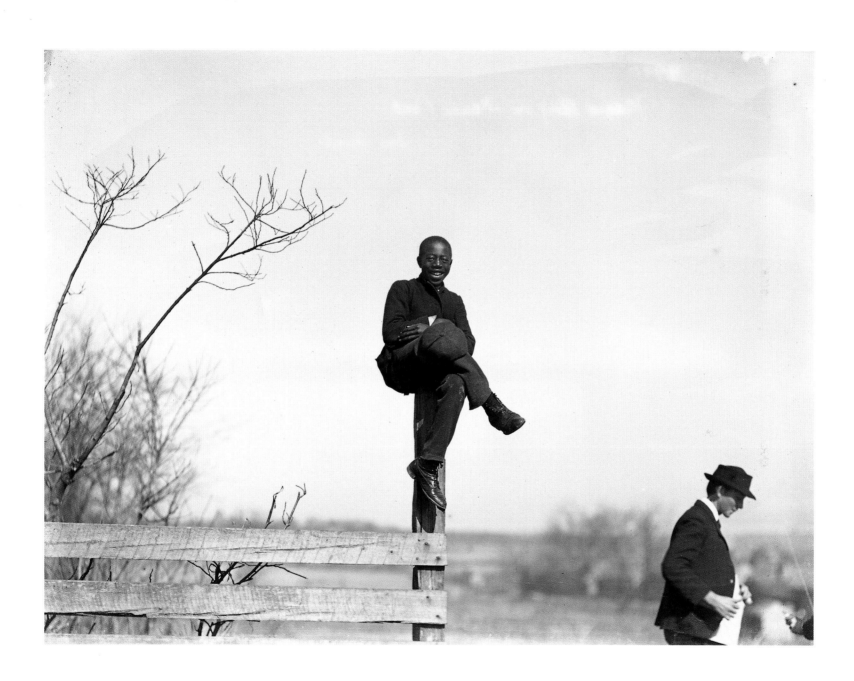

Boy on fence post. Columbia, February 2, 1904. (AMNH 47961)

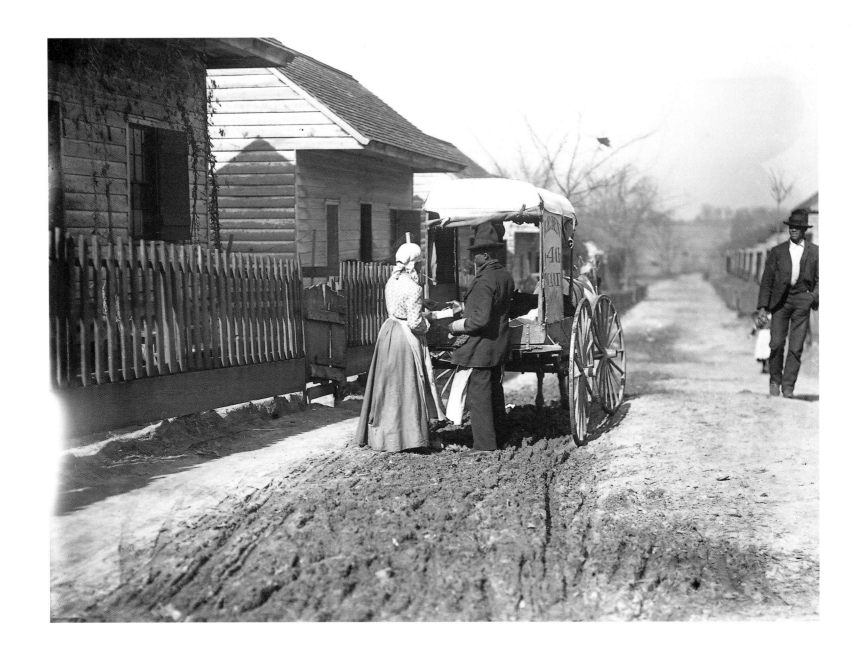

[Woman] buying meat. Columbia, February 2, 1904. (AMNH 47853)

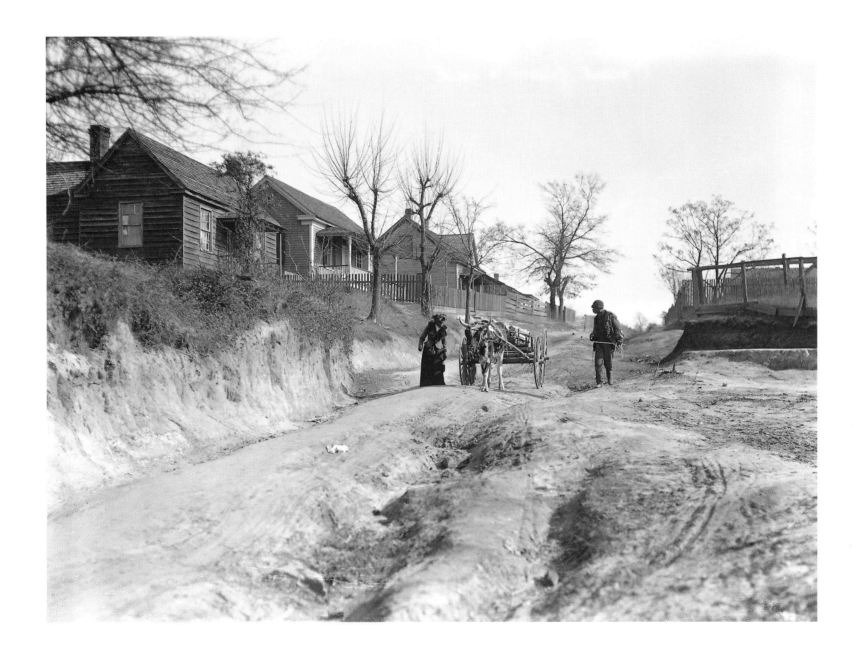

Ox cart, figures and road. Columbia, February 3, 1904. (AMNH 47856)

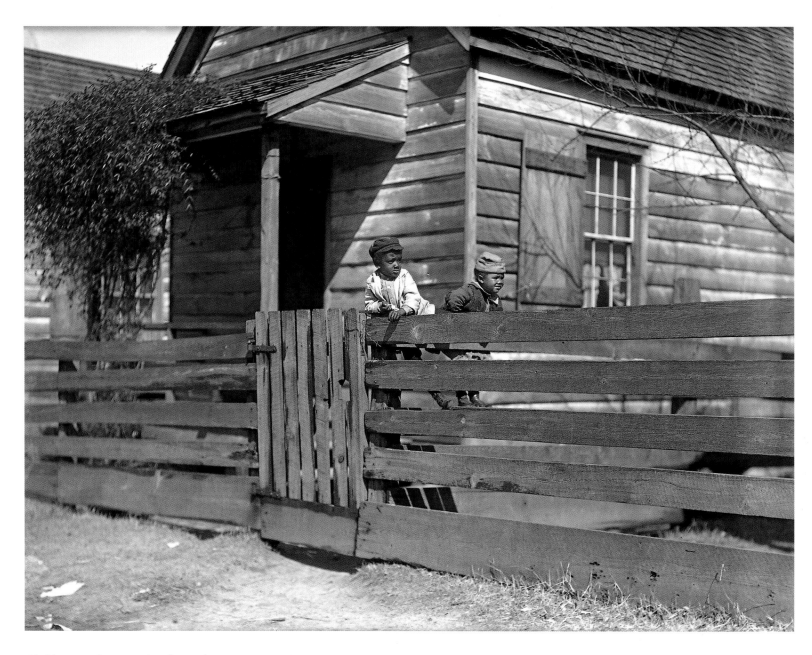

Children on fence. Columbia, February 2, 1904. (AMNH 48065)

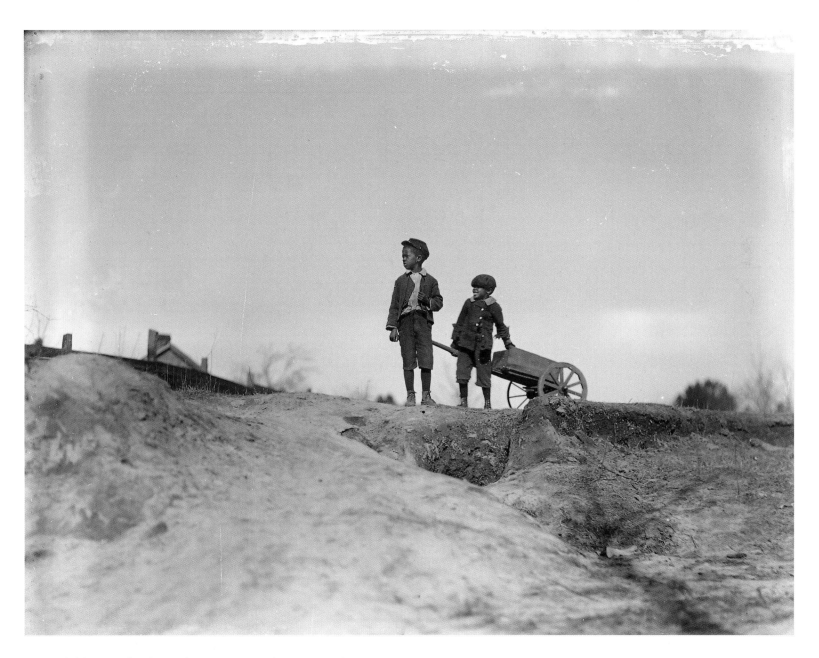

[Two] children. Columbia, February 3, 1904. (AMNH 48055)

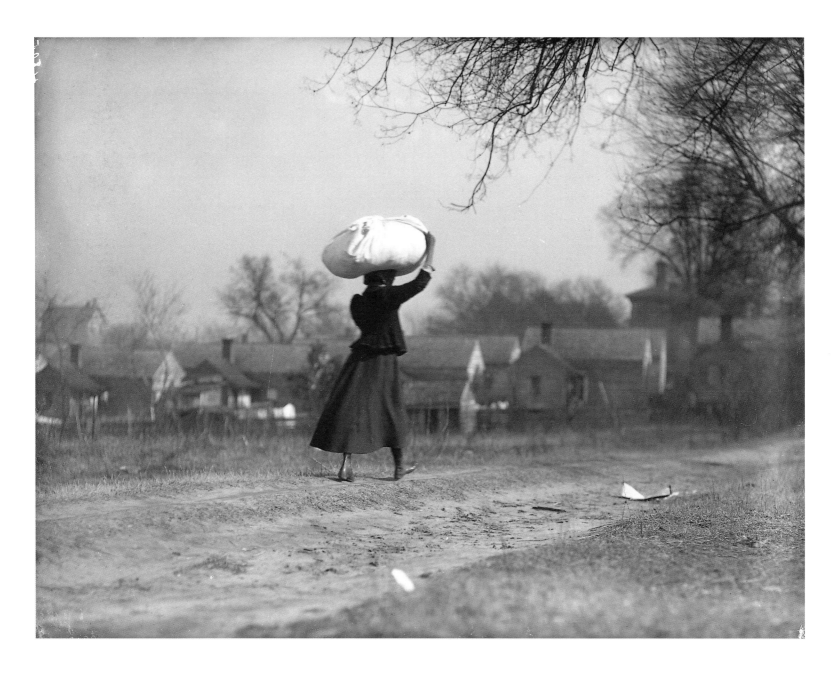

Girl with bundle on head. Columbia, February 2, 1904. (AMNH 48052)

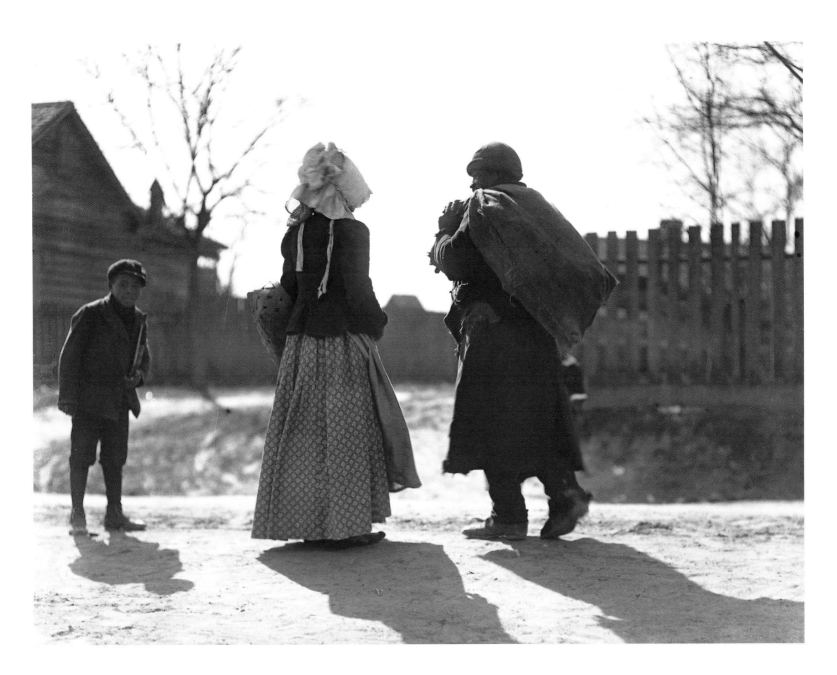

Silhouette [of a] man and woman. Columbia, February 3, 1904. (AMNH 47902)

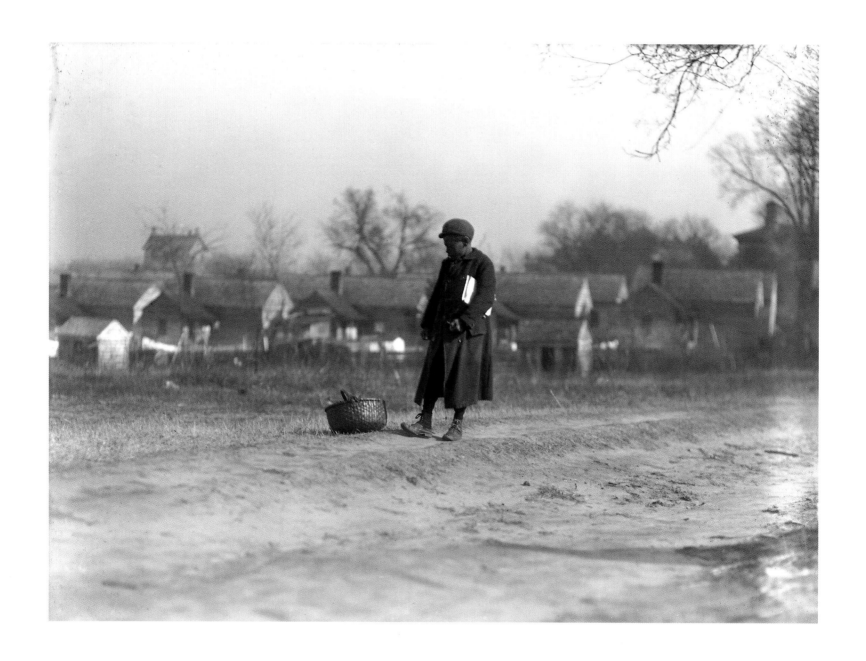

Boy, basket on ground. [Columbia], February 2, 1904. (AMNH 47960)

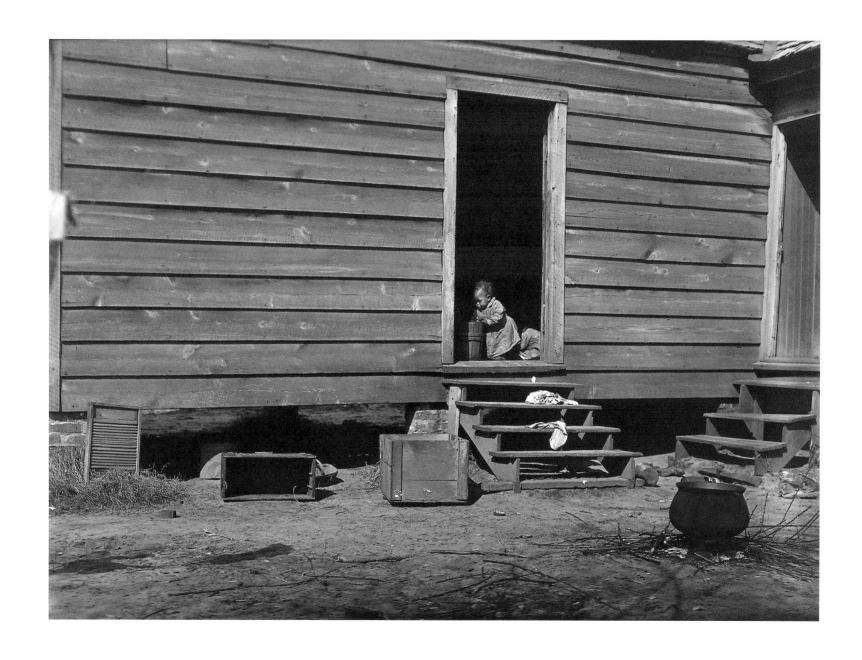

[Child] in doorway. Columbia, February 3, 1904. (AMNH 48060)

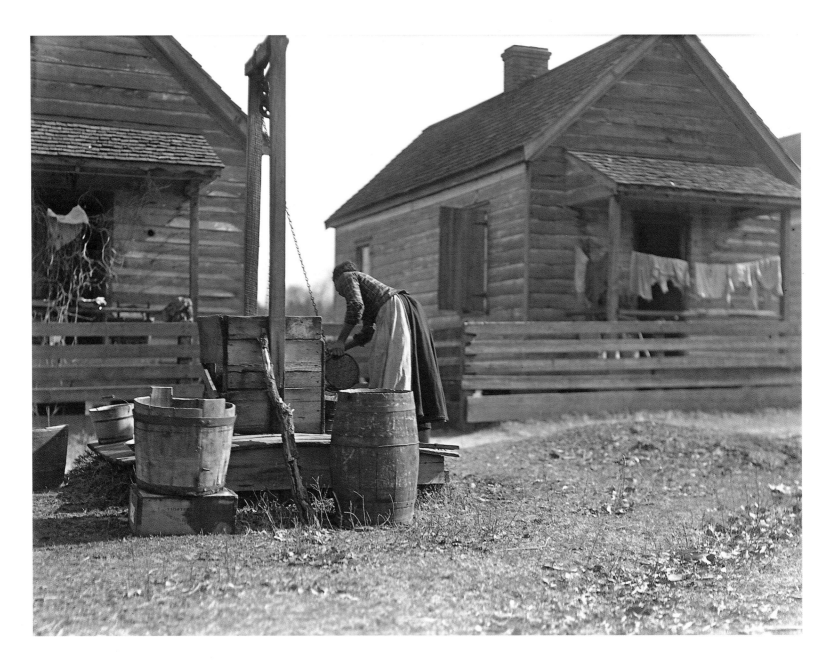

Woman drawing water from well. Columbia, February 4, 1904. (AMNH 47979)

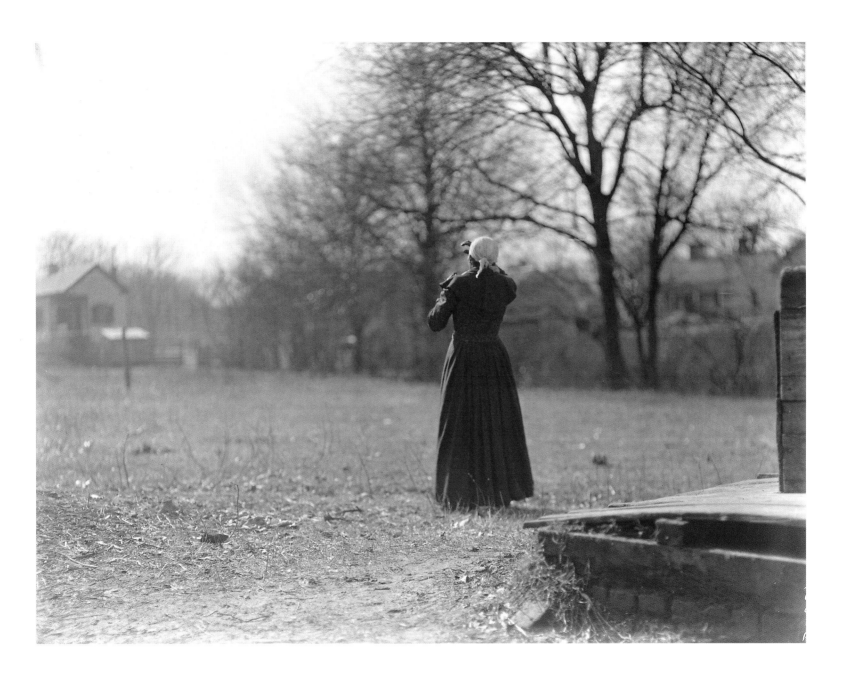

Old [woman]. Columbia, February 4, 1904. (AMNH 47978)

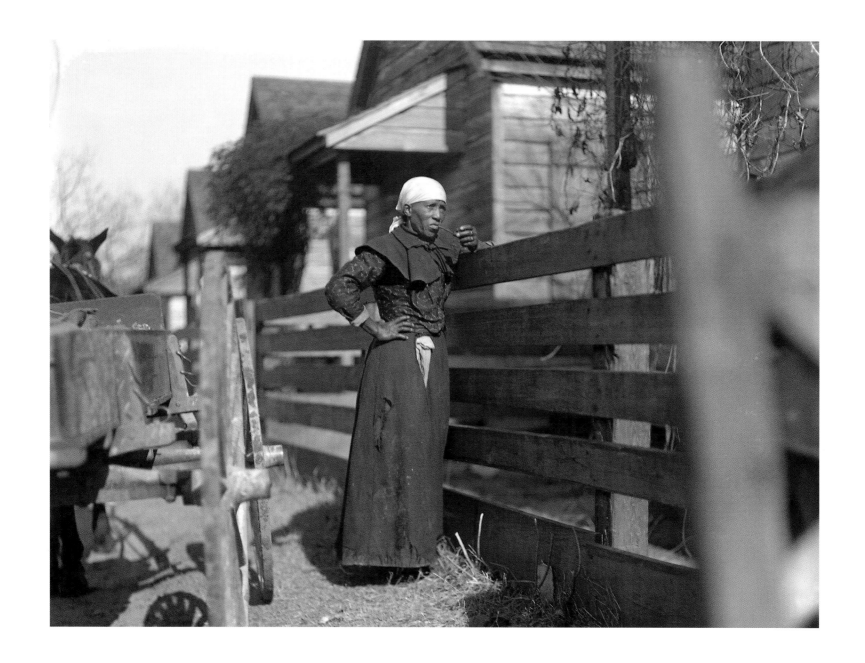

[Woman] leaning against fence. Columbia, February 4, 1904. (AMNH 47977)

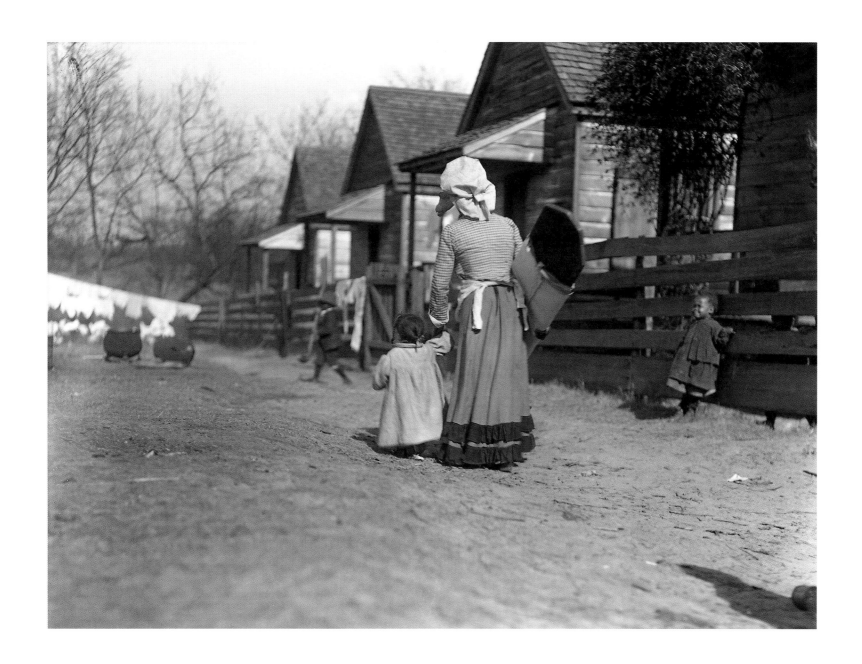

Woman and child in foreground, houses in background. Columbia, February 4, 1904. (AMNH 48042)

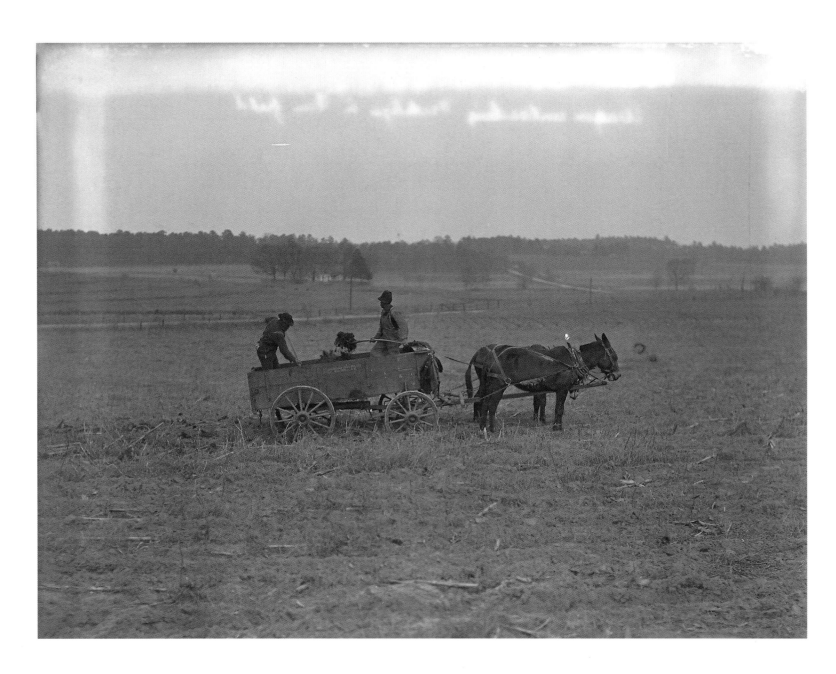

Wagon unloading fertilizer in field. Columbia, February 5, 1904. (AMNH 47873)

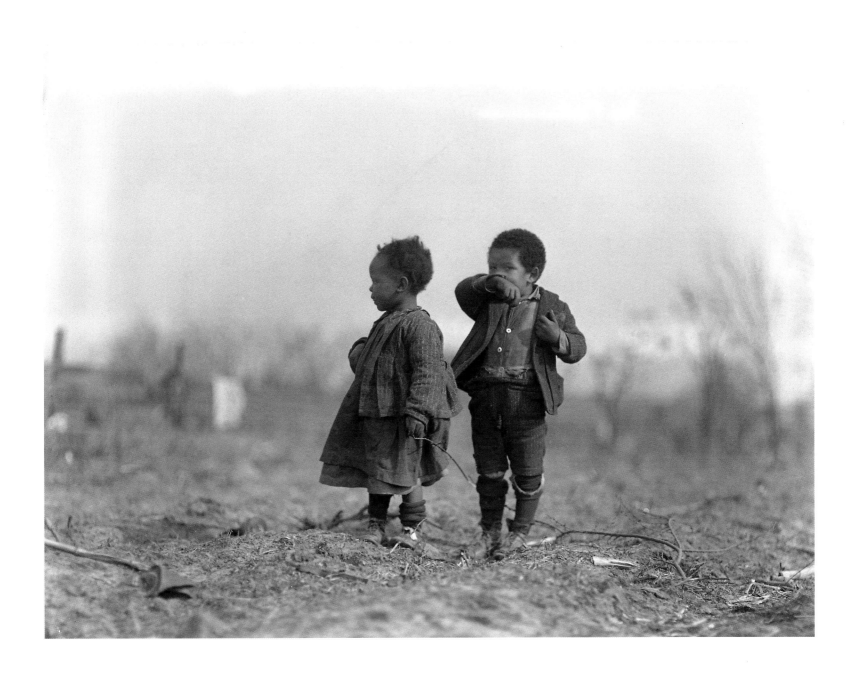

Two [children]. Columbia, February 5, 1904. (AMNH 48061)

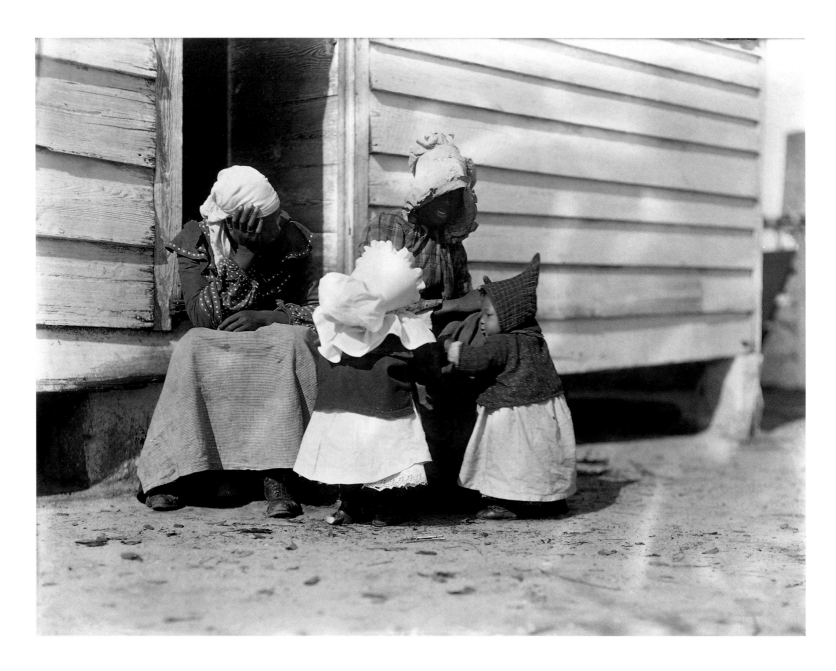

Women and children. Columbia, February 8, 1904. (AMNH 48043)

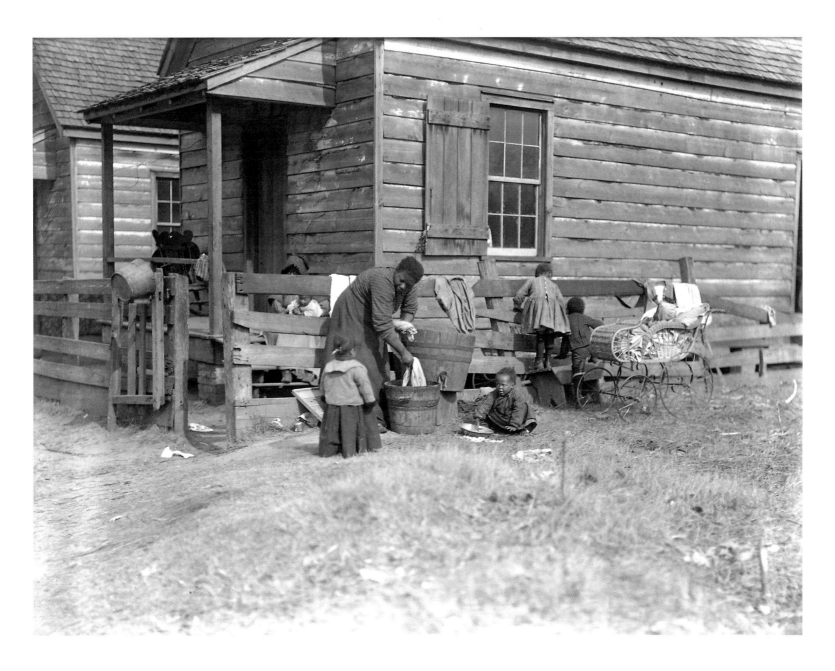

[Children] and washing. Columbia, February 5, 1904. (AMNH 48062)

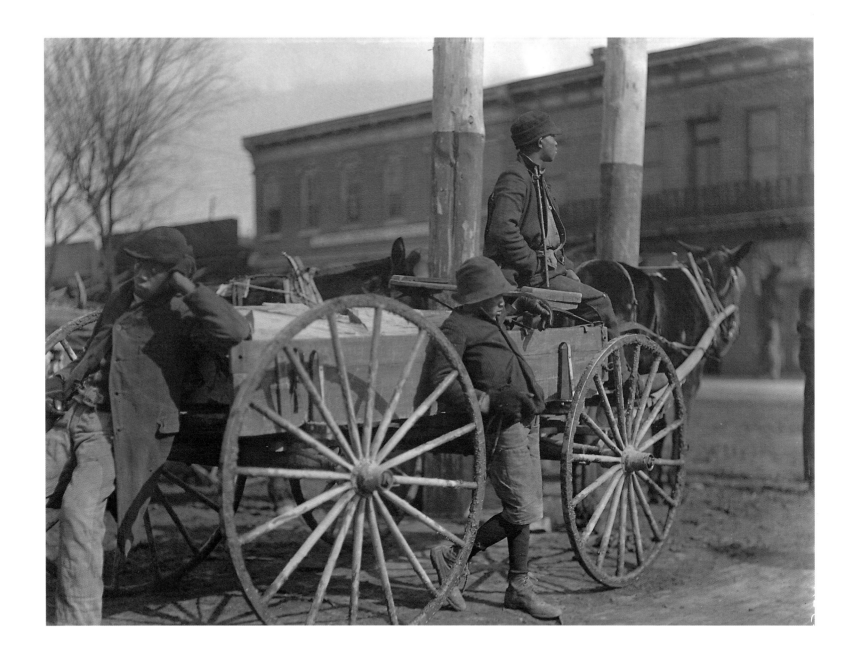

Two boys and wagon load of wood. Columbia, February 12, 1904. (AMNH 47871)

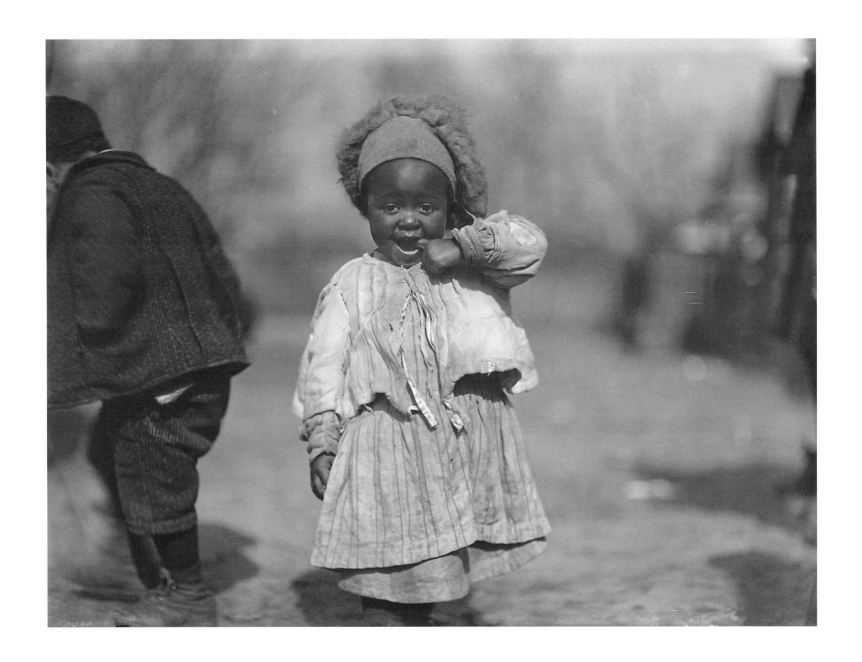

[Child]. Columbia, February 20, 1904. (AMNH 48064)

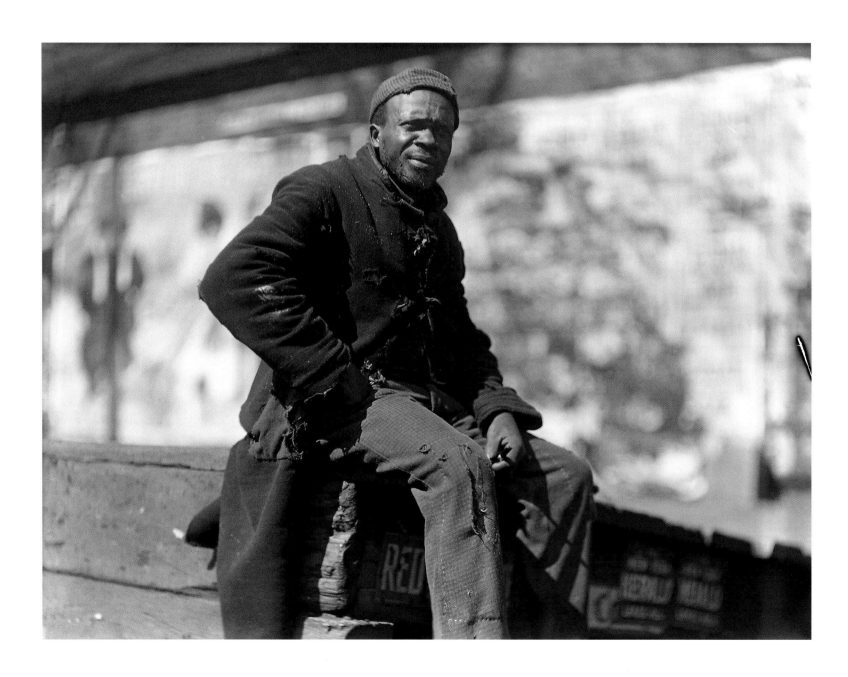

[Unidentified man]. Columbia, February 22, 1904. (AMNH 47903)

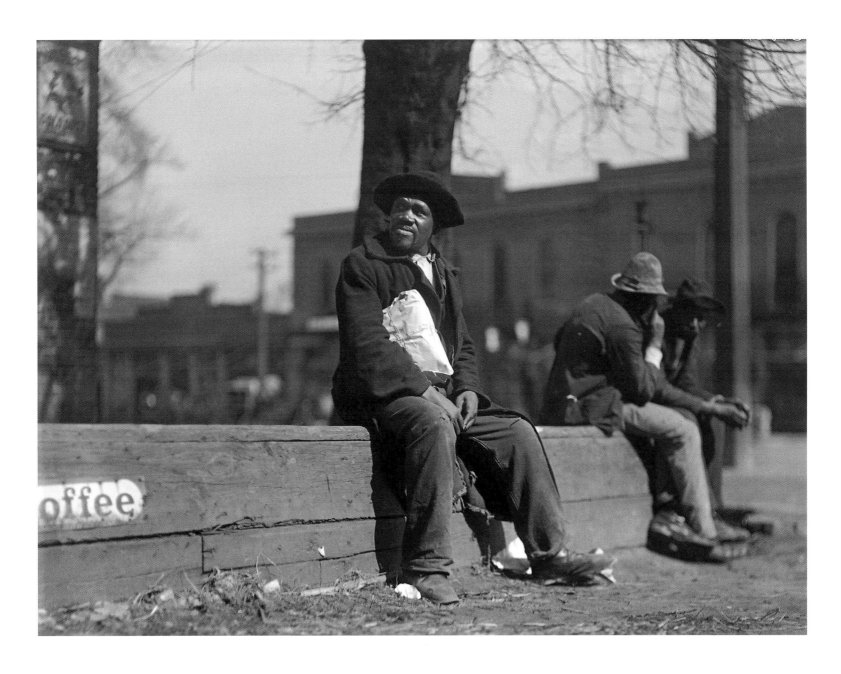

[Three men on a corner]. Columbia, February 23, 1904. (AMNH 47907)

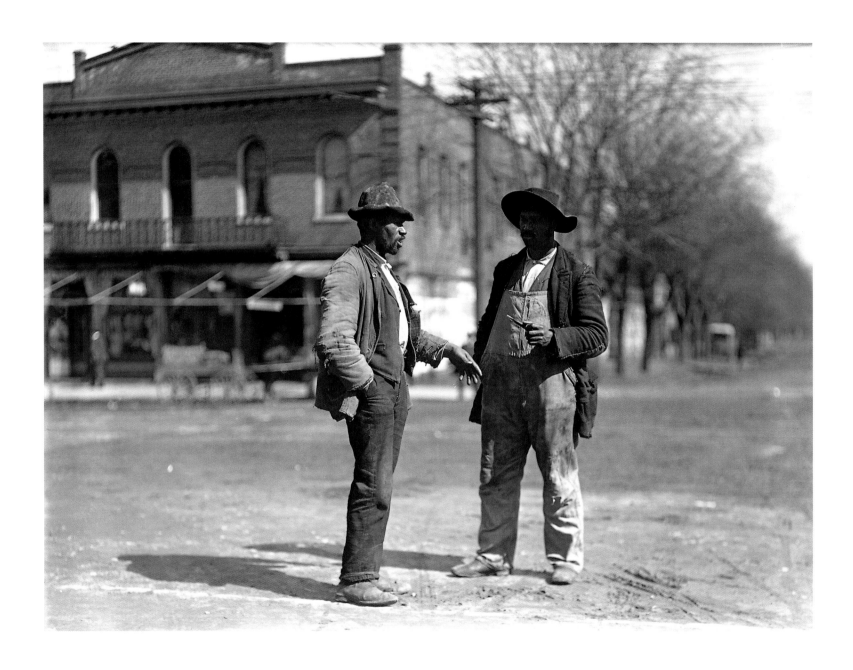

Two [men]. [Columbia], February 22, 1904. (AMNH 47906)

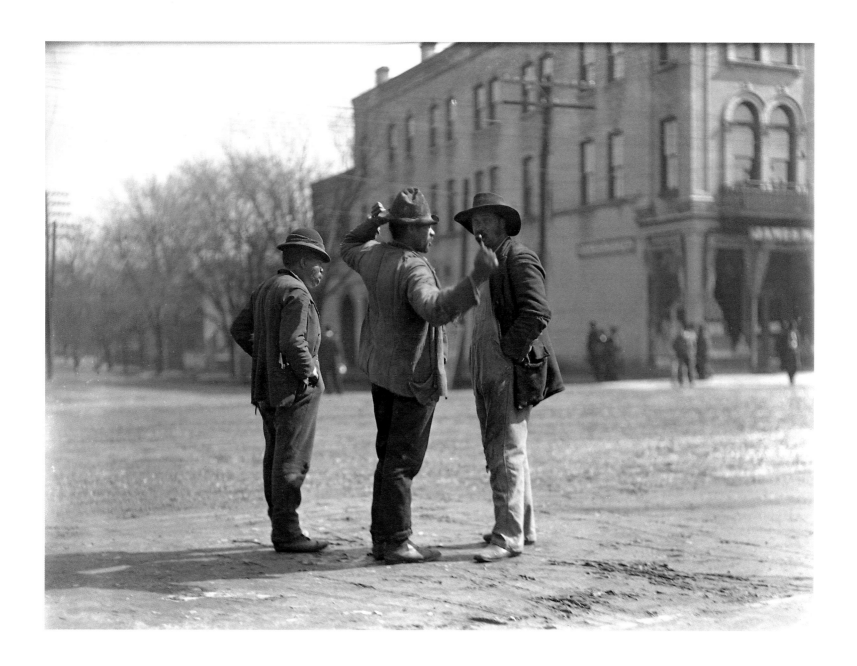

Three [men] talking. Columbia, February 22, 1904. (AMNH 47904)

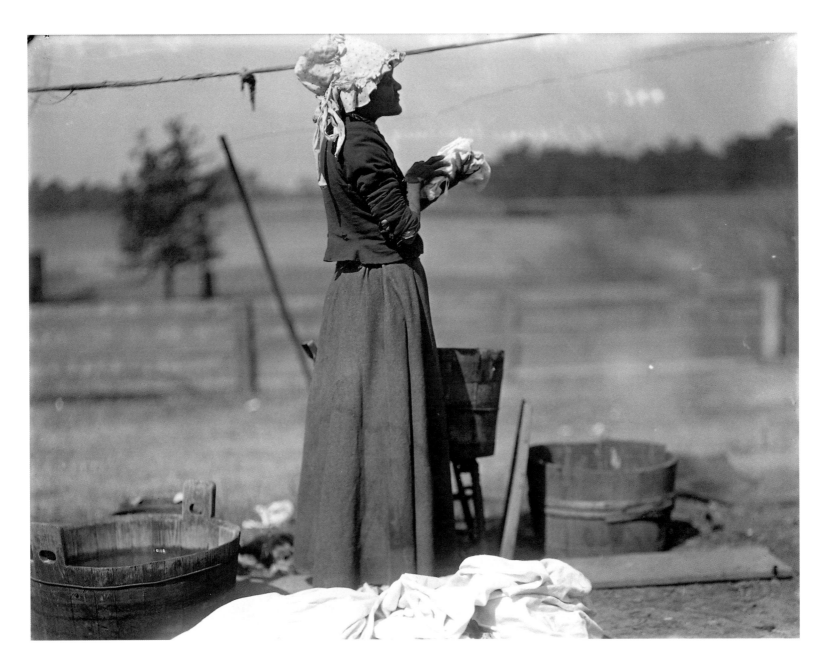

[Woman] washing. Columbia, February 23, 1904. (AMNH 47981)

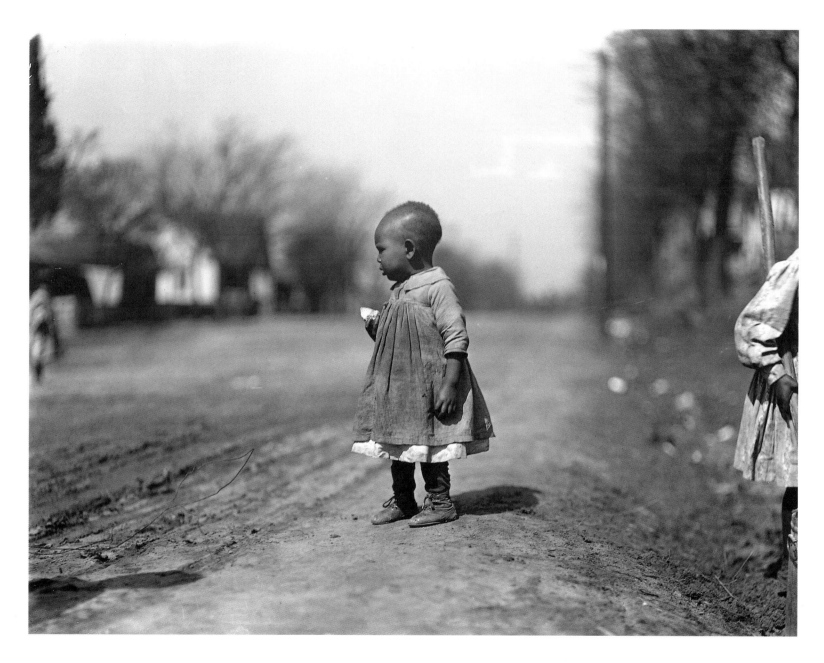

[Child]. Columbia, February 23, 1904. (AMNH 48066)

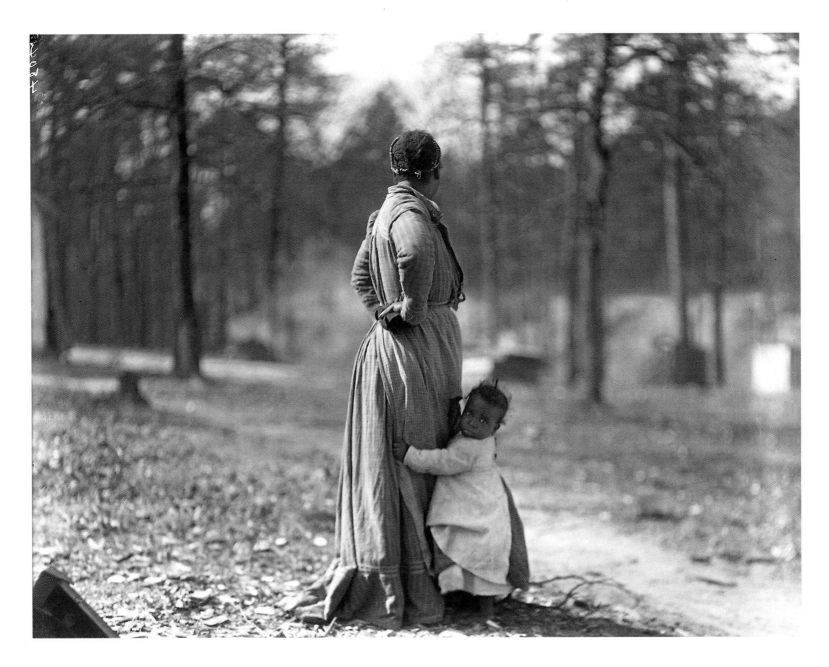

Woman and child standing. Columbia, February 24, 1904. (AMNH 48045)

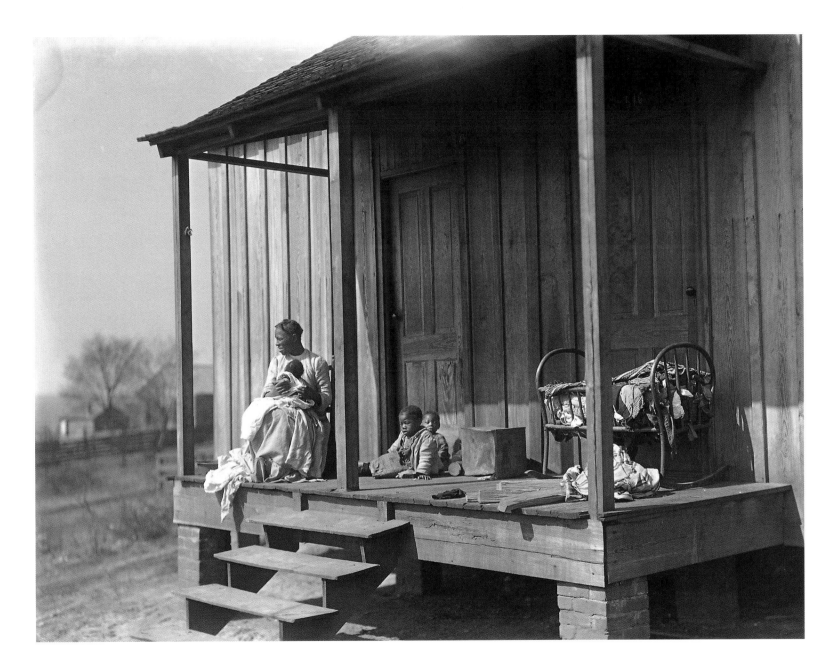

Mother, [baby] and two children. Columbia, February 23, 1904. (AMNH 48044)

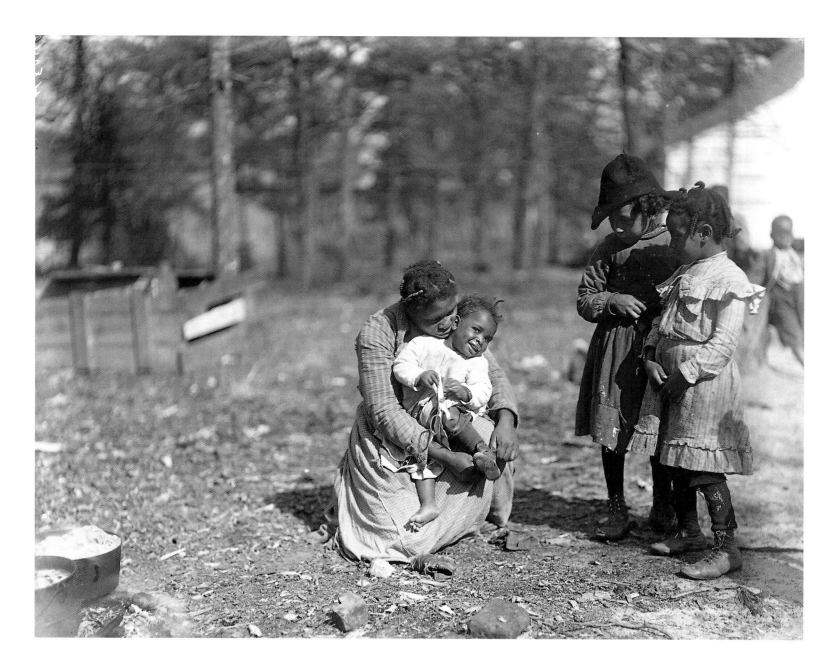

Woman putting shoes and stockings on [child]. Columbia, February 24, 1904. (AMNH 48046)

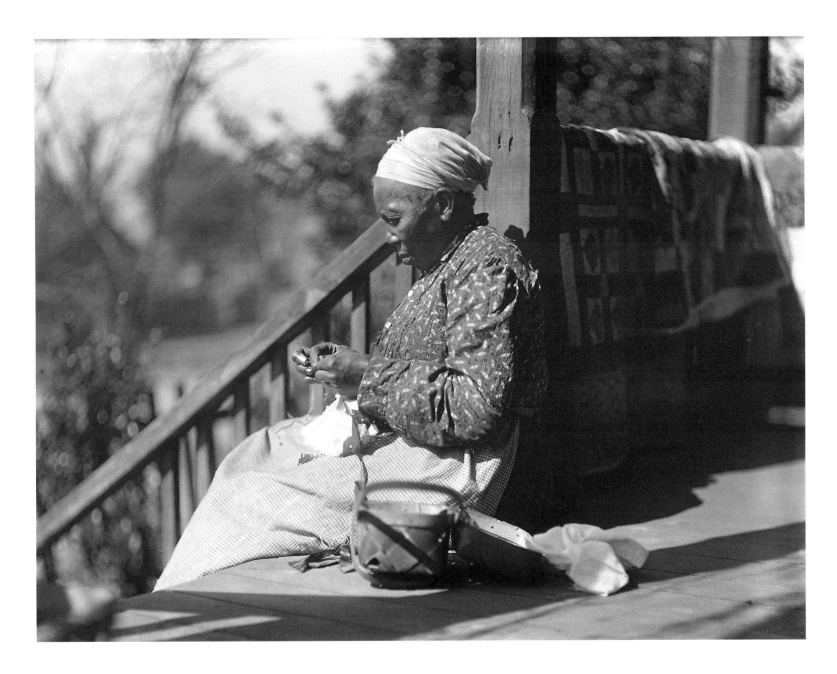

Old [woman] sewing. Columbia, February 23, 1904. (AMNH 47980)

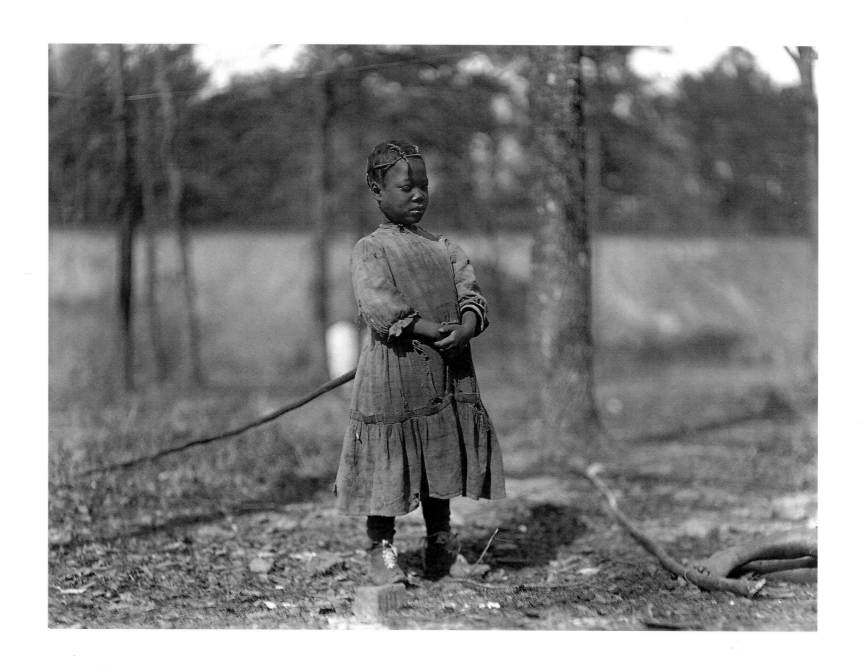

Child. Columbia, February 24, 1904. (AMNH 48069)

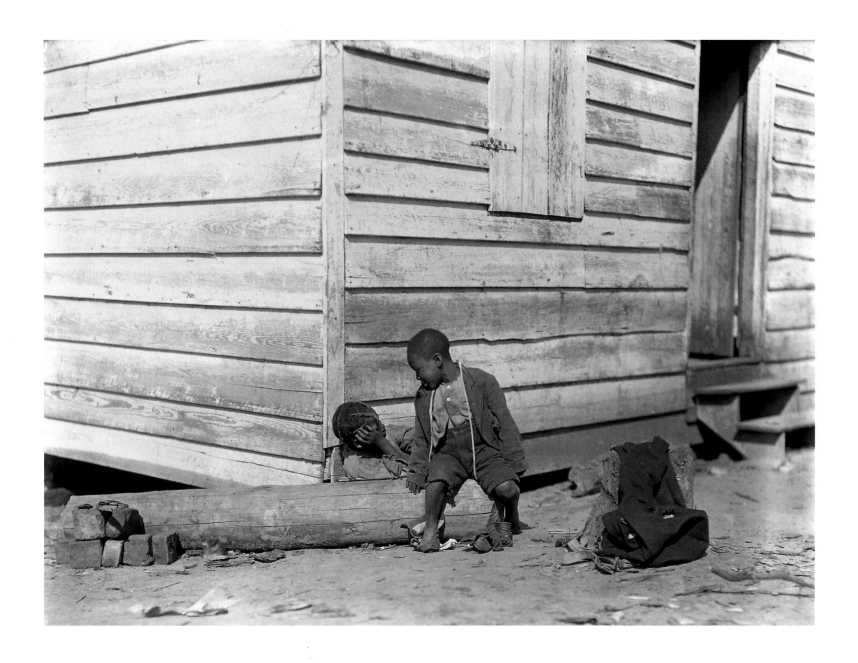

Two [children]. Columbia, February 24, 1904. (AMNH 48068)

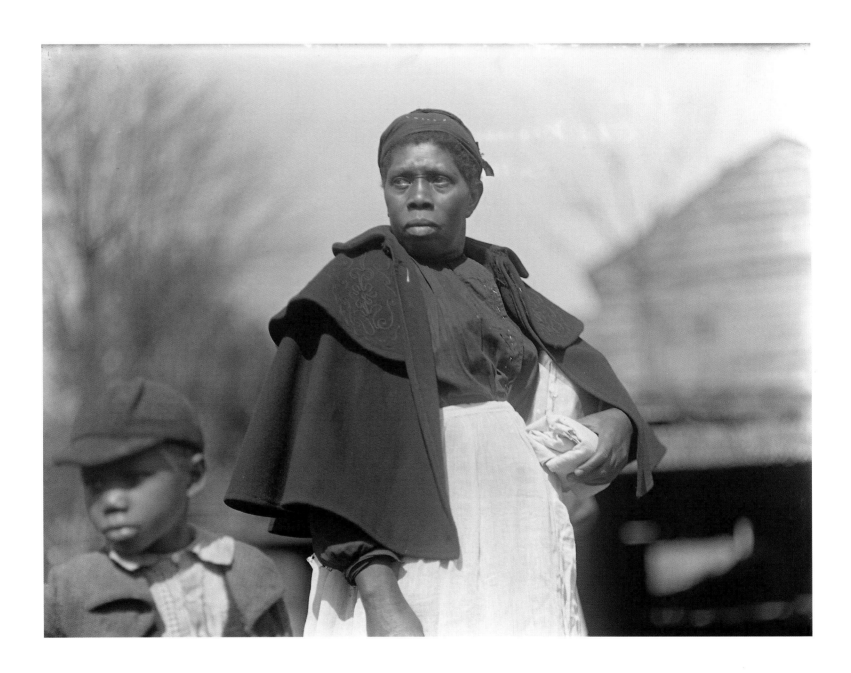

Old [woman]. Columbia, February 25, 1904. (AMNH 47982)

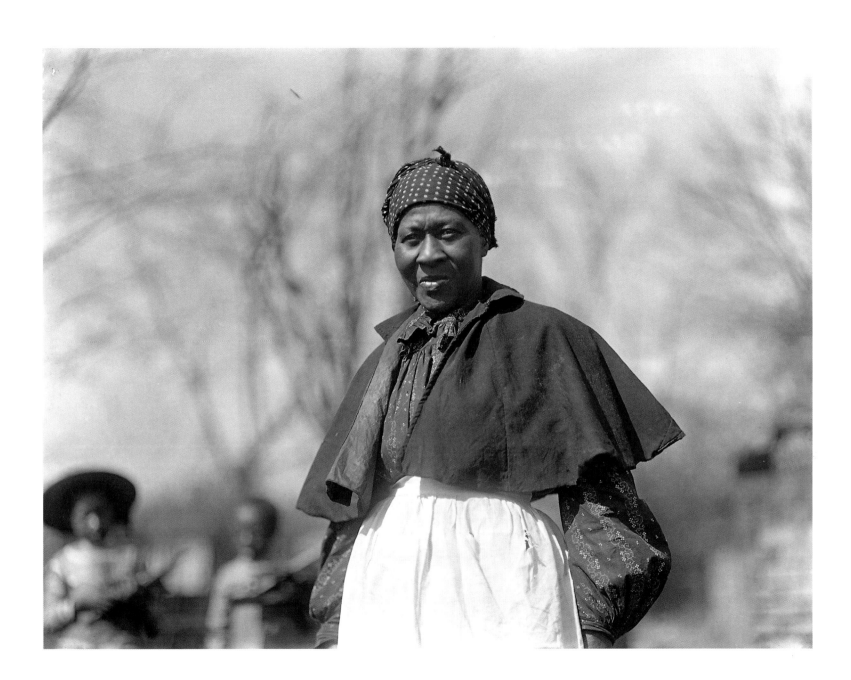

Old [woman]. Columbia, February 25, 1904. (AMNH 47983)

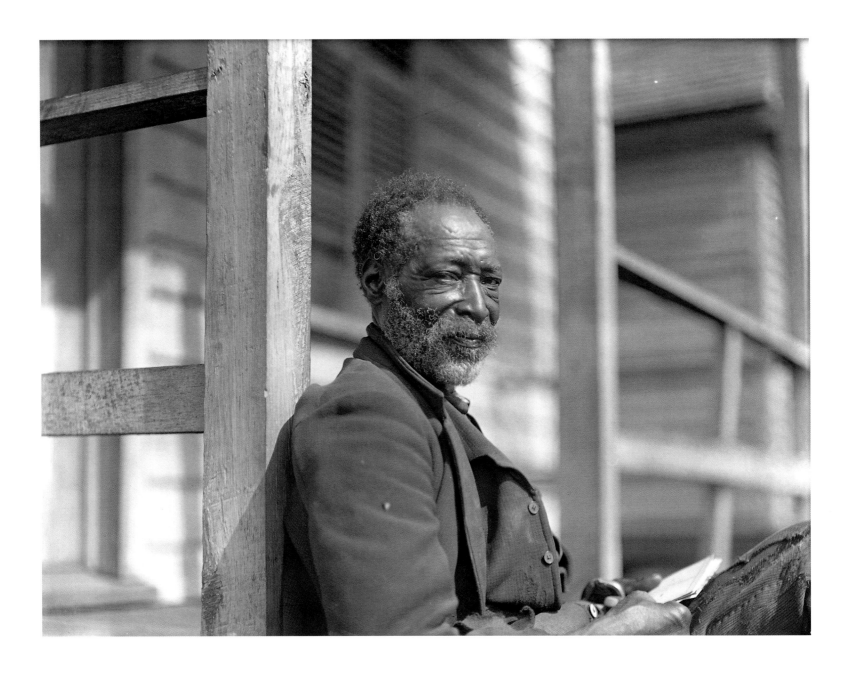

Old [man]—head and shoulders. Columbia, February 29, 1904. (AMNH 47909)

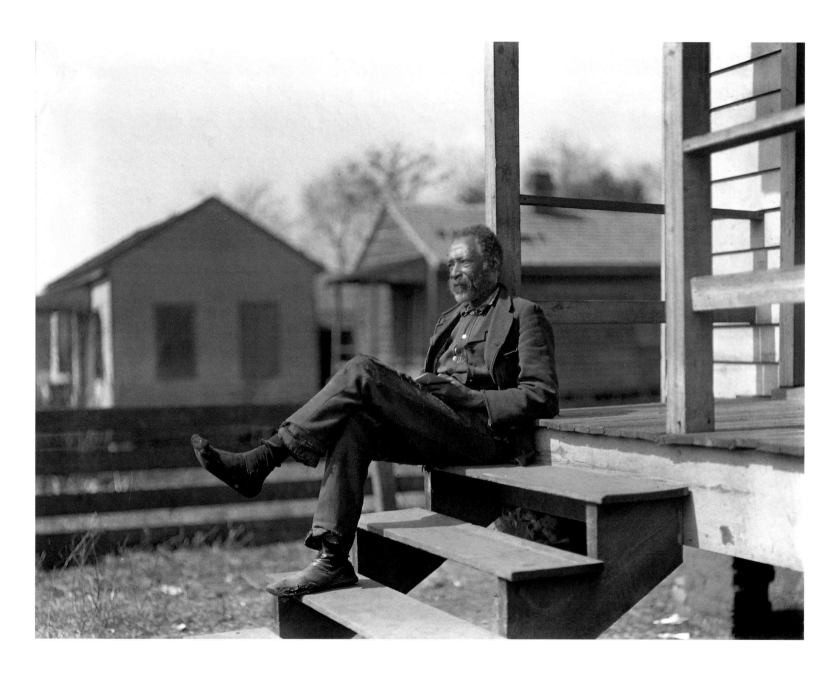

Old [man] on stoop. [Columbia], February 29, 1904. (AMNH 47908)

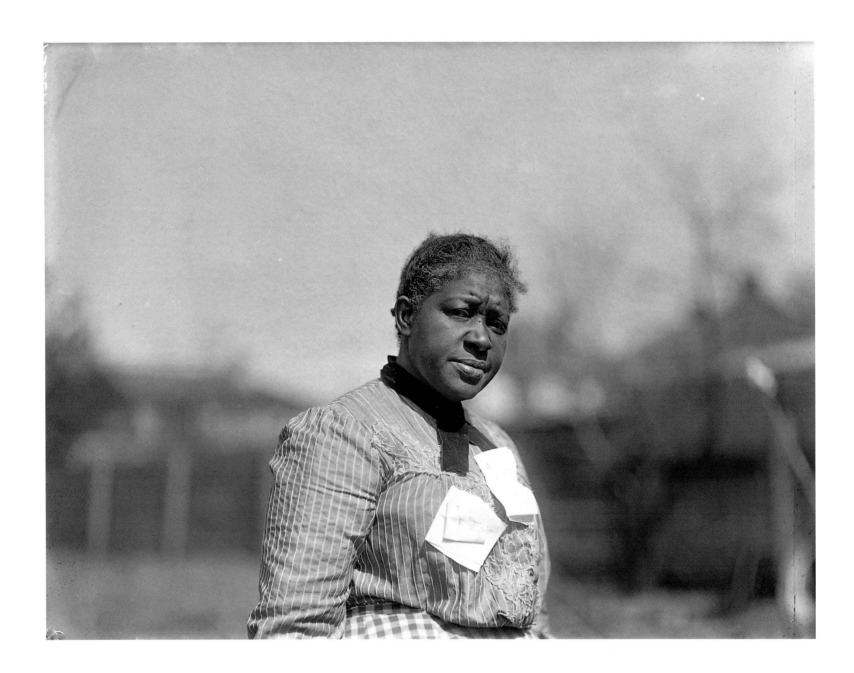

[Unidentified woman]. Columbia, February 29, 1904. (AMNH 47984)

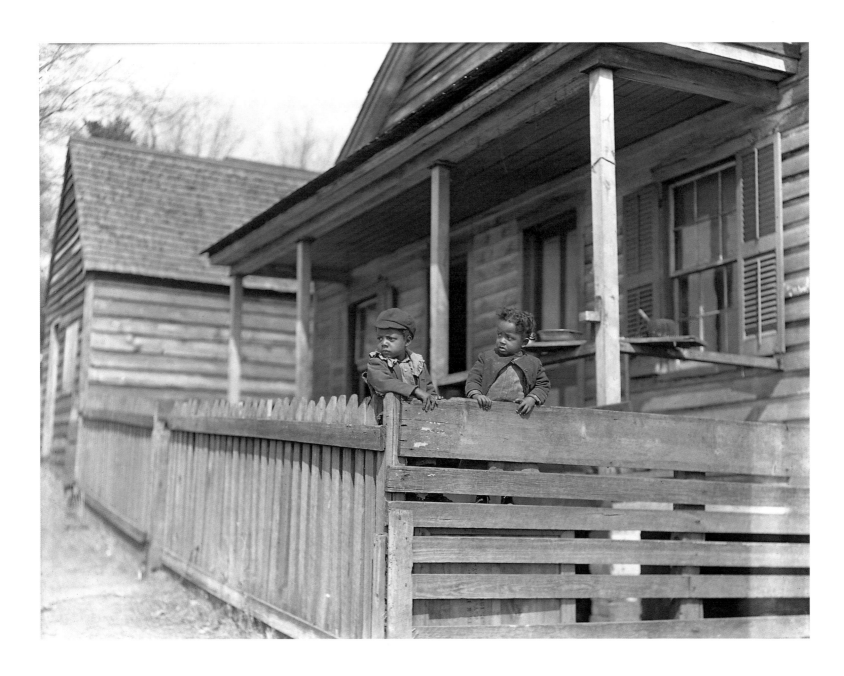

[Children on fence]. Columbia, February 29, 1904. (AMNH 48070)

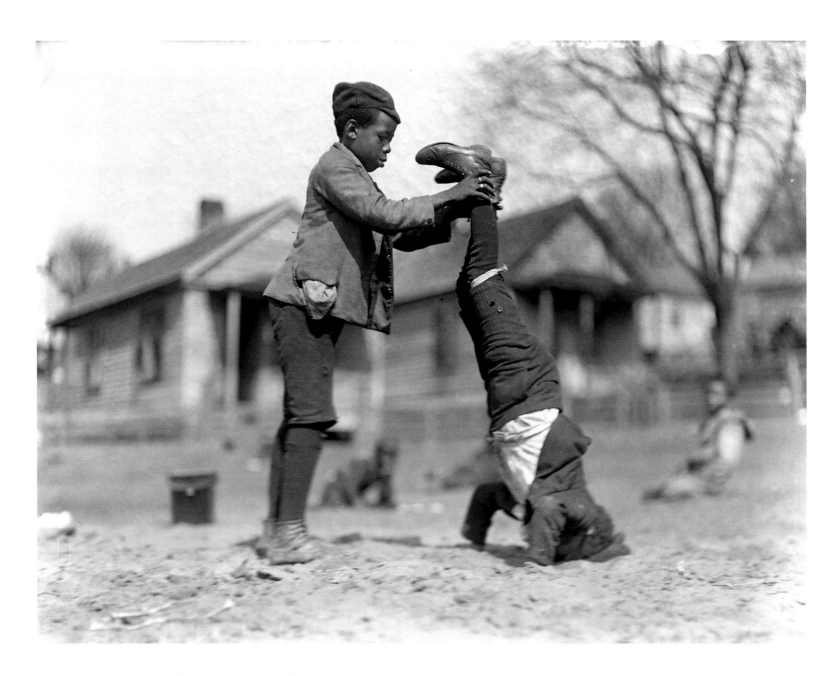

Boys, one standing on his head. [Columbia], February 29, 1904. (AMNH 47959)

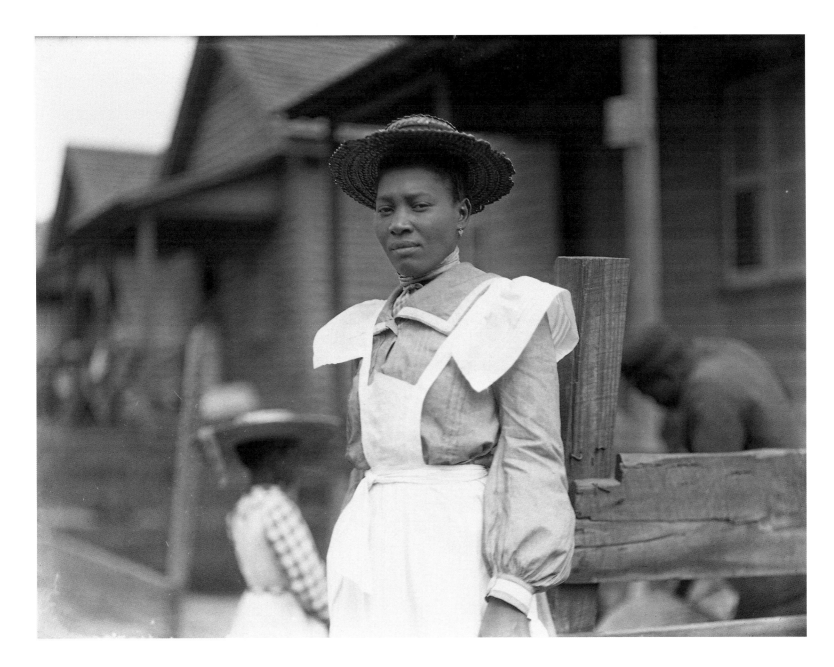

Nurse. Columbia, March 1, 1904. (AMNH 47990)

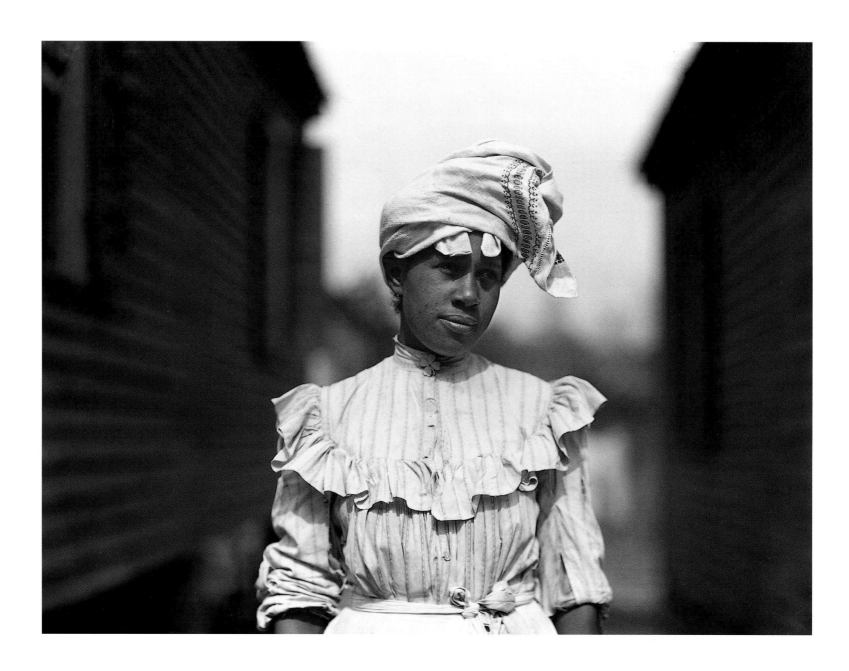

[Young woman] with towel on head. Columbia, March 1, 1904. (AMNH 47985)

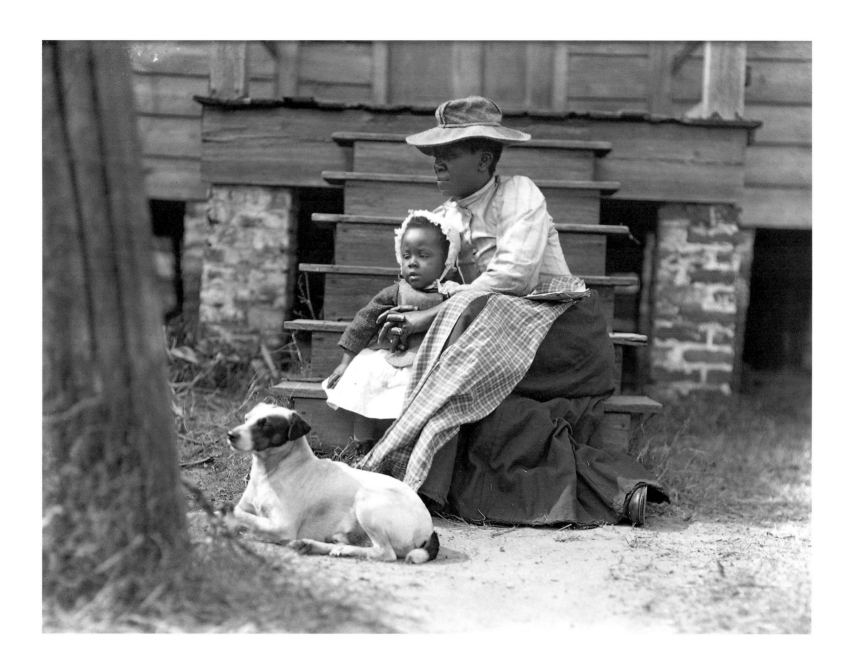

Woman, child and dog. Columbia, March 1, 1904. (AMNH 48047)

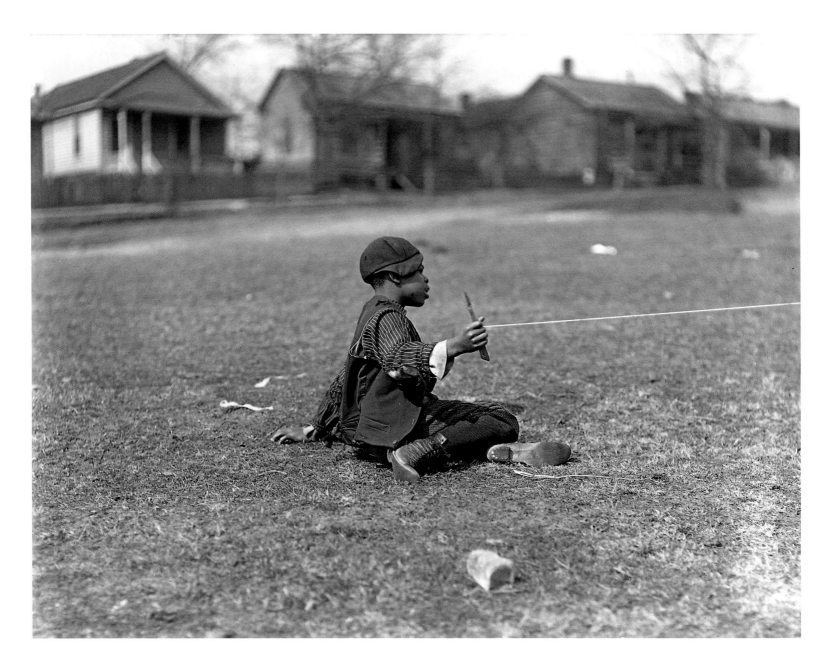

Boy flying kite. [Columbia], March 3, 1904. (AMNH 47965)

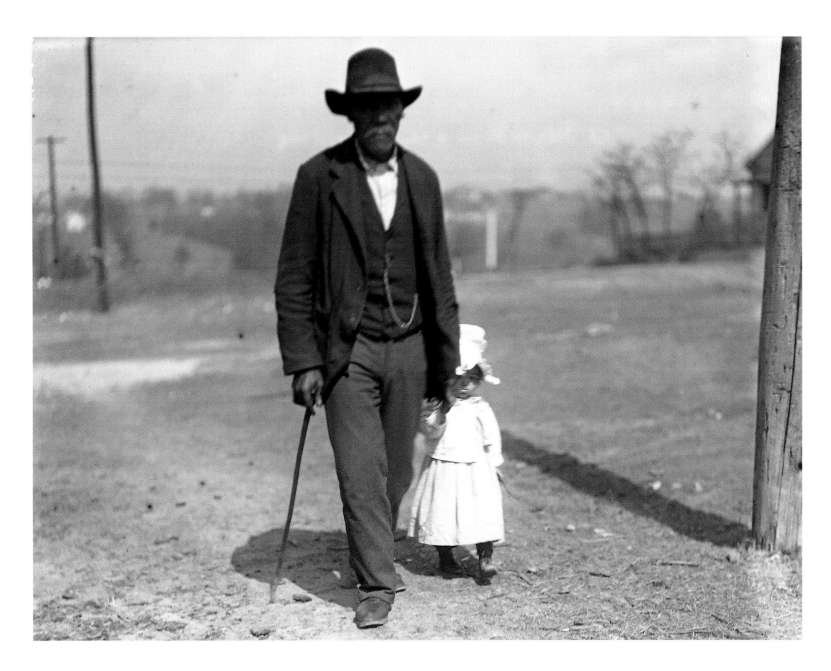

Old man and child walking. Columbia, March 3, 1904. (AMNH 47913)

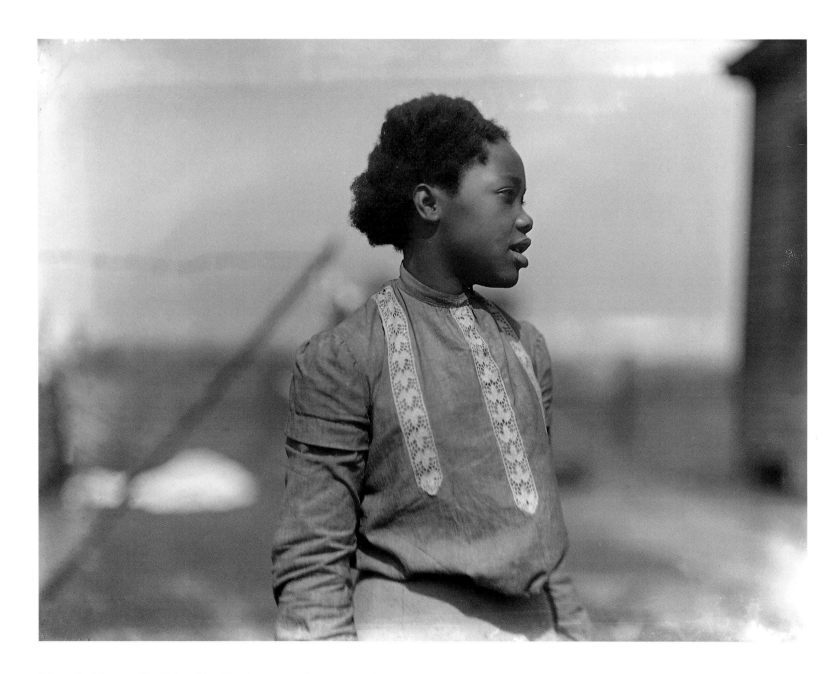

[Young] girl—profile. Columbia, March 3, 1904. (AMNH 48053)

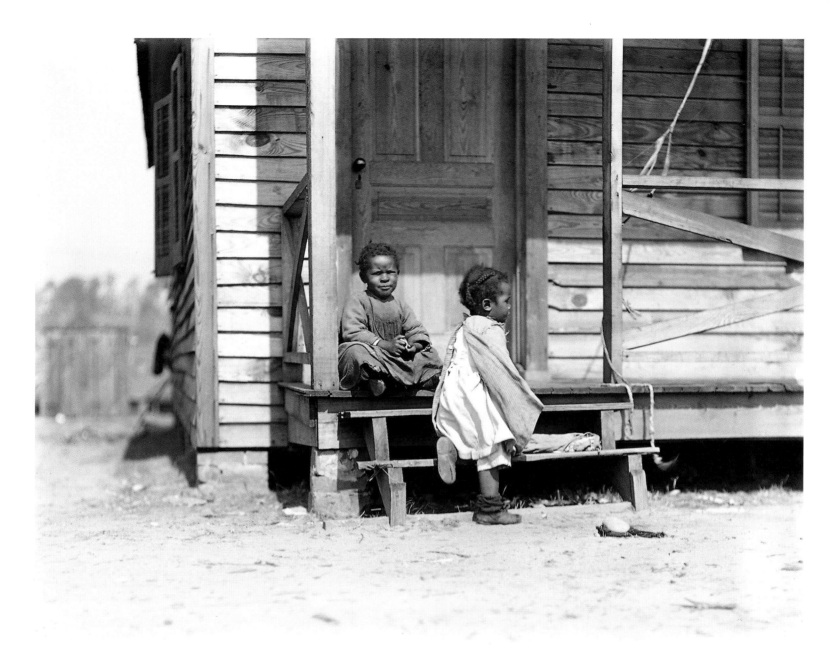

Two [children] on stoop. Columbia, March 3, 1904. (AMNH 48071)

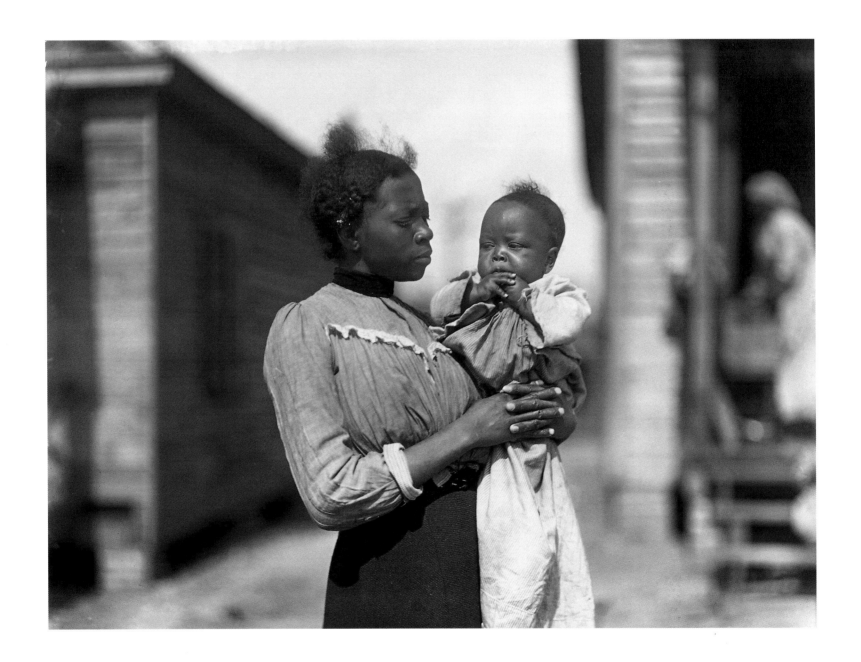

Woman holding [baby]. Columbia, March 4, 1904. (AMNH 48048)

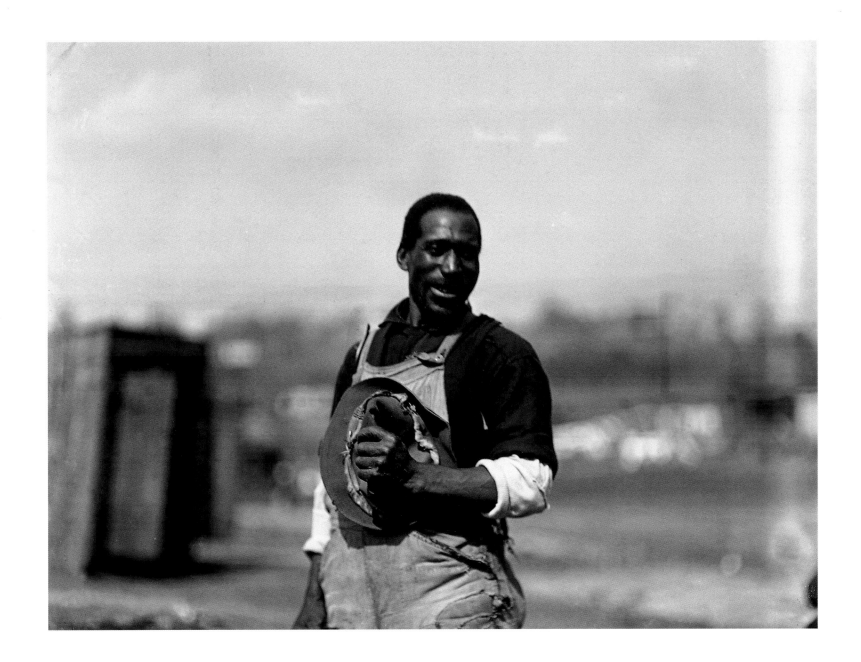

Man with hat in hand. Columbia, March 3, 1904. (AMNH 47914)

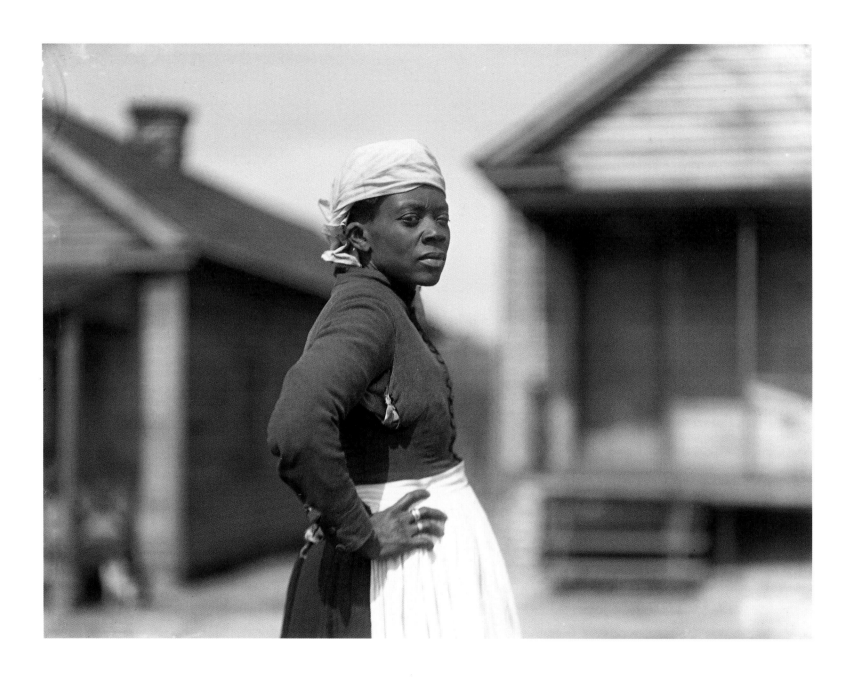

[Unidentified] woman. Columbia, March 4, 1904. (AMNH 47992)

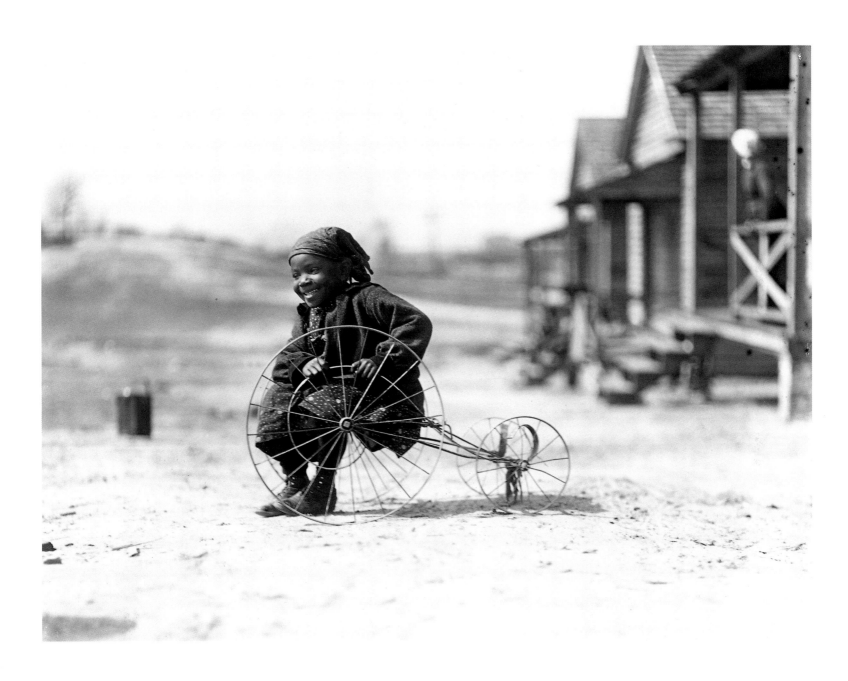

Boy on [velocipede]. [Columbia], March 4, 1904. (AMNH 47970)

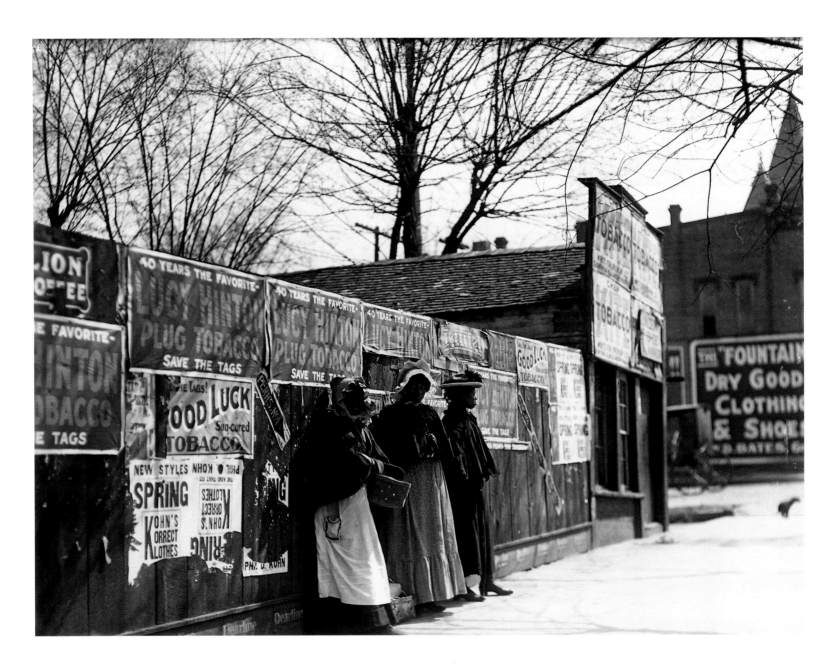

Three women in town. Columbia, March 4, 1904. (AMNH 47995)

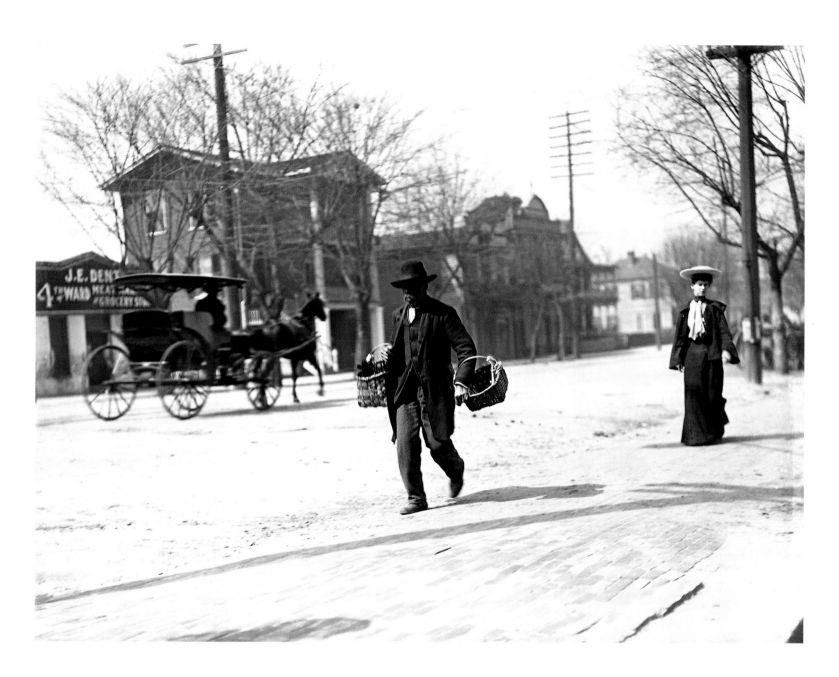

Man with basket crossing street. Columbia, March 4, 1904. (AMNH 47920)

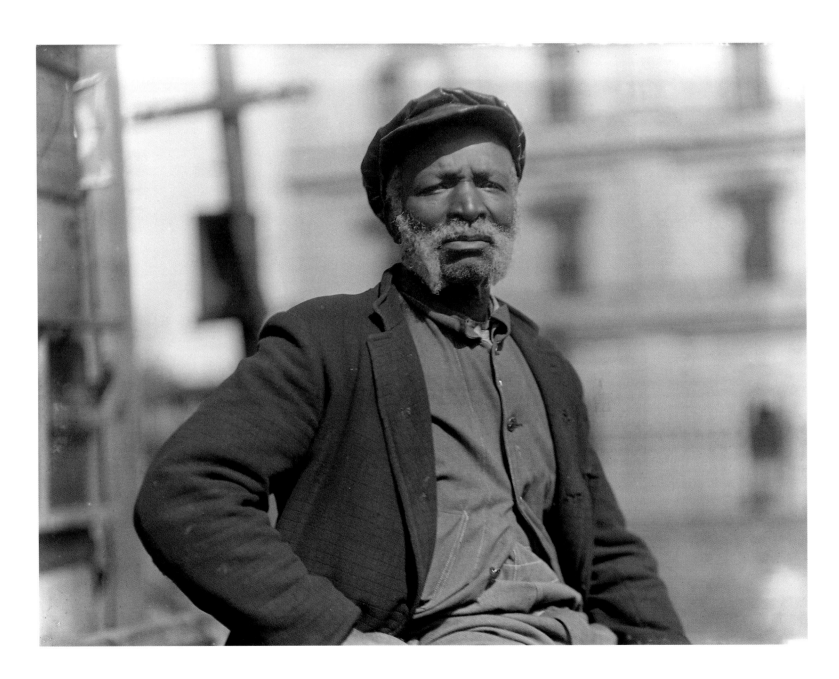

Old [man] with side whiskers. Columbia, March 4, 1904. (AMNH 47919)

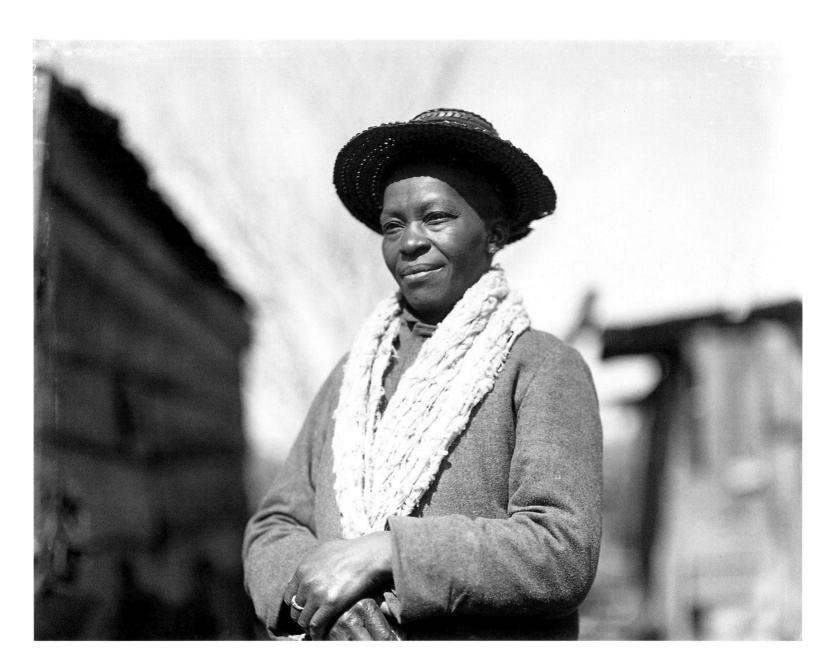

[Unidentified woman]. Columbia, March 4, 1904. (AMNH 47993)

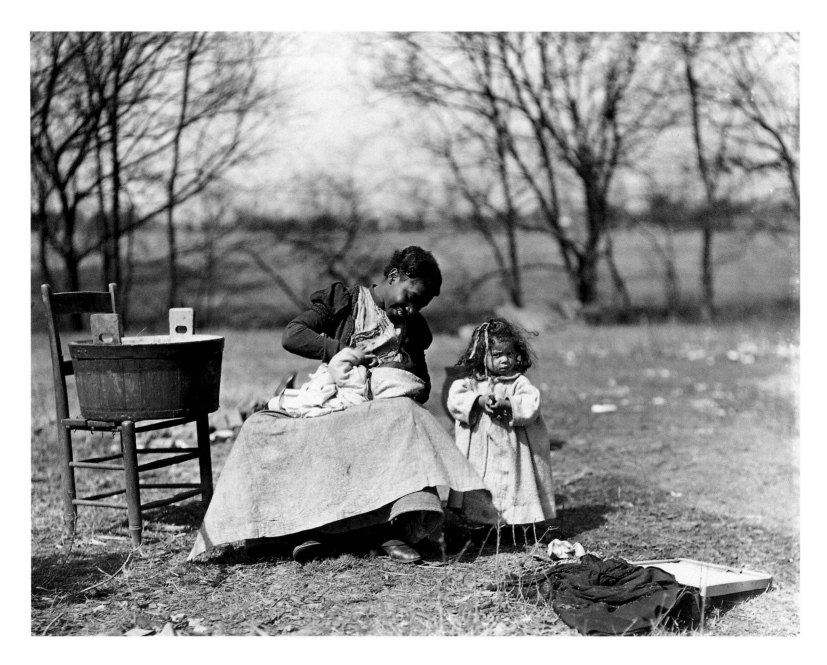

[Woman] and two [children]. Columbia, March 8, 1904. (AMNH 48049)

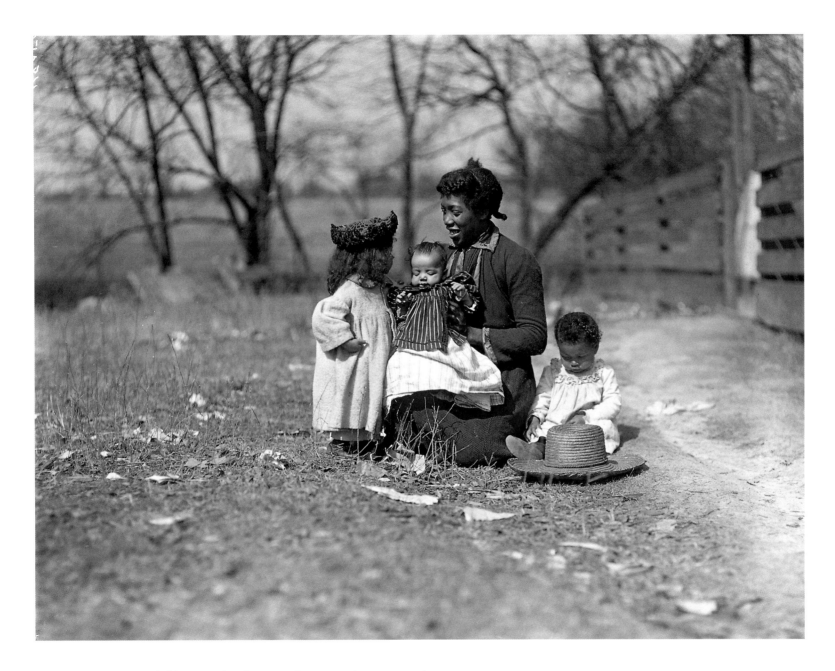

[Woman] and three [children]. Columbia, March 8, 1904. (AMNH 48050)

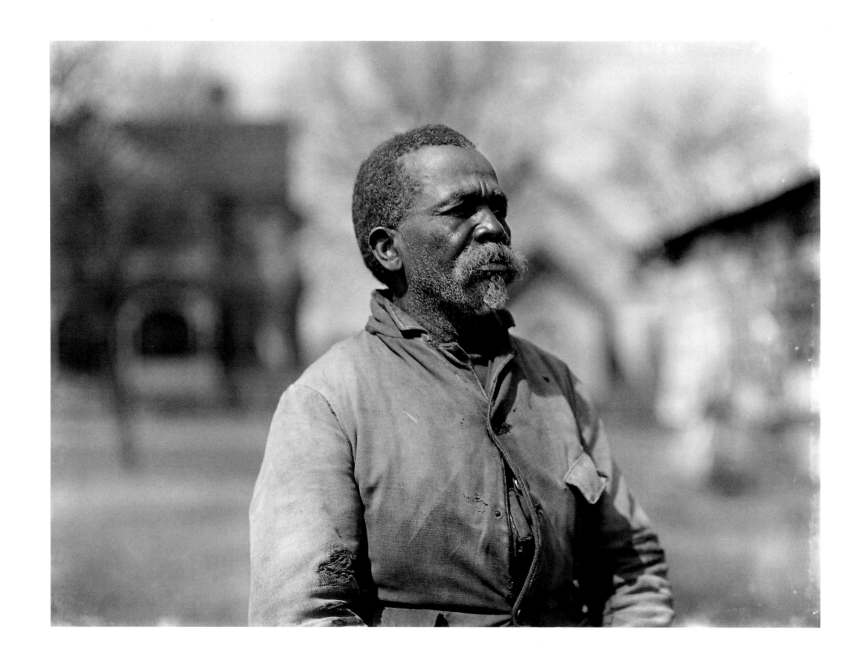

Old [man]. Columbia, March 8, 1904. (AMNH 47921)

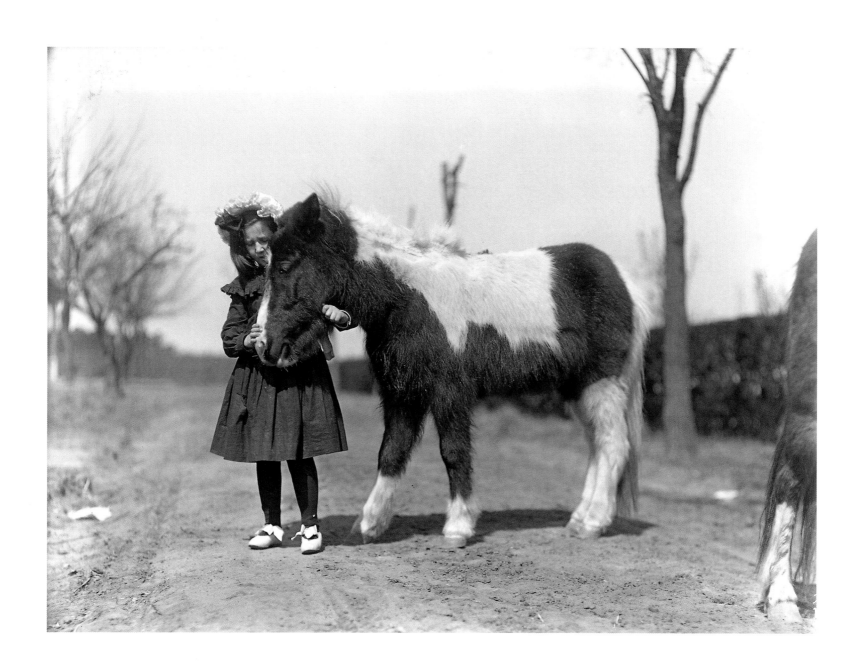

Shetland pony and child. Columbia, March 16, 1904. (AMNH 47704)

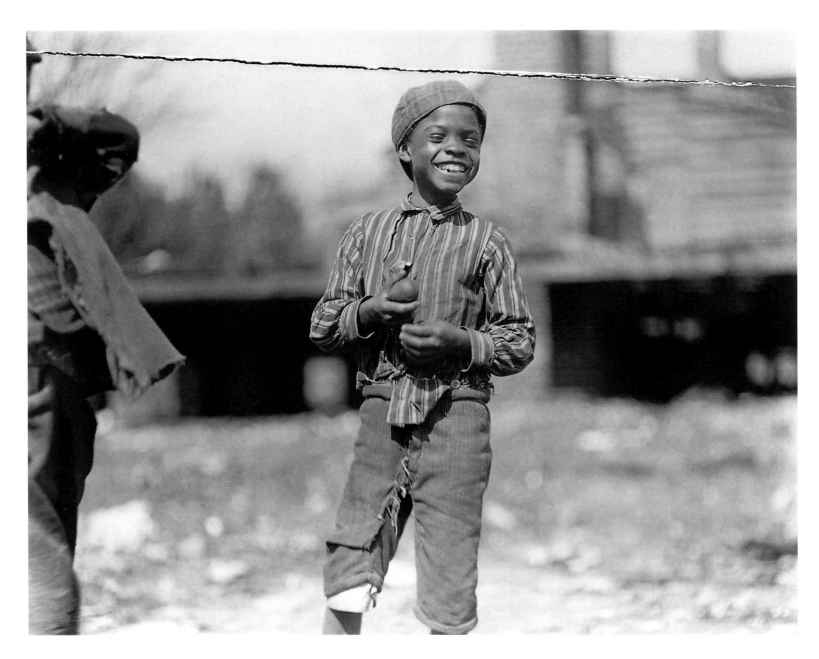

[Smiling boy in striped shirt]. [Columbia?, date unknown]. (AMNH 9972)

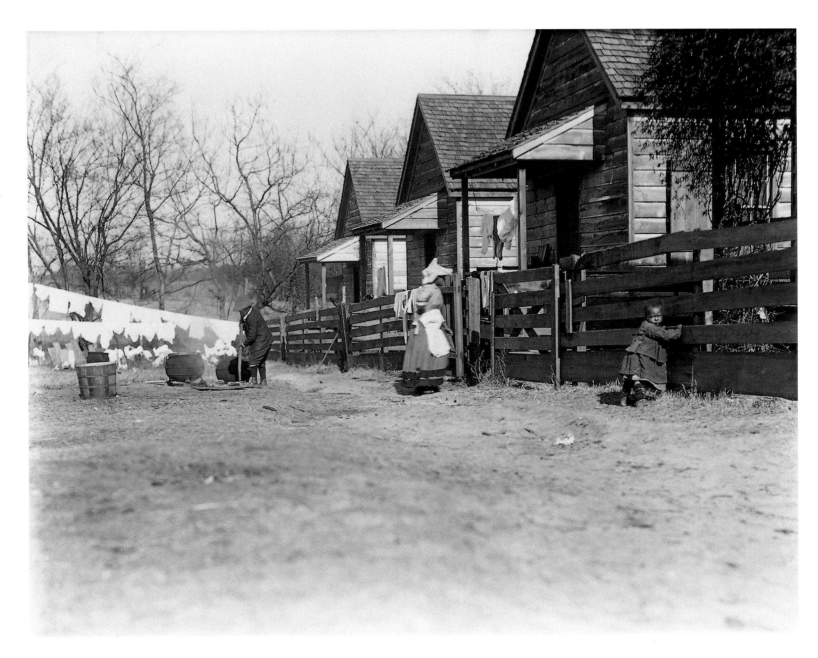

[Cabins with laundry]. [Columbia, date unknown]. (AMNH 9930)

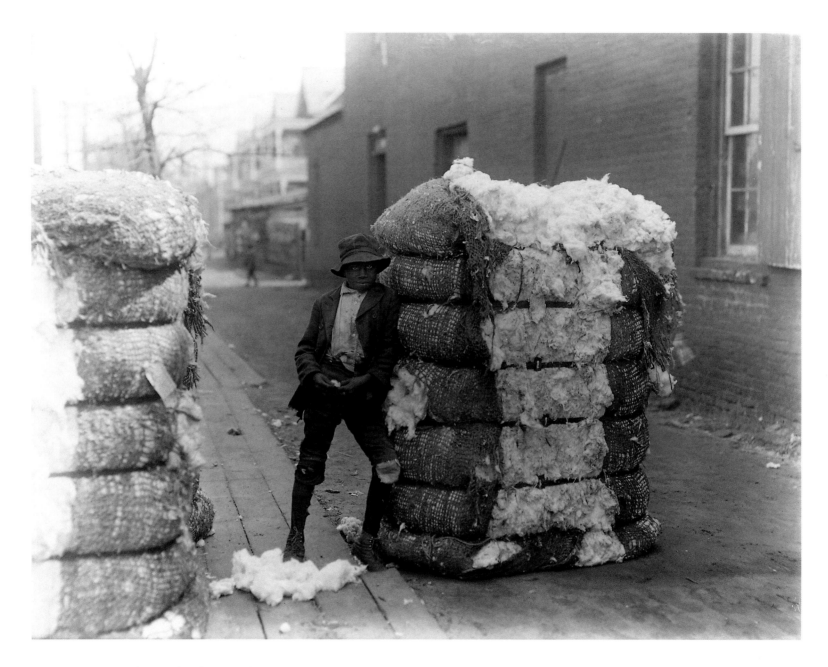

Bale of cotton and boy. Columbia, March 19, 1904. (AMNH 47793)

Beaufort: Town and County

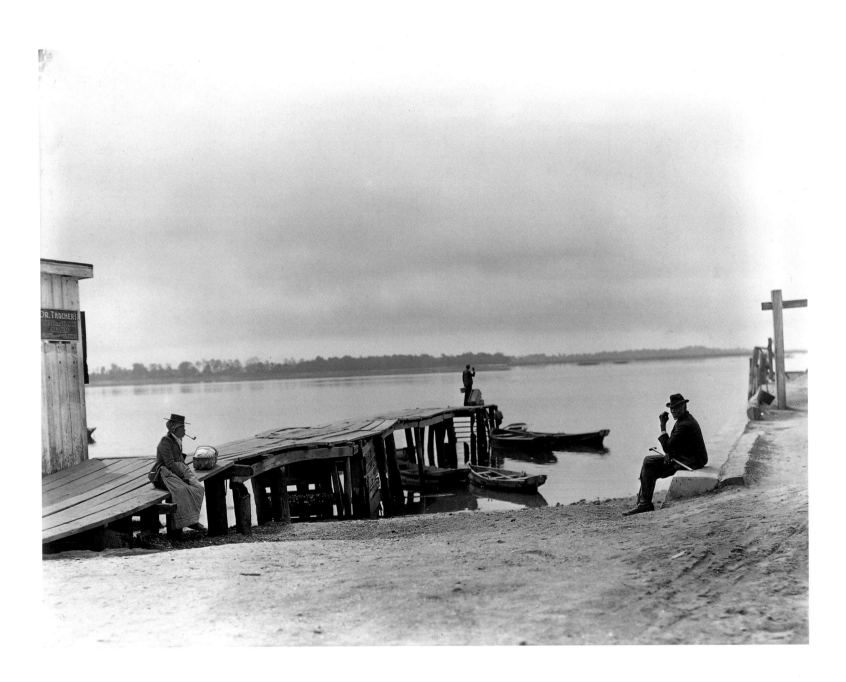

Waiting for the ferry. Beaufort, March 23, 1904. (AMNH 47857)

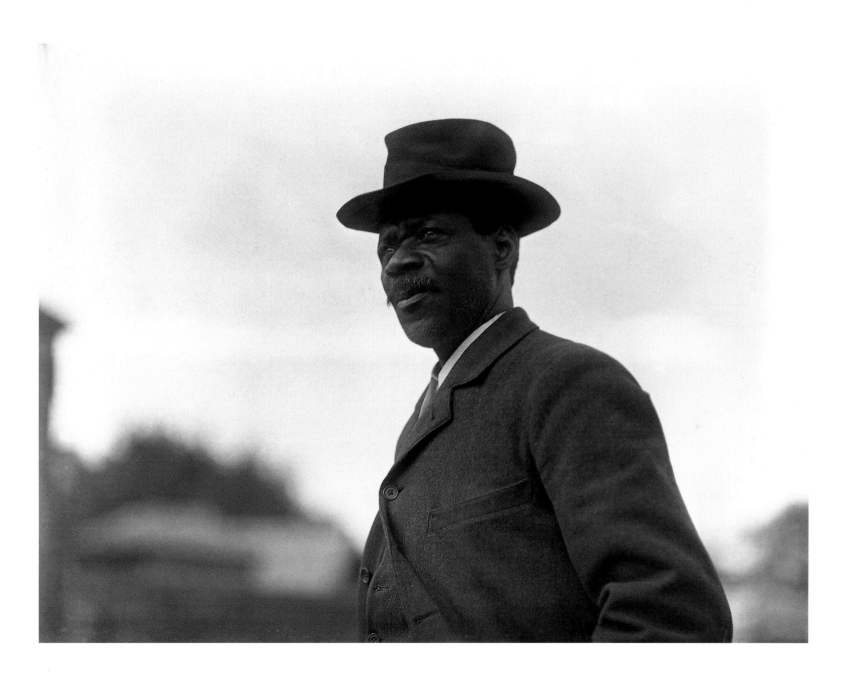

[Unidentified man]. Beaufort, March 23, 1904. (AMNH 47922)

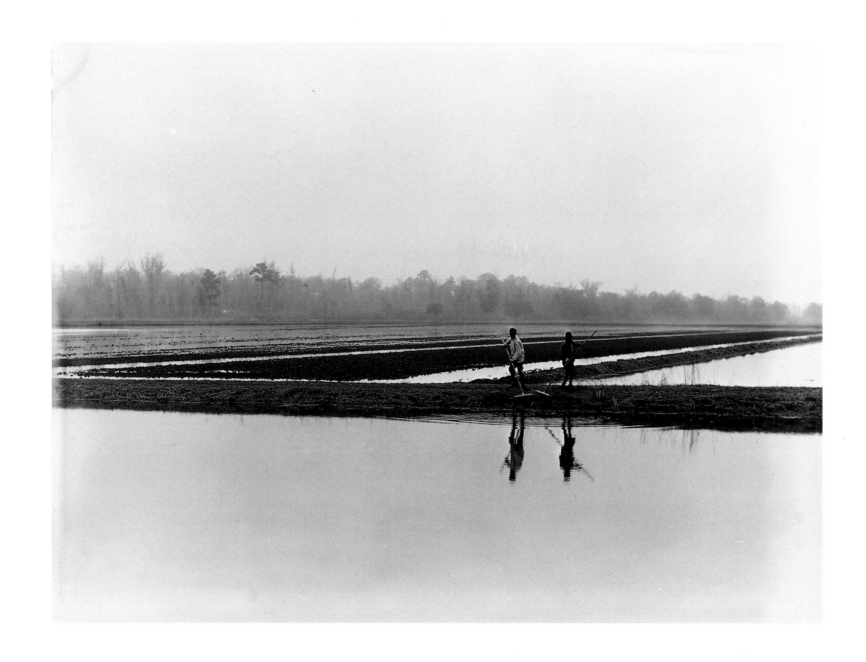

Rice fields—raking off trash. [Tomotley Plantation, Beaufort County], March 25, 1904. (AMNH 47796)

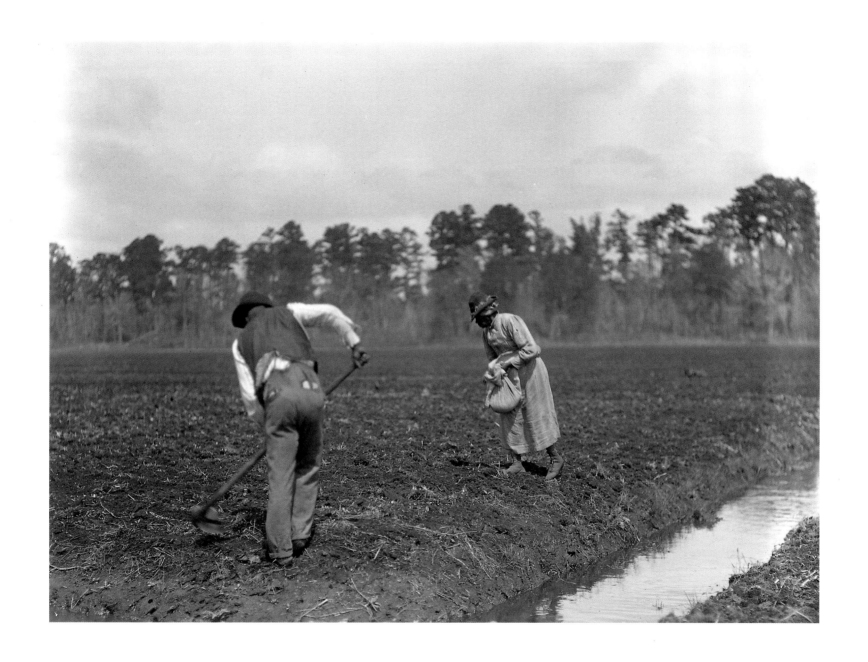

Sower [rice]. [Tomotley Plantation, Beaufort County], March 23, 1904. (AMNH 47801)

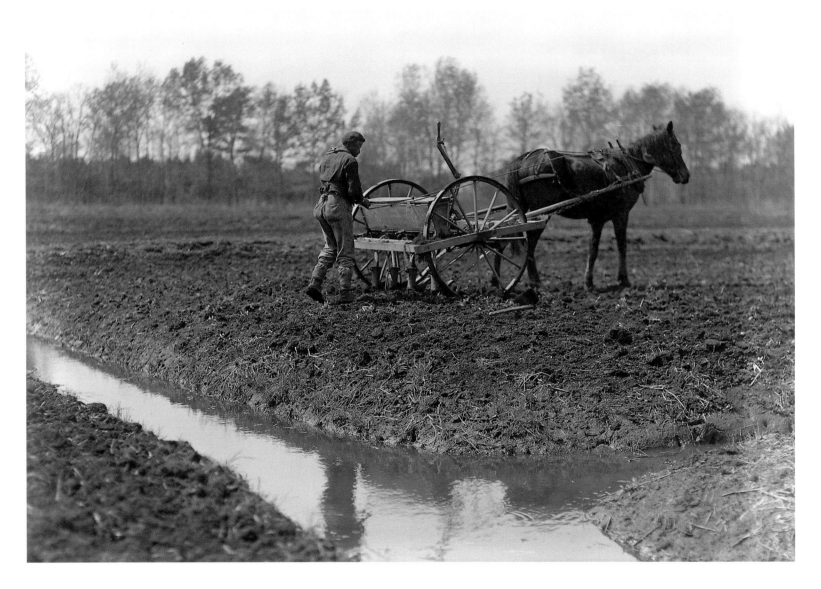

Man and [rice] driller. [Tomotley Plantation, Beaufort County], March 25, 1904. (AMNH 47800)

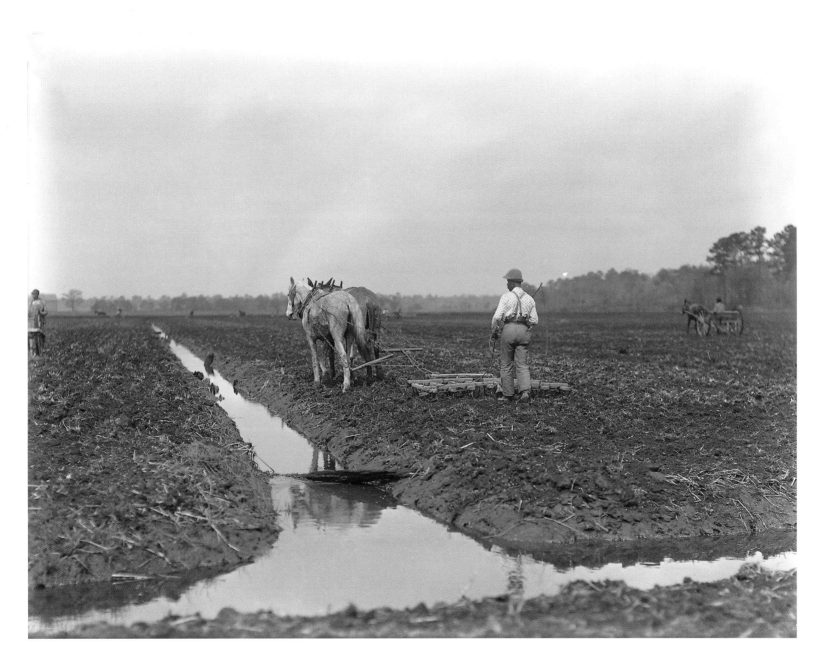

Harrowing after rice is sowed. [Tomotley Plantation, Beaufort County], March 25, 1904. (AMNH 47805)

DeVeaux House. [Tomotley Plantation, Beaufort County], March 25, 1904. (AMNH 47806)

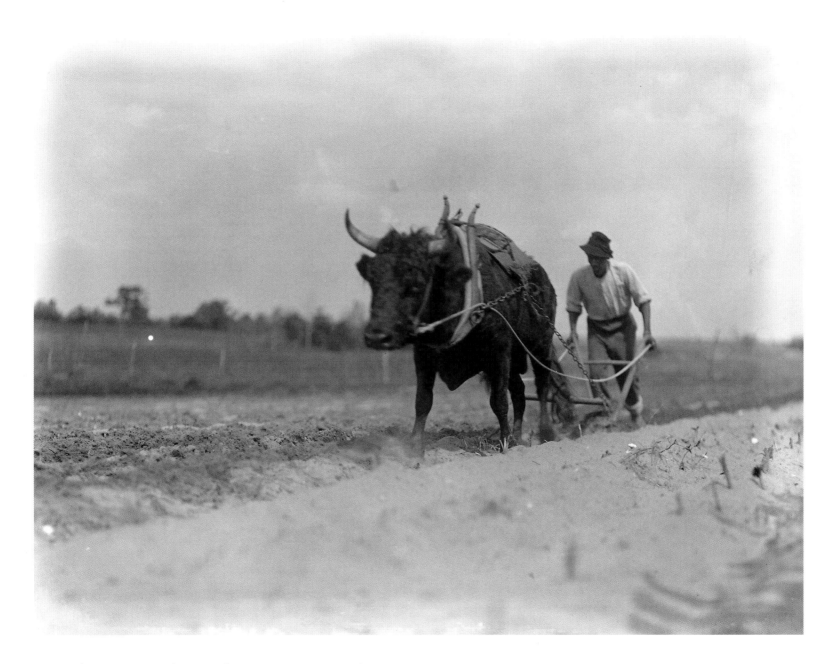

Ploughing with ox. Beaufort, March 26, 1904. (AMNH 47880)

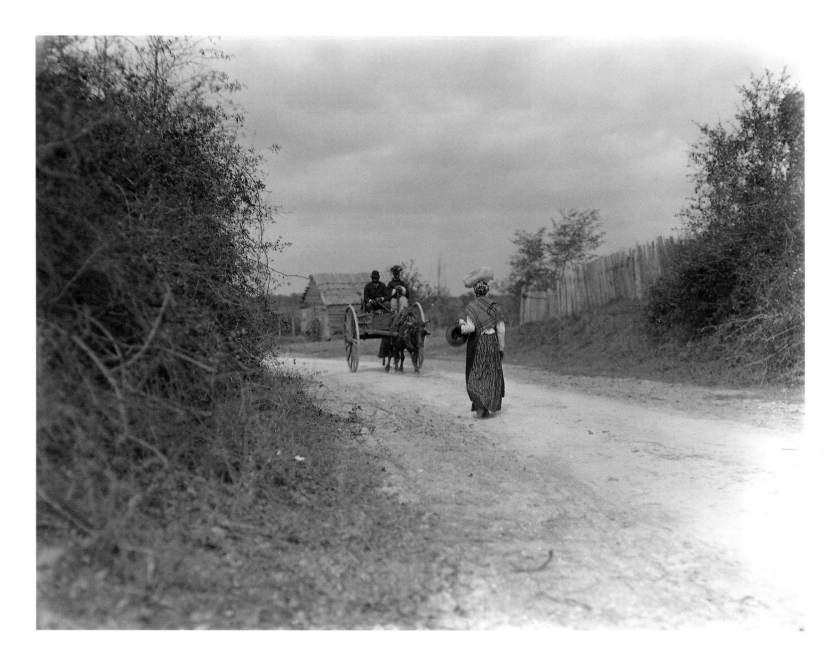

Ox cart and woman walking. Beaufort, March 26, 1904. (AMNH 47996)

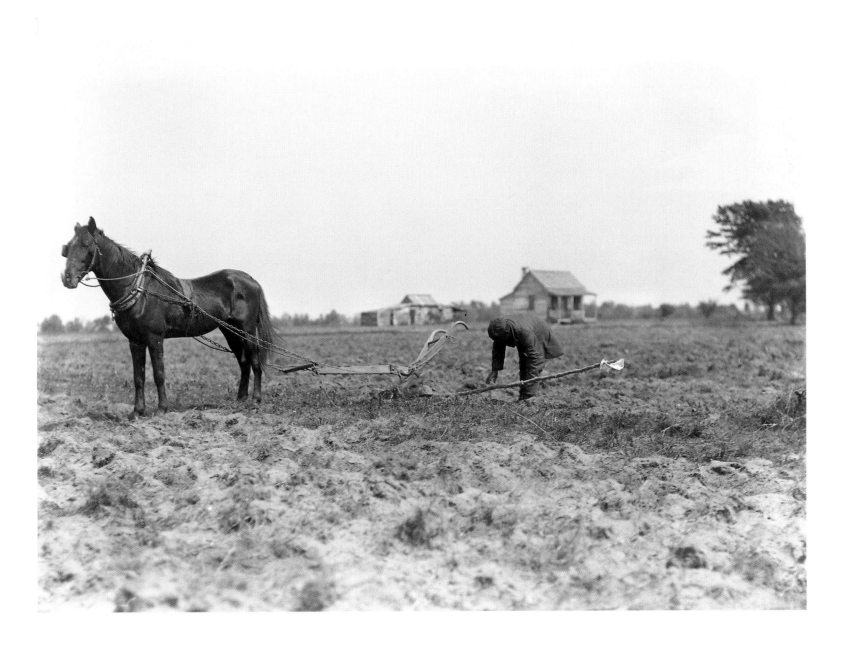

Plough and furrow guide. Beaufort, March 28, 1904. (AMNH 47875)

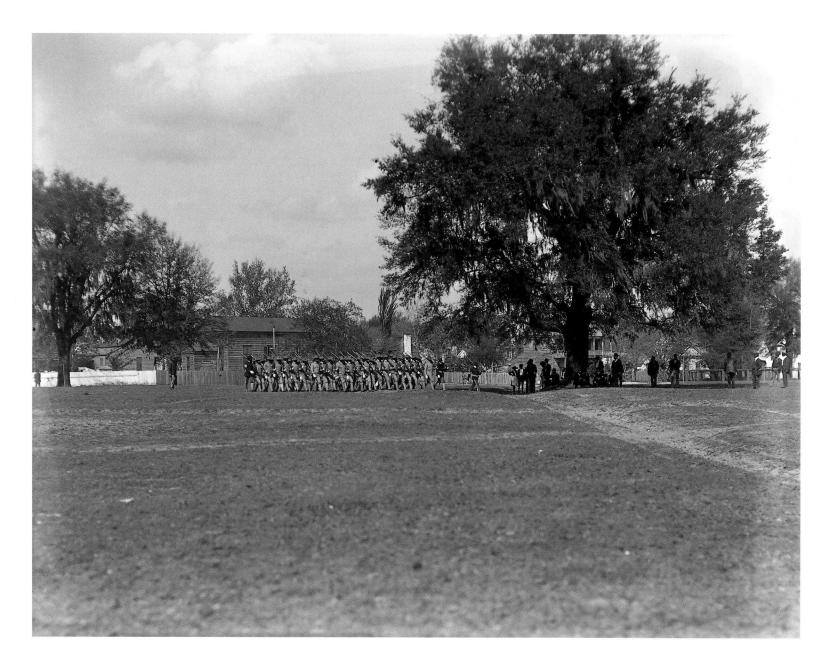

Beaufort colored troop. Beaufort, March 28, 1904. (AMNH 47859)

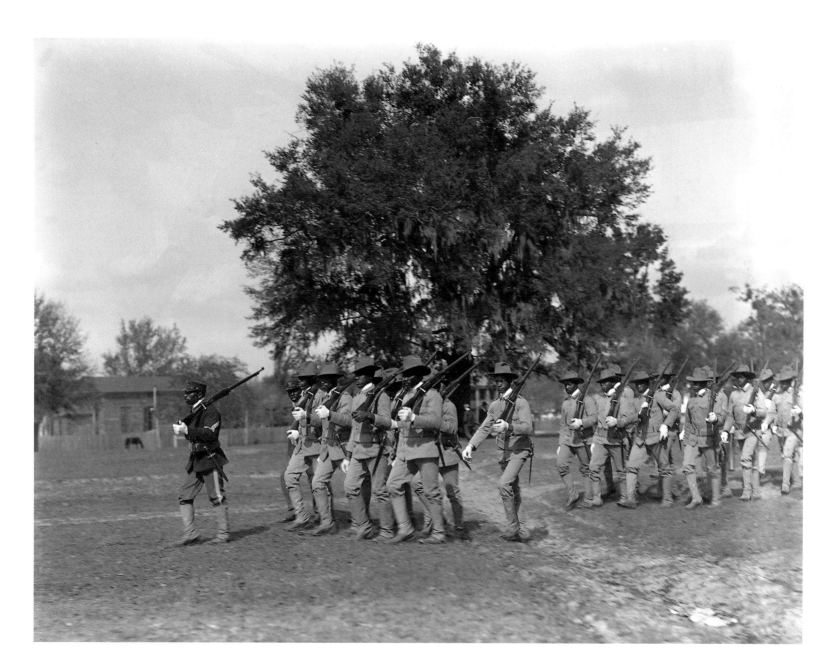

Beaufort colored troop. Beaufort, March 28, 1904. (AMNH 47858)

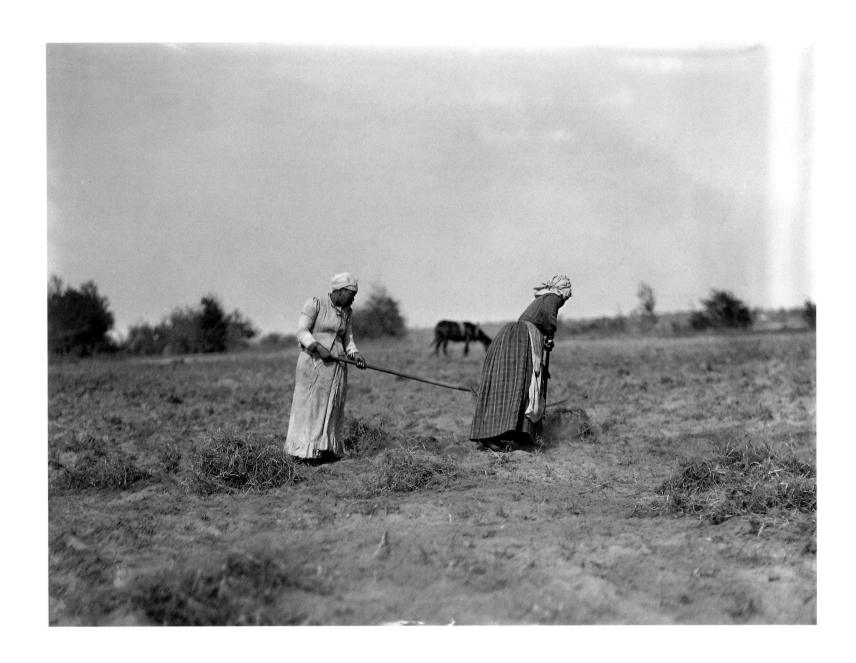

Group in field. Beaufort, March 29, 1904. (AMNH 47997)

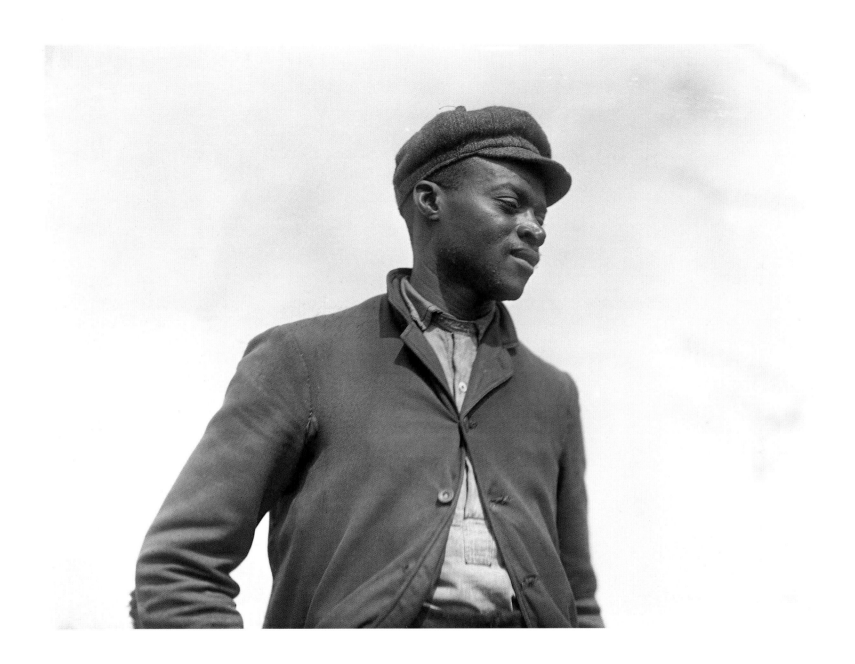

[Young man]. Beaufort, March 30, 1904. (AMNH 47923)

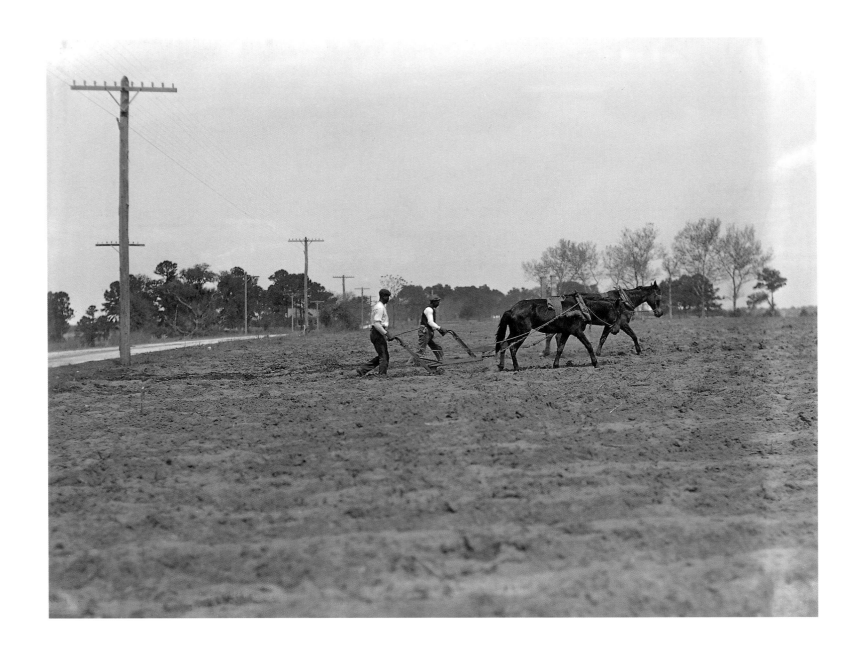

Ploughing. Beaufort, March 31, 1904. (AMNH 47882)

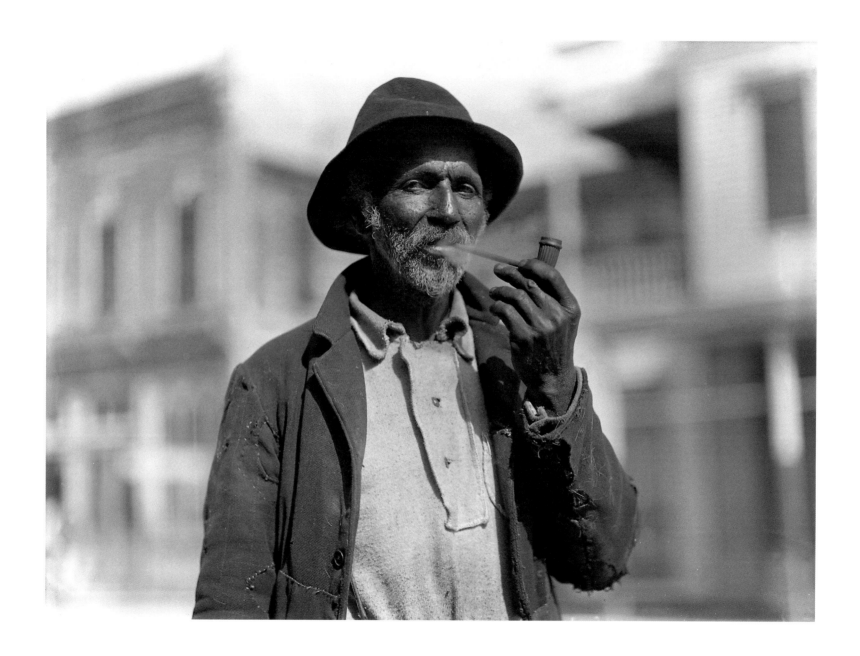

Fisherman. Beaufort, March 31, 1904. (AMNH 47924)

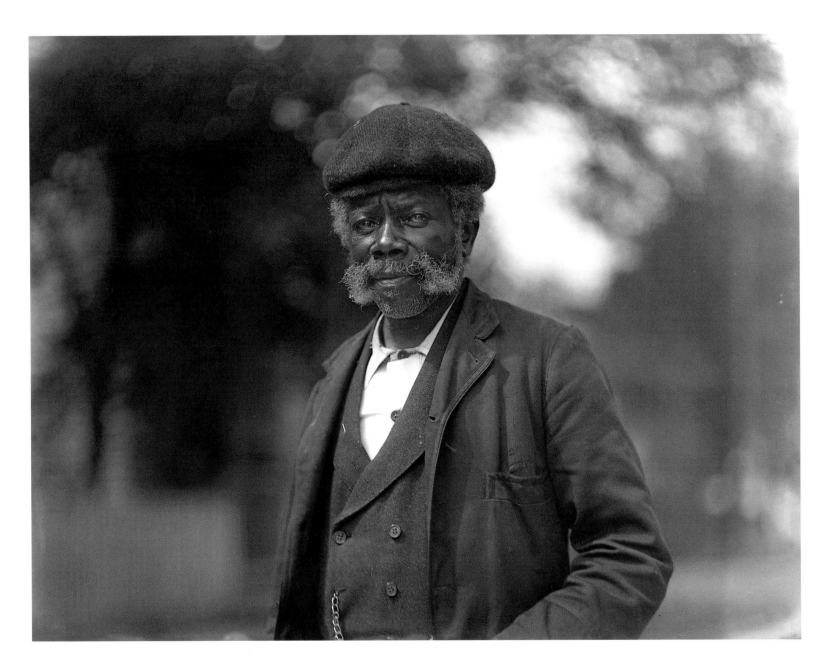

[Unidentified man]. Beaufort, March 30, 1904. (AMNH 47926)

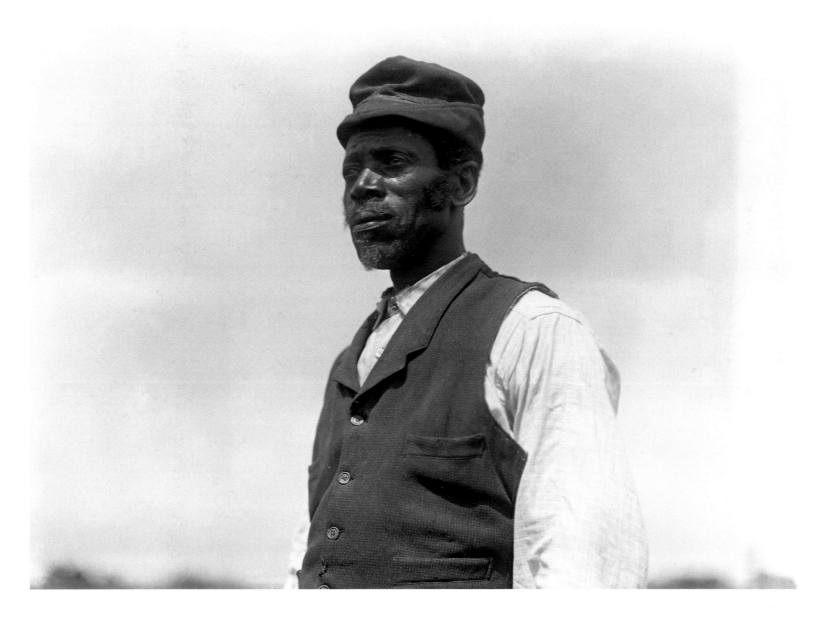

John Smith. Beaufort, March 31, 1904. (AMNH 47929)

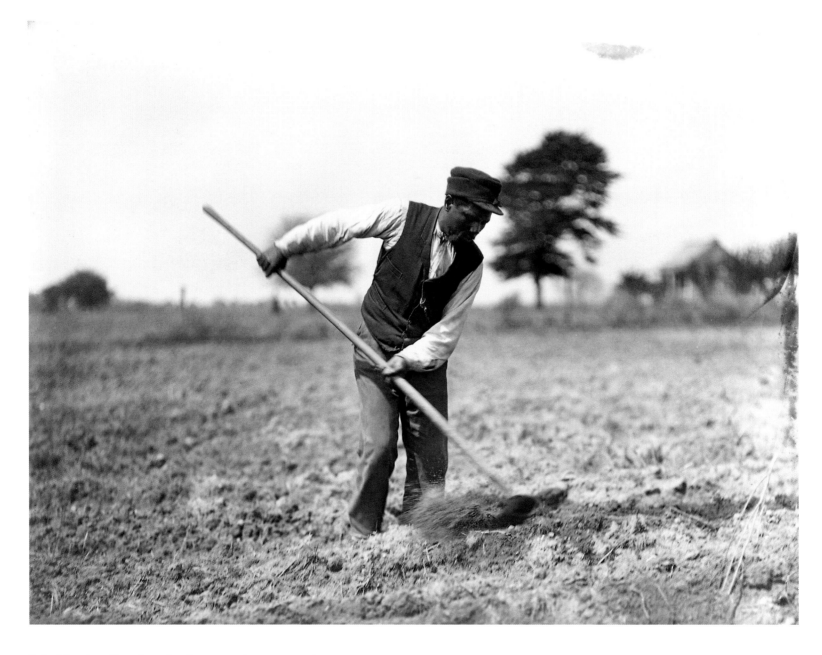

[Man] hoeing. Beaufort, April 1, 1904. (AMNH 47887)

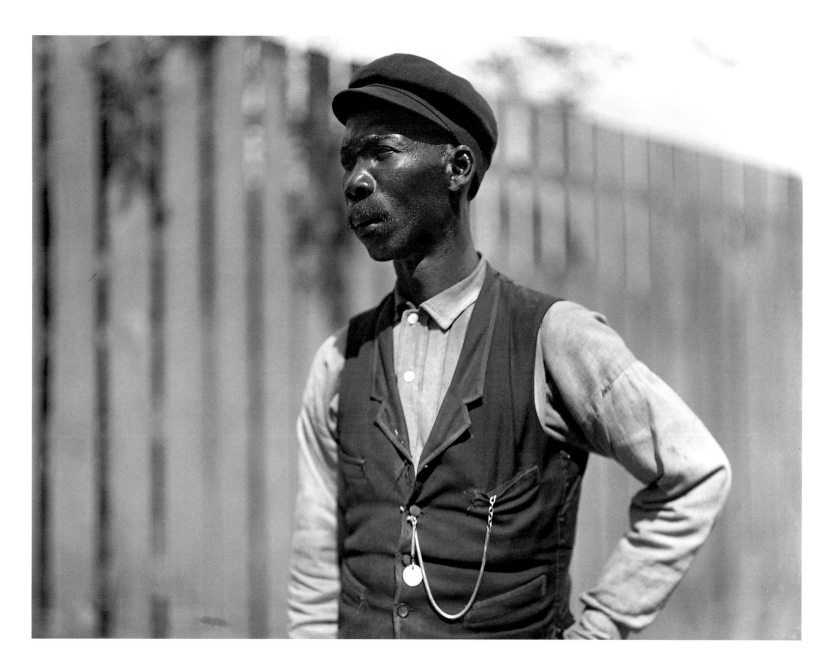

[Unidentified man]. Beaufort, April 1, 1904. (AMNH 47933)

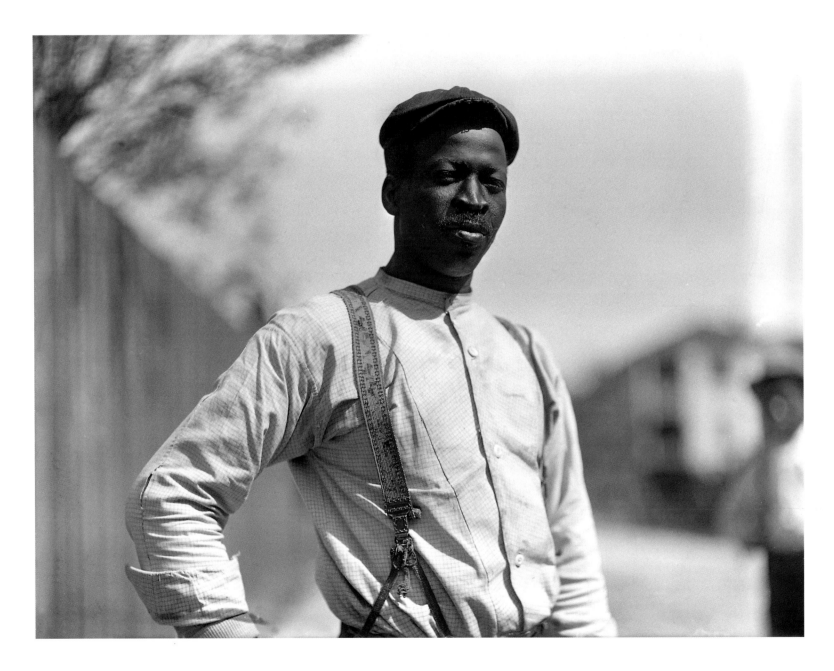

[Unidentified man]. Beaufort, April 1, 1904. (AMNH 47932)

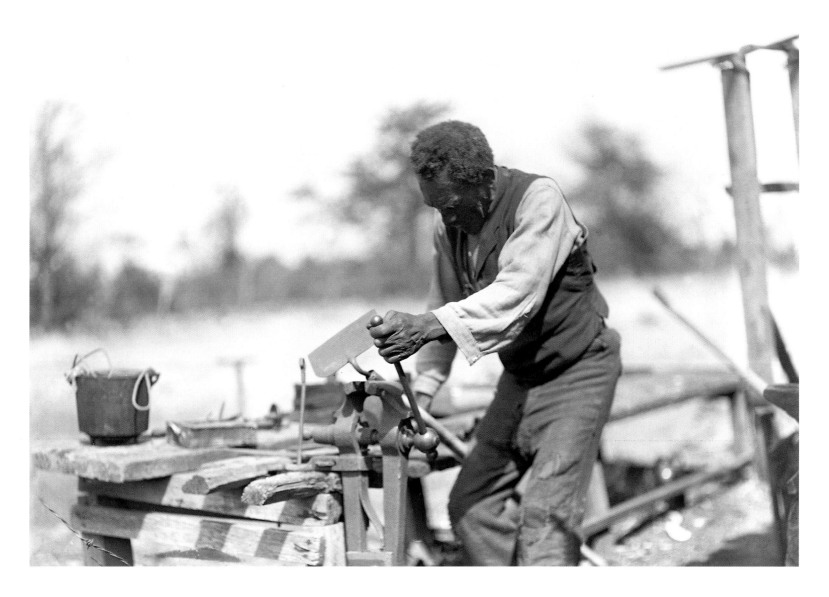

Blacksmith. Beaufort, April 1, 1904. (AMNH 47891)

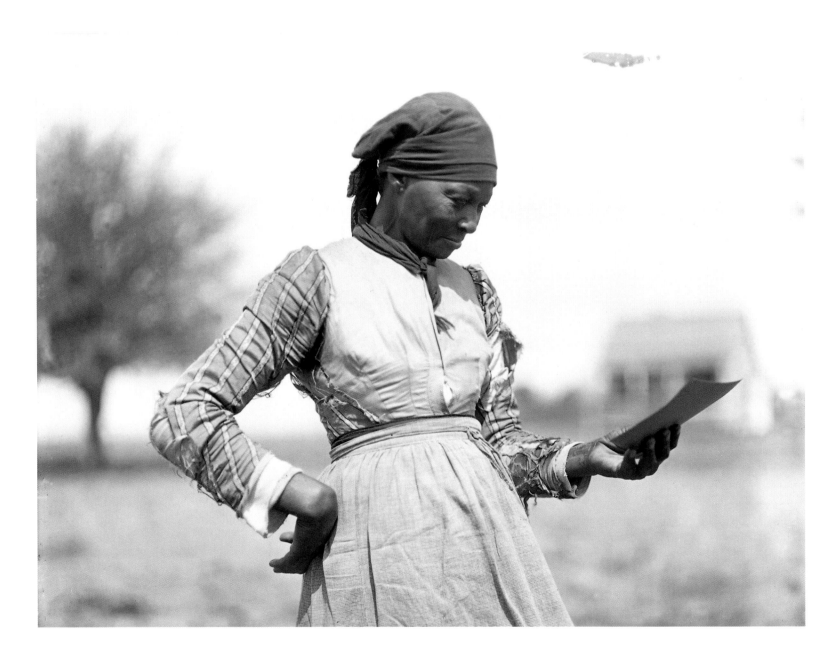

[Woman] looking at picture. Beaufort, April 1, 1904. (AMNH 47998)

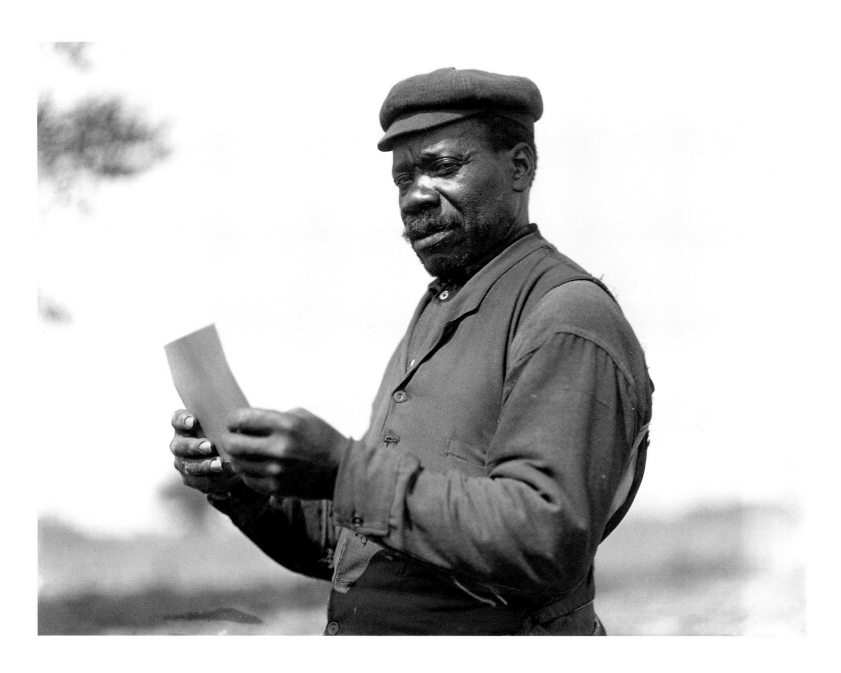

[Man] looking at picture. Beaufort, April 1, 1904. (AMNH 47934)

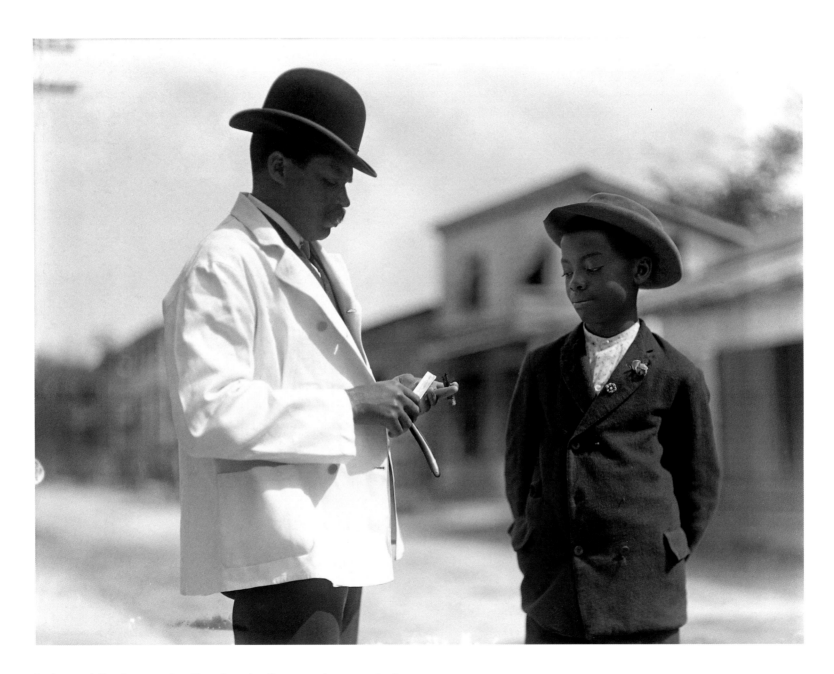

Barber and [boy] apprentice. Beaufort, April 1, 1904. (AMNH 47890)

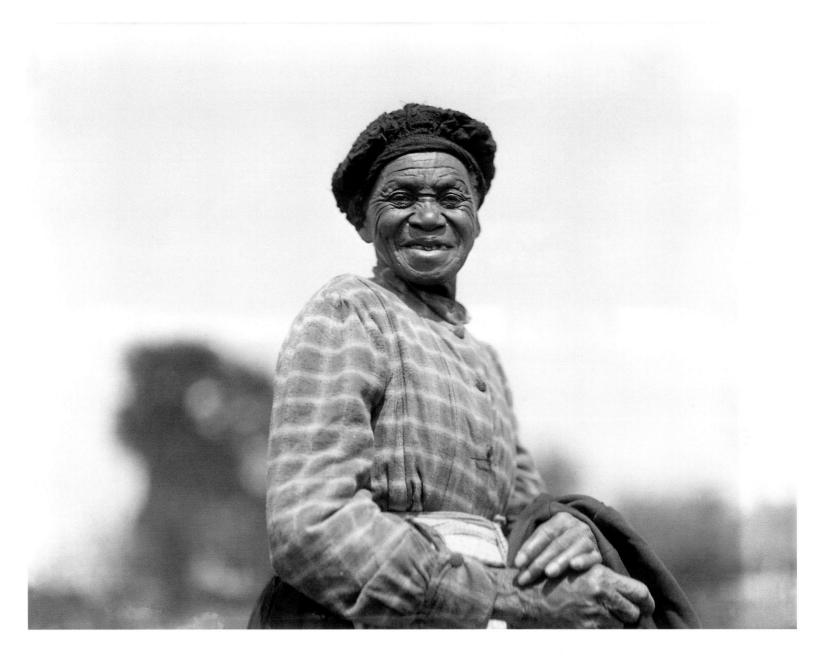

Old [woman]. Beaufort, April 2, 1904. (AMNH 48002)

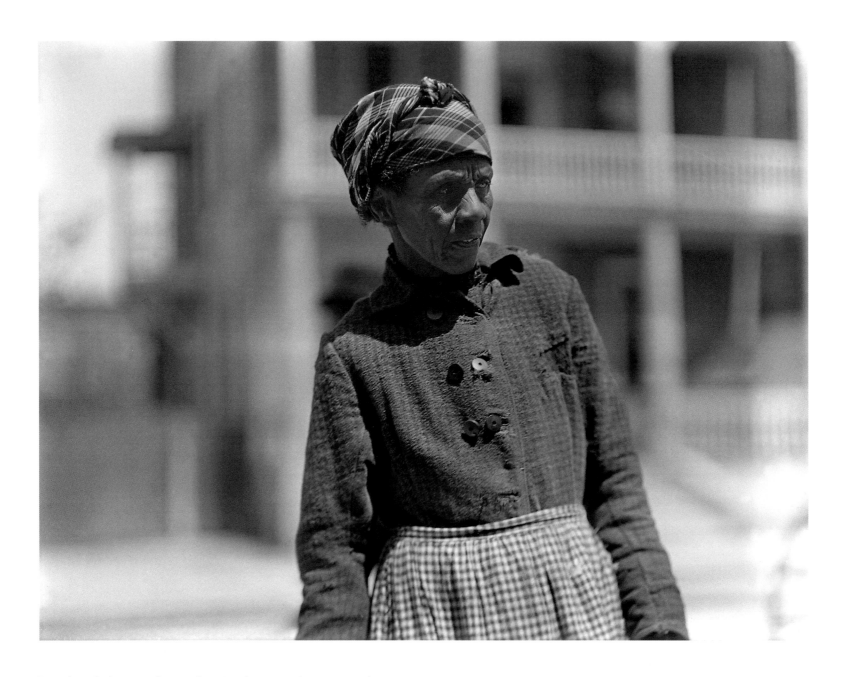

[Unidentified woman]. Beaufort, April 2, 1904. (AMNH 48003)

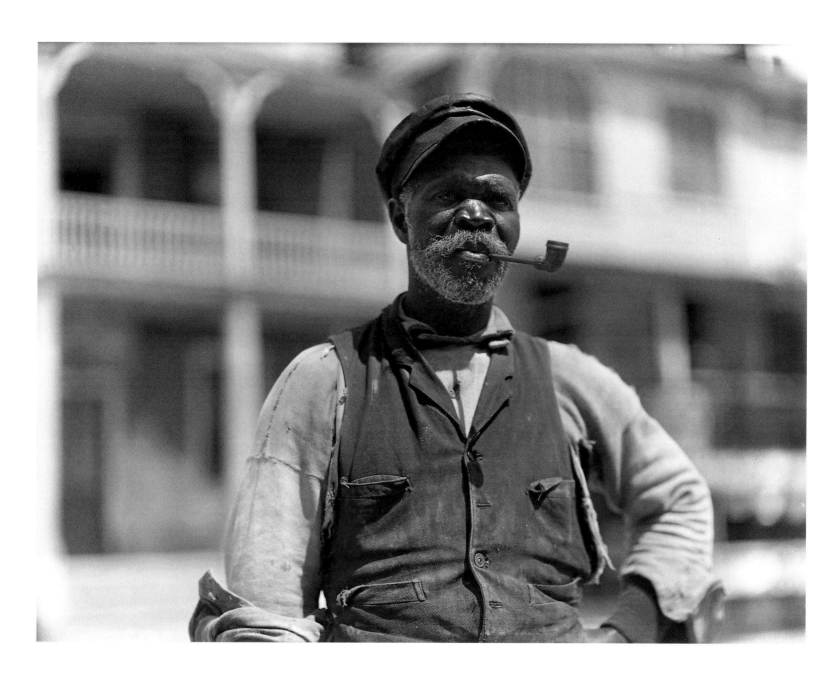

[Man] with pipe in mouth. Beaufort, April 2, 1904. (AMNH 47938)

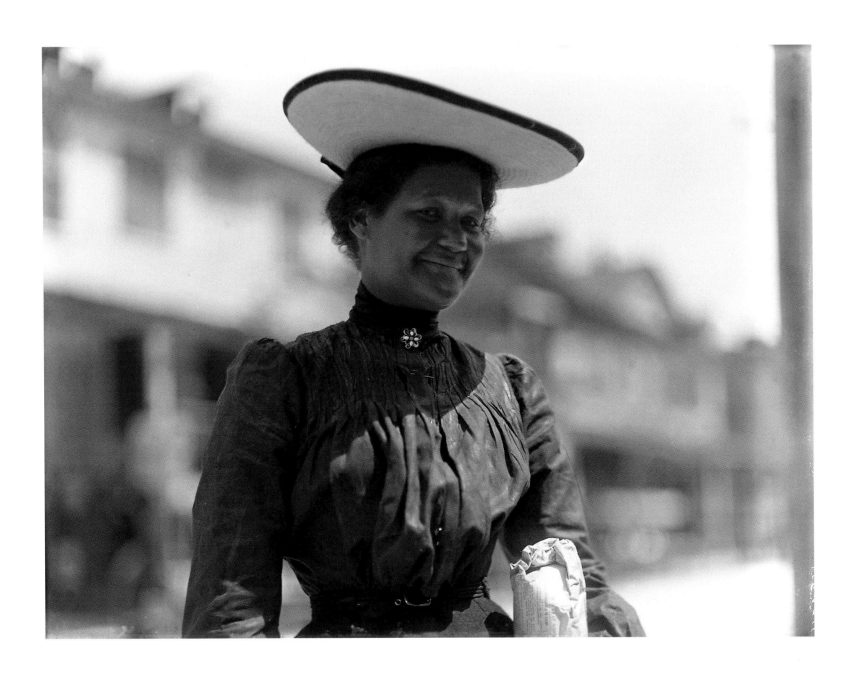

[Woman] with Easter hat. Beaufort, April 2, 1904. (AMNH 48004)

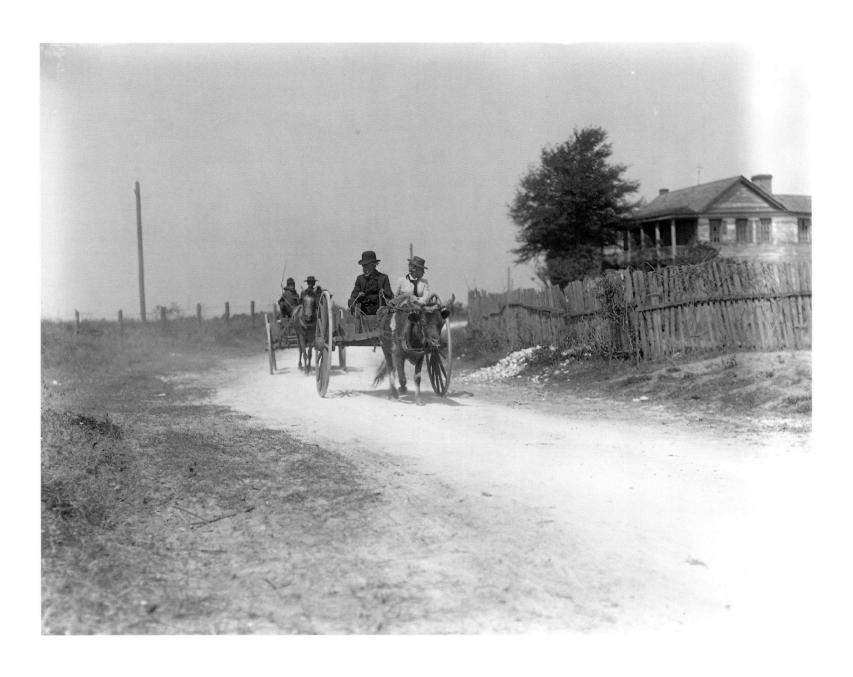

Ox cart [on a country road]. Beaufort, April 2, 1904. (AMNH 47935)

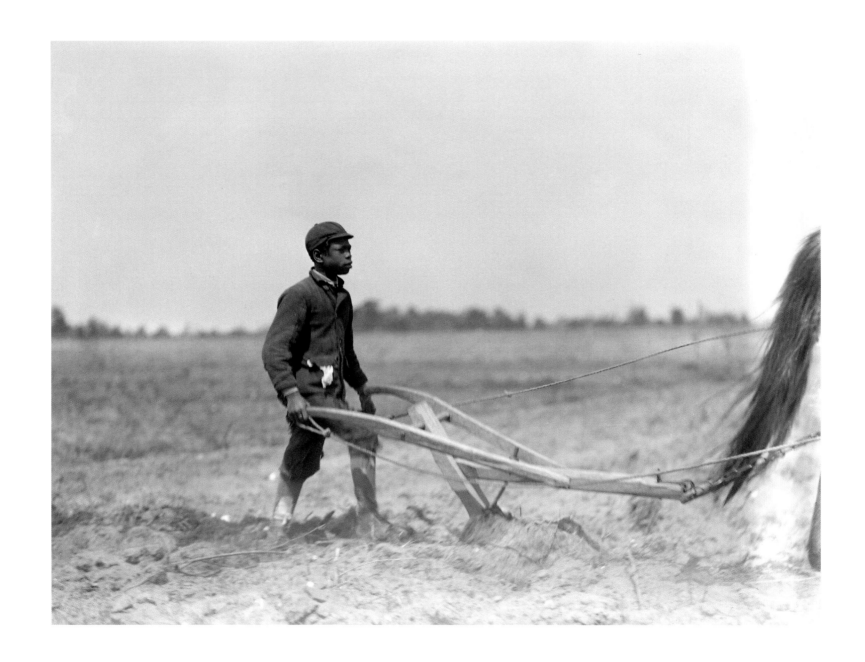

Boy ploughing. Beaufort, April 4, 1904. (AMNH 47883)

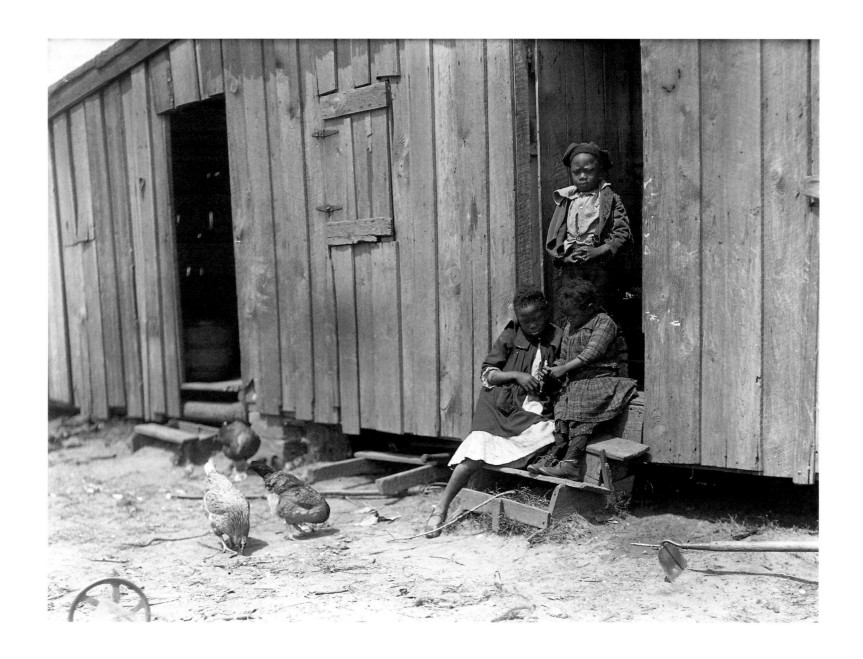

[Children] and chickens. Beaufort, April 4, 1904. (AMNH 48074)

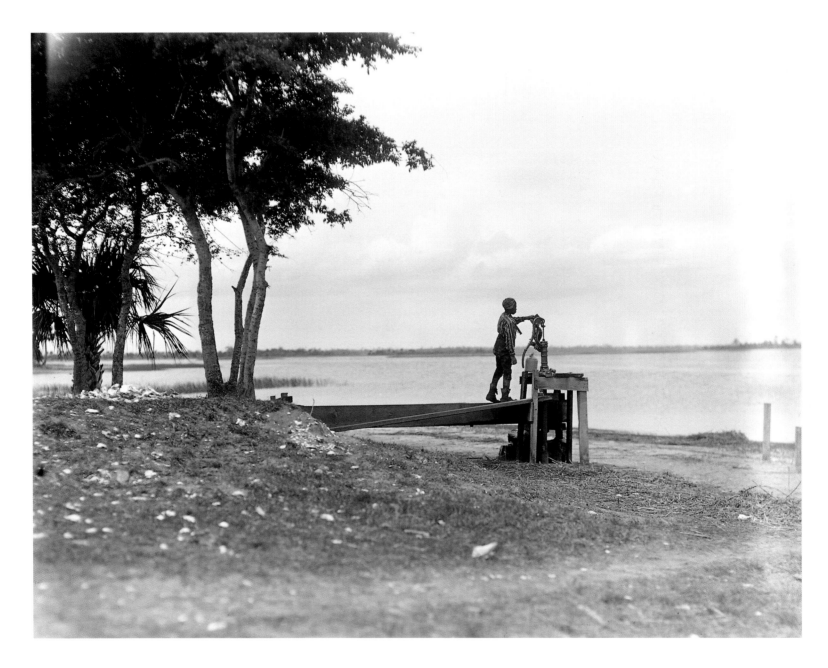

Boy at pump. Hilton Head, April 6, 1904. (AMNH 47974)

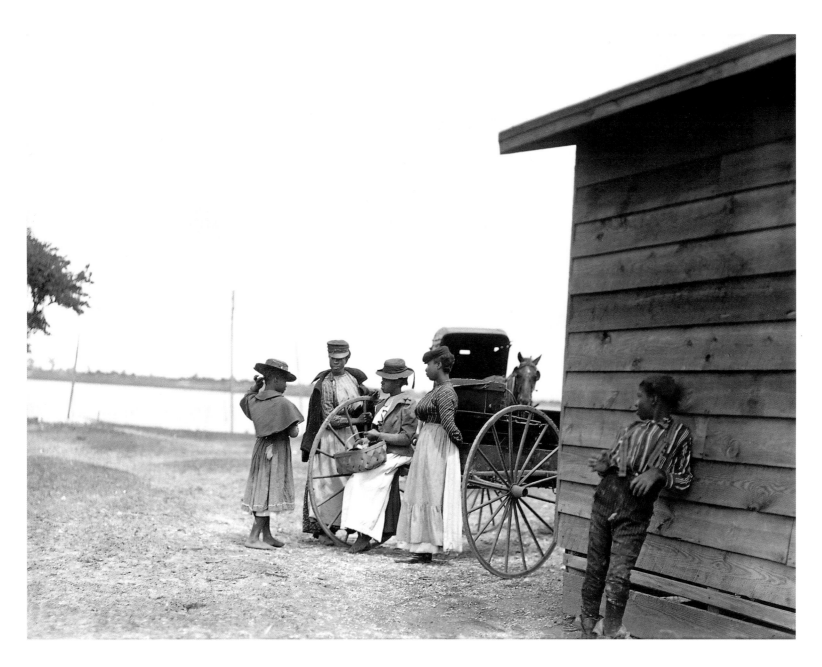

Group of boys and girls. Hilton Head, April 6, 1904. (AMNH 48076)

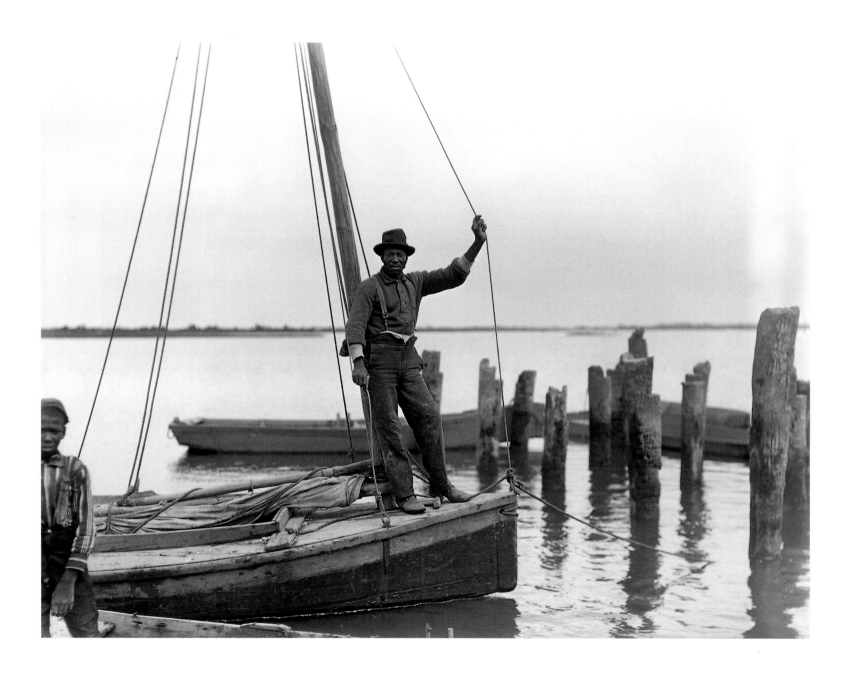

Fisherman. Hilton Head, April 6, 1904. (AMNH 47813)

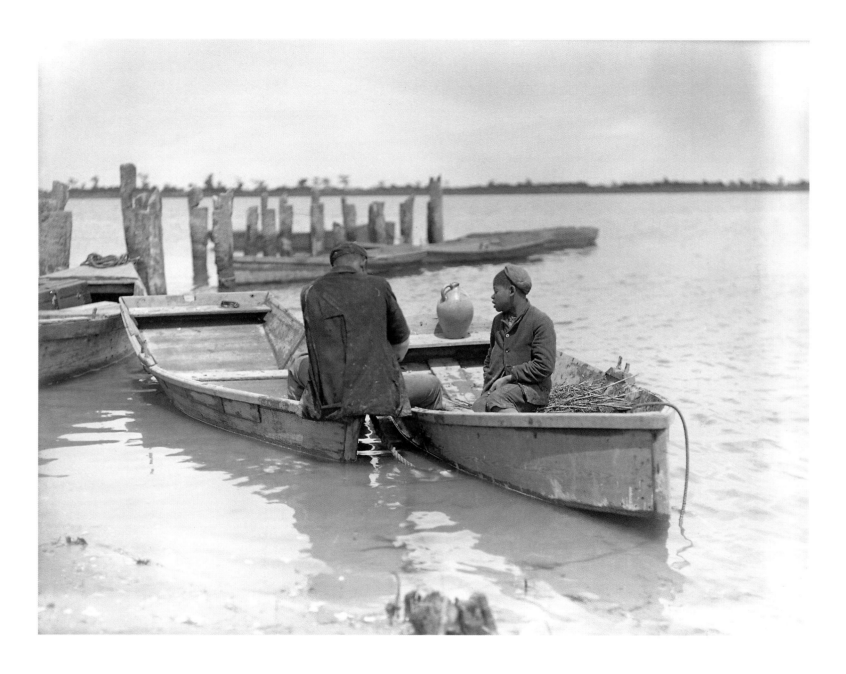

Boy and man opening oysters. Hilton Head, April 6, 1904. (AMNH 47815)

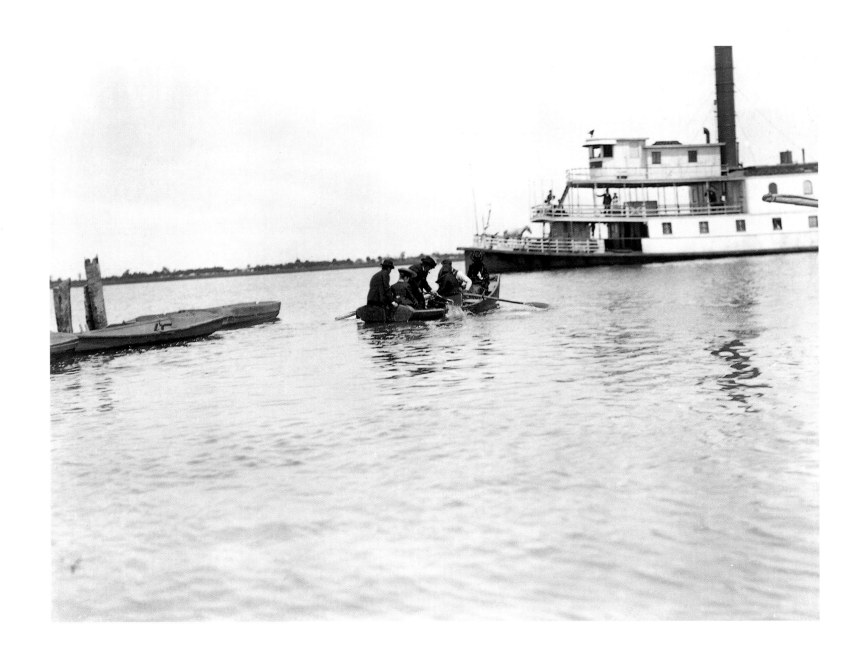

[Men and women in dinghy going out to steamboat]. [Hilton Head?, date unknown]. (AMNH 10136)

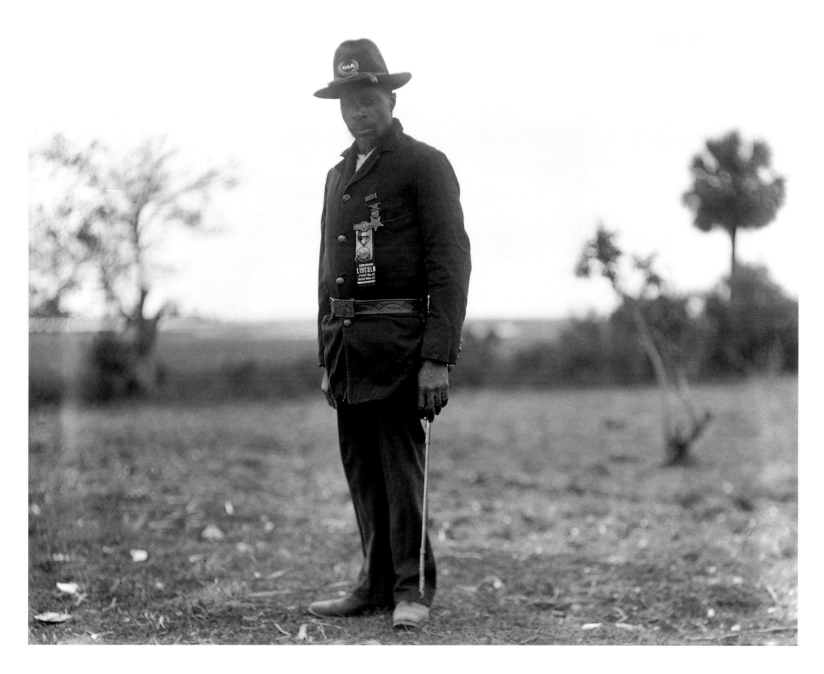

[Matt Jones] in regimentals. Hilton Head, April 6, 1904. (AMNH 47860)

Old Graham House. Hilton Head, April 7, 1904. (AMNH 47811)

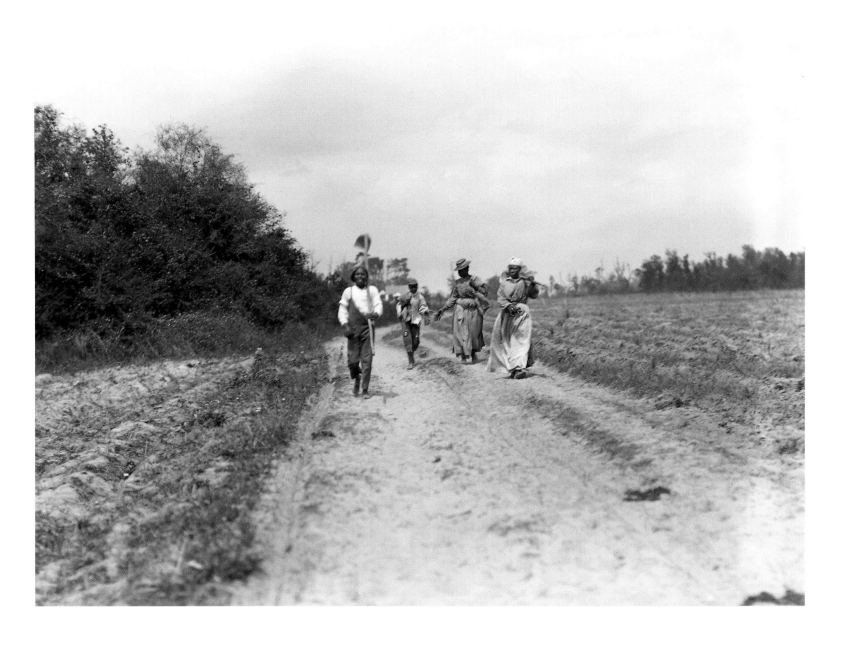

Group of [farm hands] walking. Hilton Head, April 7, 1904. (AMNH 47942)

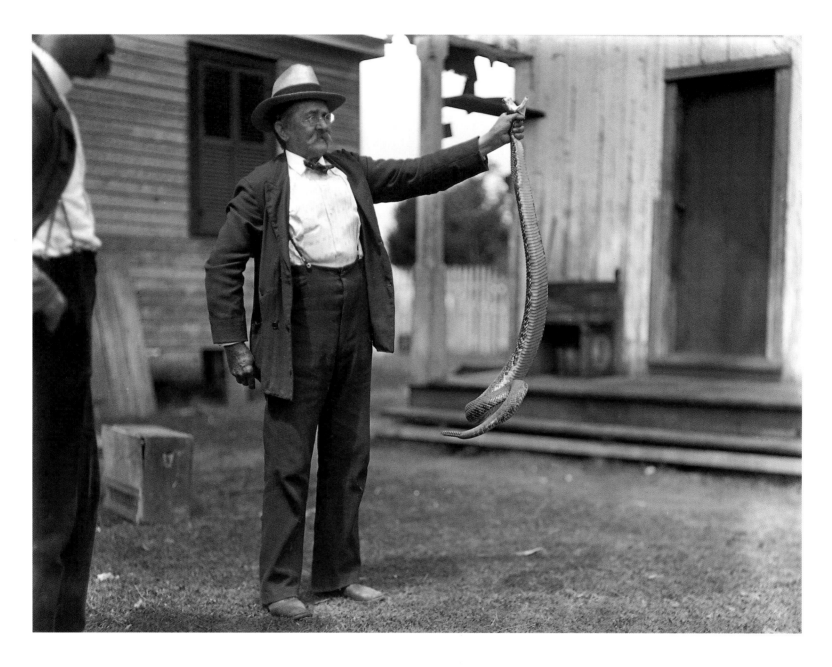

Dr. Wilder holding rattlesnake. Hilton Head, April 7, 1904. (AMNH 49363)

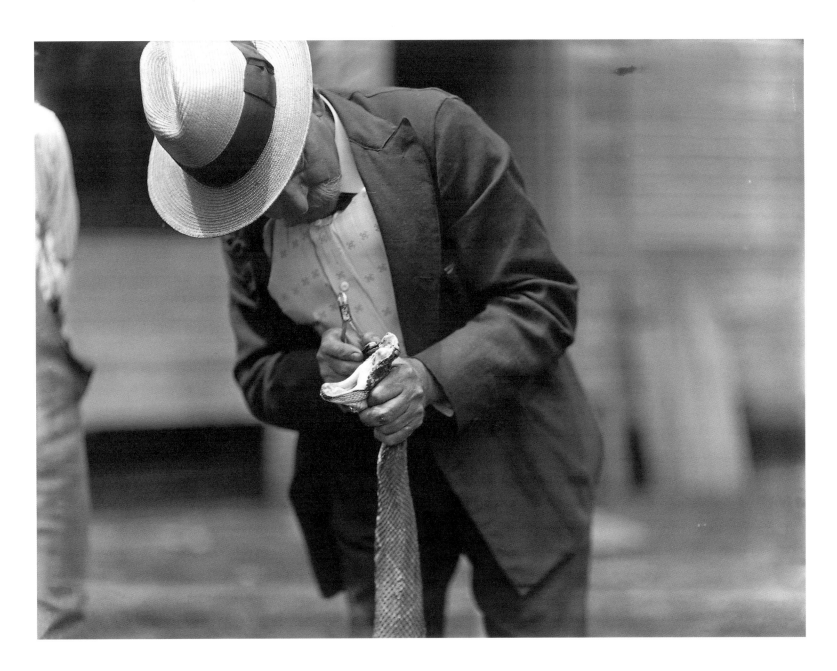

Dr. Wilder extracting fangs of rattlesnake. Hilton Head, April 7, 1904. (AMNH 49364)

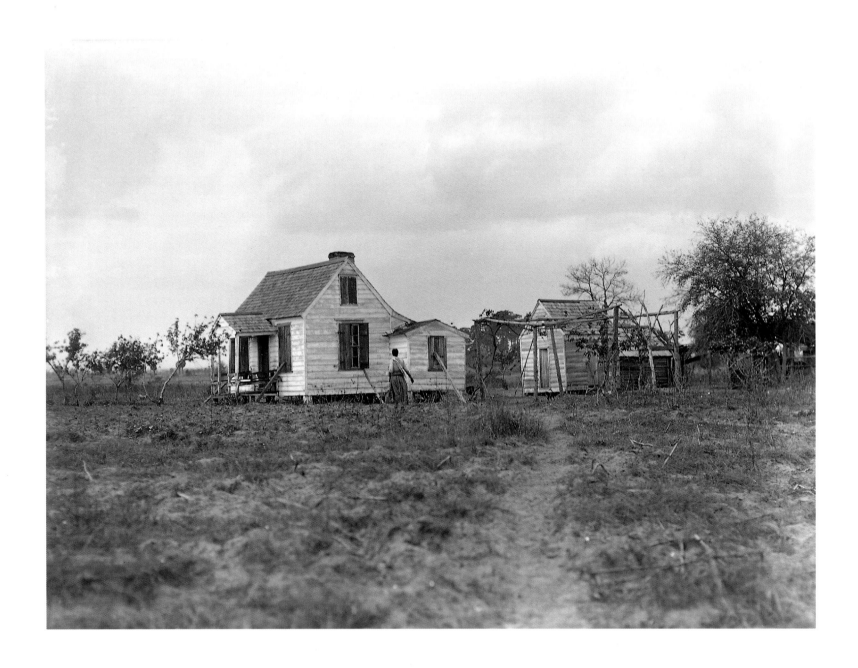

Cabin. Hilton Head, April 7, 1904. (AMNH 47850)

Donkey. Hilton Head, April 8, 1904. (AMNH 47816)

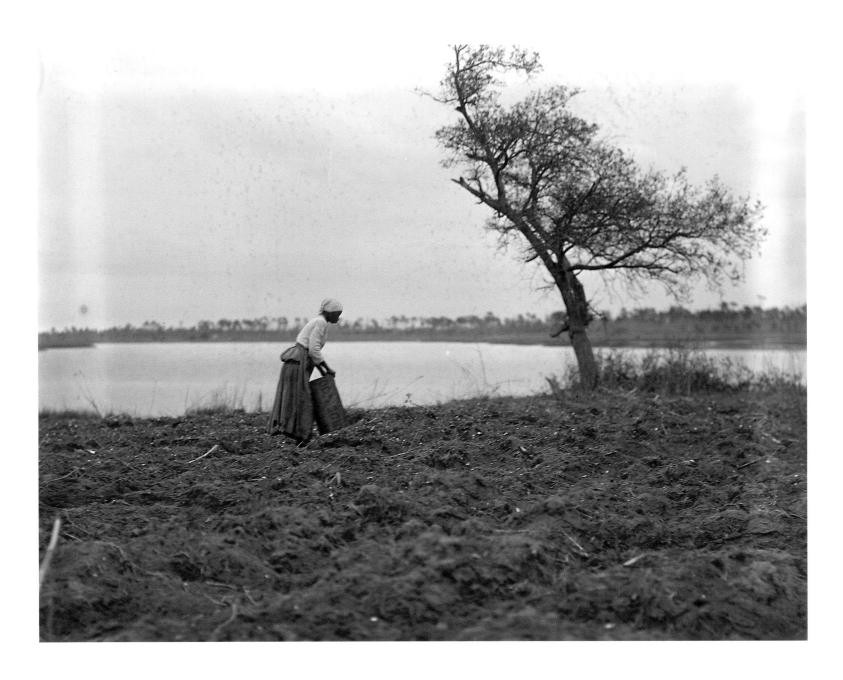

Planting watermelon. Hilton Head, April 9, 1904. (AMNH 47895)

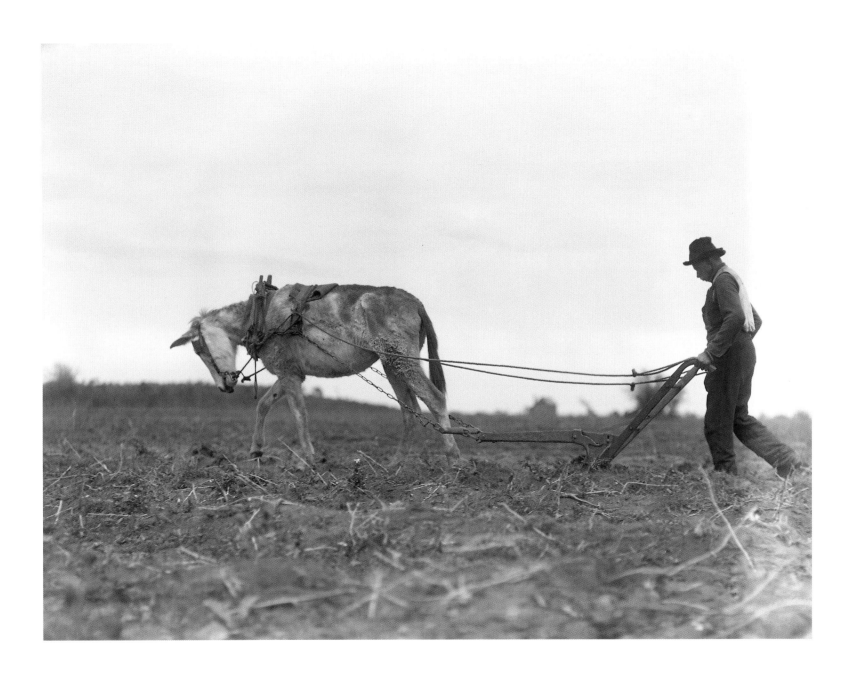

Ploughing. Hilton Head, April 8, 1904. (AMNH 47885)

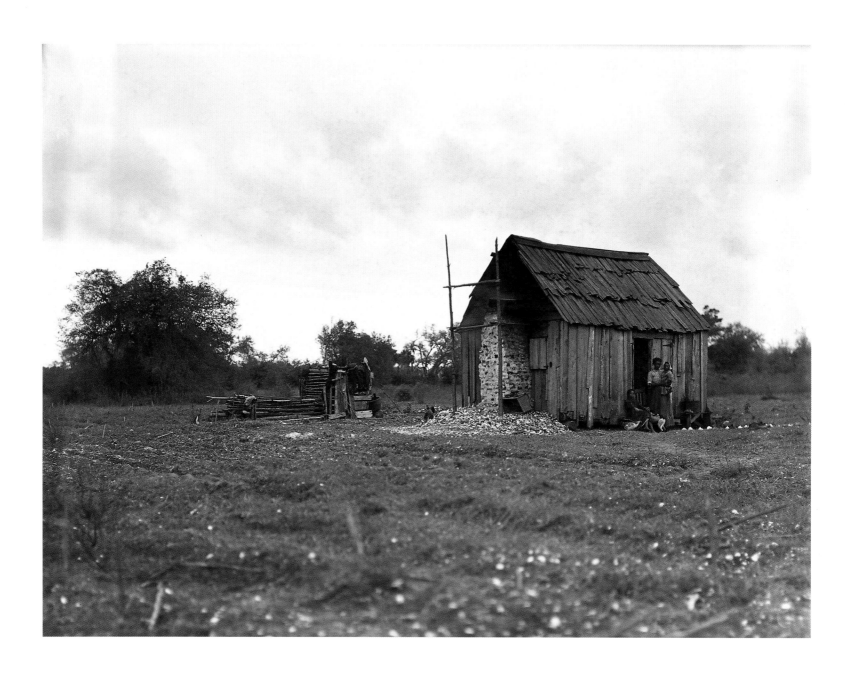

Cabin and family. Hilton Head, April 9, 1904. (AMNH 47851)

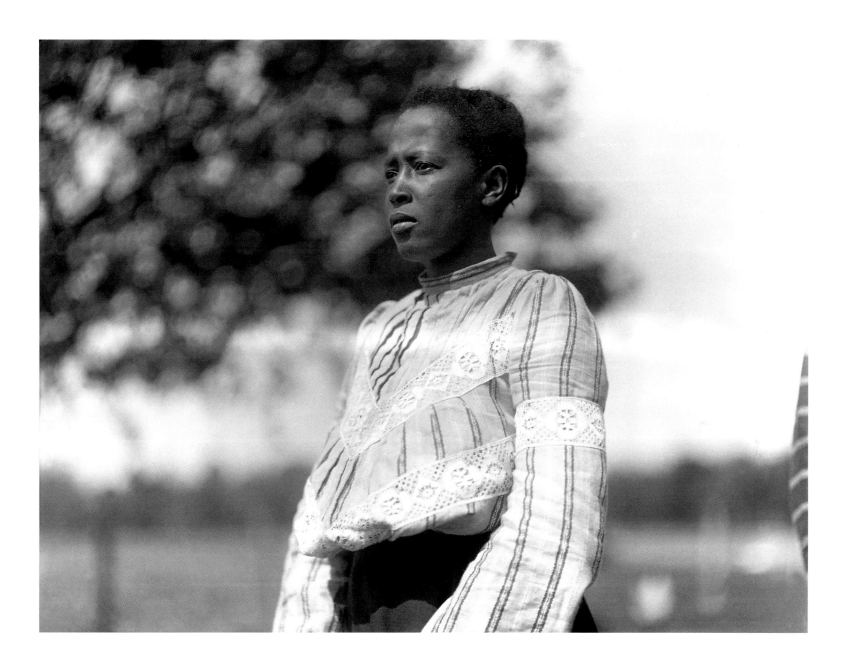

[Unidentified woman]. Hilton Head, April 9, 1904. (AMNH 48006)

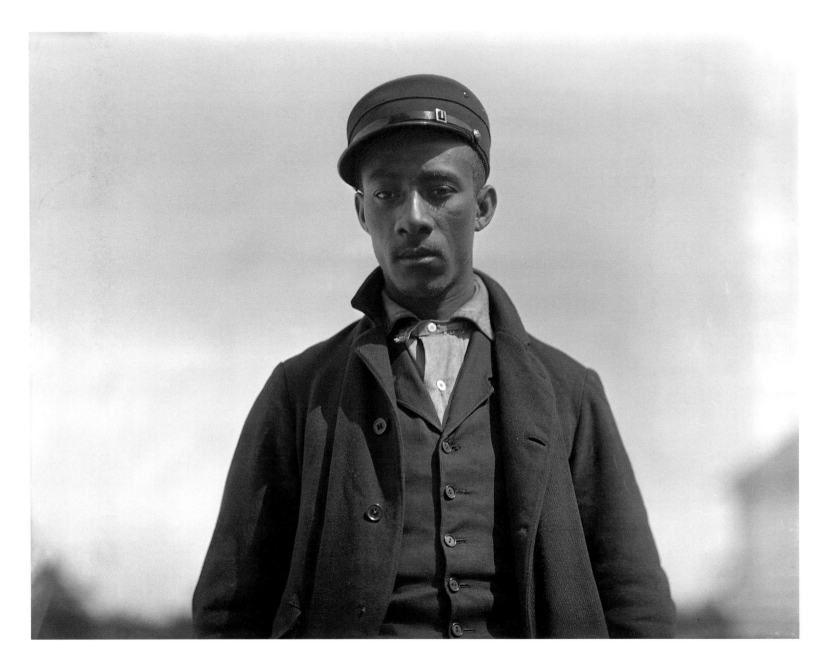

[Young man]. Hilton Head, April 9, 1904. (AMNH 47943)

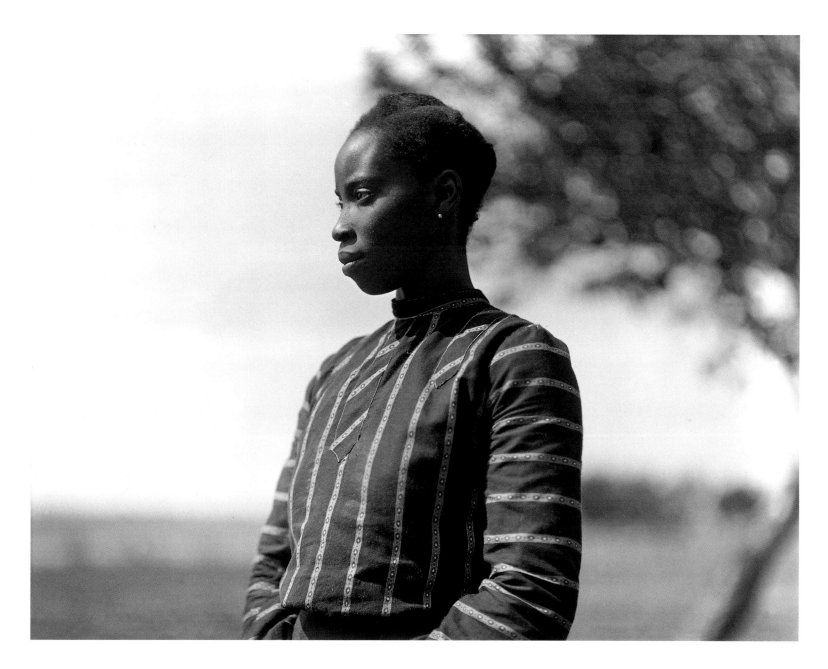

[Young woman]. Hilton Head, April 9, 1904. (AMNH 48007)

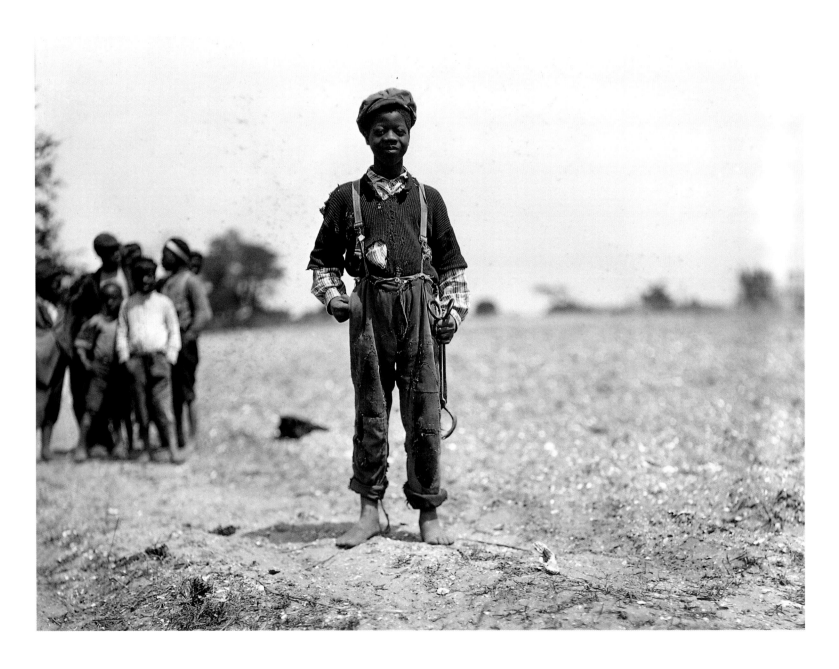

[Unidentified] boy. Hilton Head, April 10, 1904. (AMNH 47976)

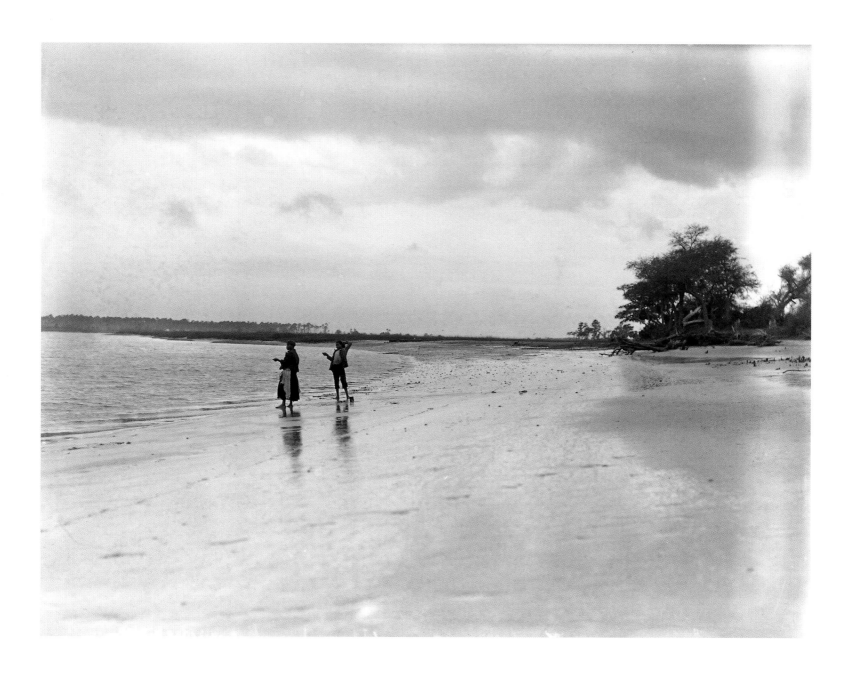

Boy and woman fishing. Hilton Head, April 9, 1904. (AMNH 47892)

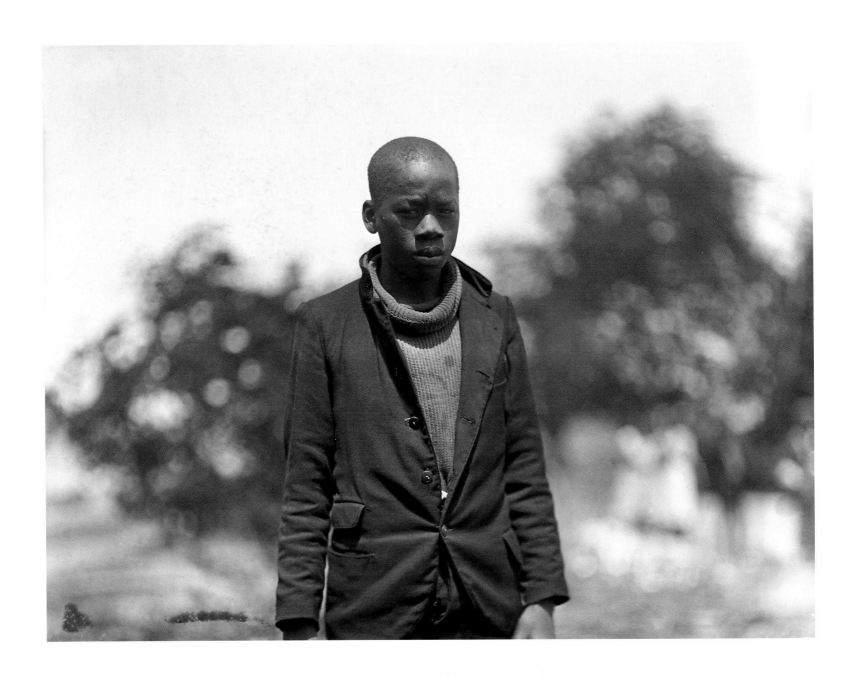

Albert Singleton. Hilton Head, April 10, 1904. (AMNH 47975)

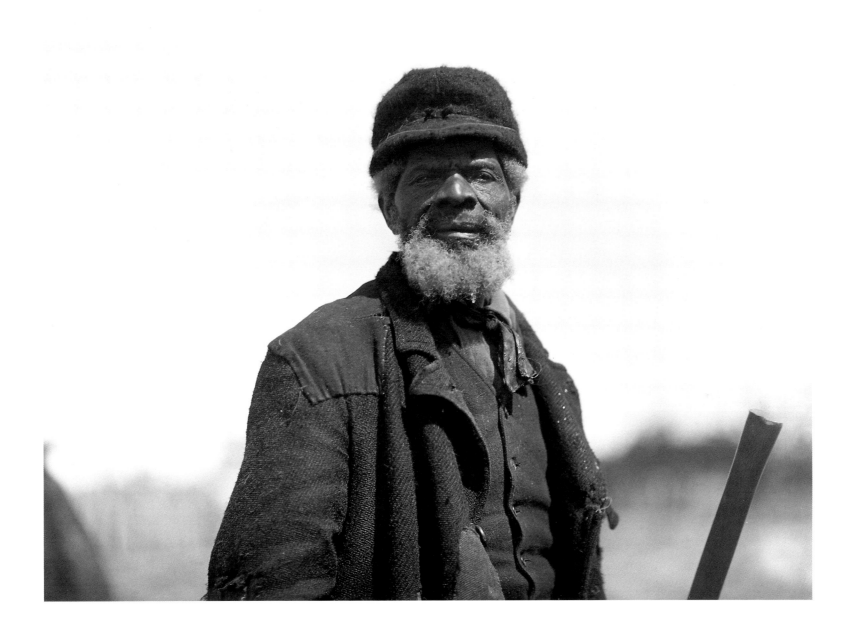

John Ford. Hilton Head, April 10, 1904. (AMNH 47944)

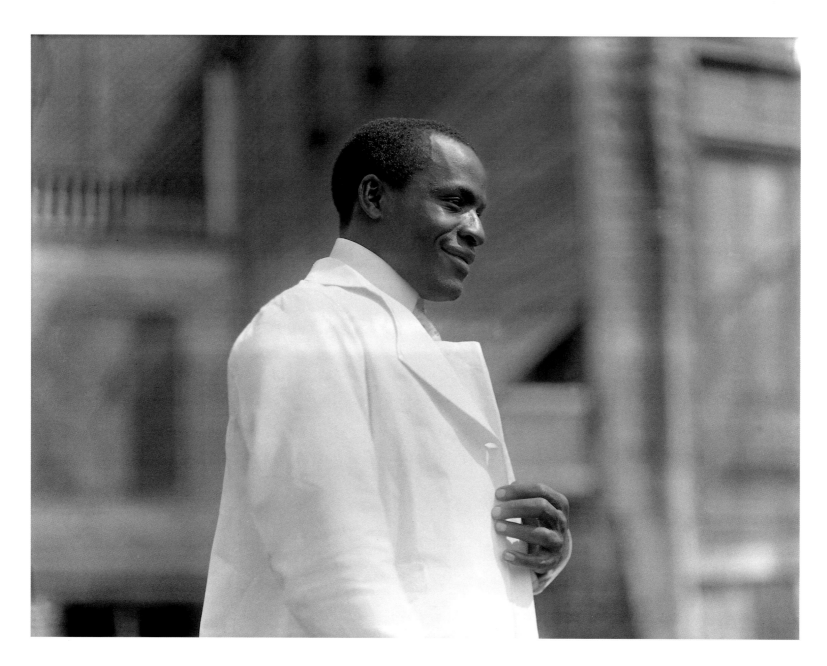

Nero. Beaufort, April 15, 1904. (AMNH 47946)

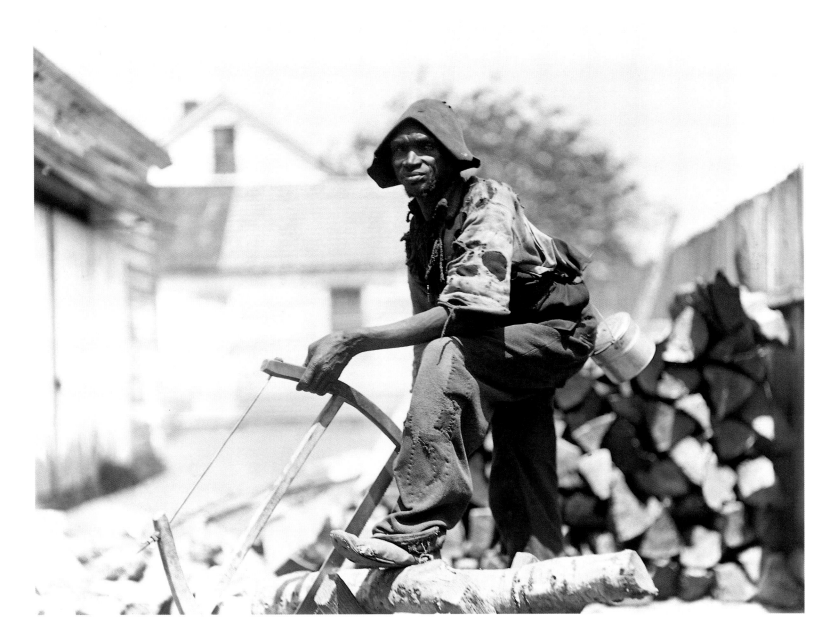

Sawyer. Beaufort, April 16, 1904. (AMNH 47897)

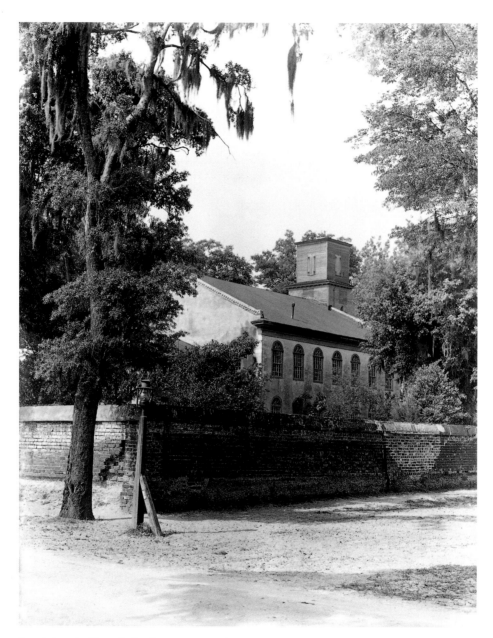

St. Helena's Church, built 1712. Beaufort, April 18, 1904. (AMNH 47834)

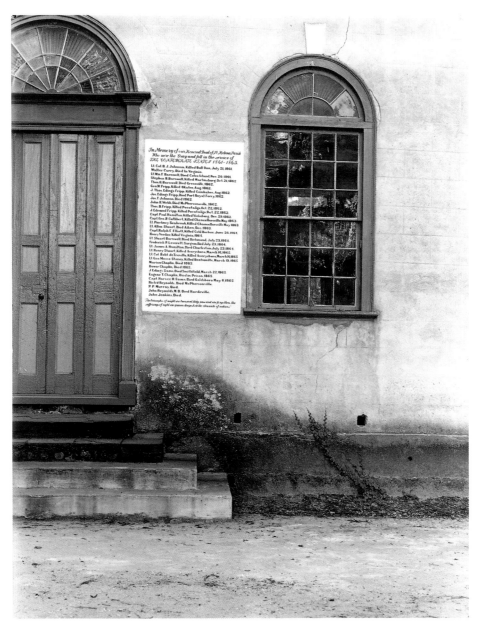

Tablet to boys in gray—St. Helena's [Episcopal Church]. Beaufort, April 18, 1904.
(AMNH 47835)

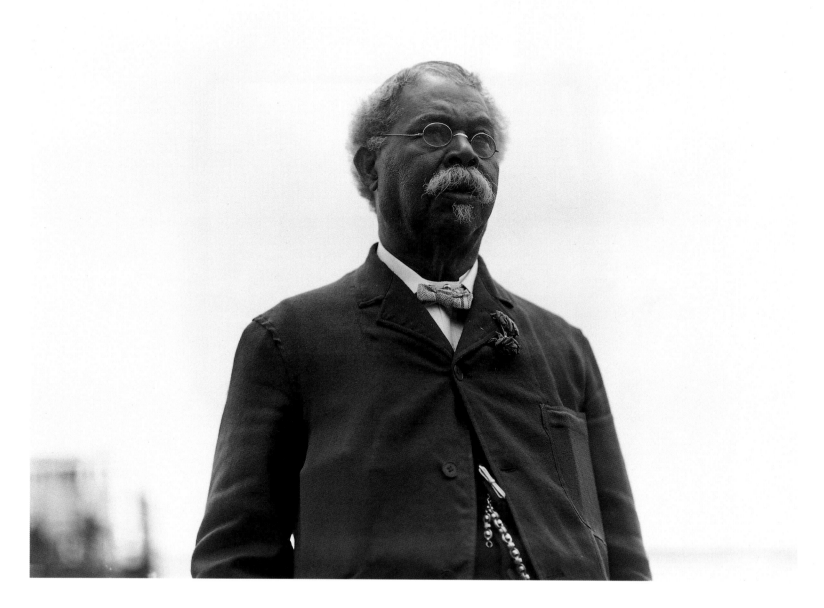

Robert Smalls—full face. Beaufort, April 23, 1904. (AMNH 47849)

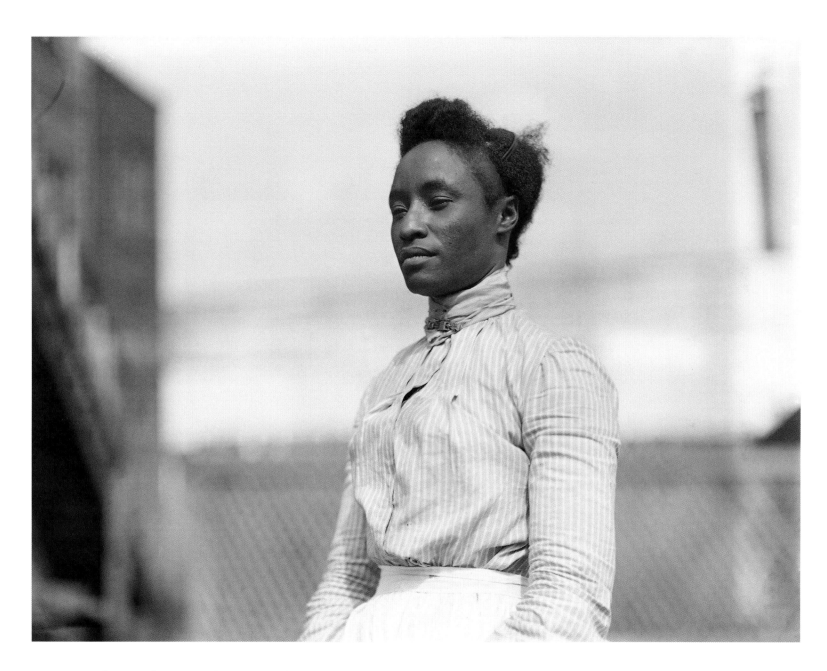

Nancy. Beaufort, April 27, 1904. (AMNH 48008)

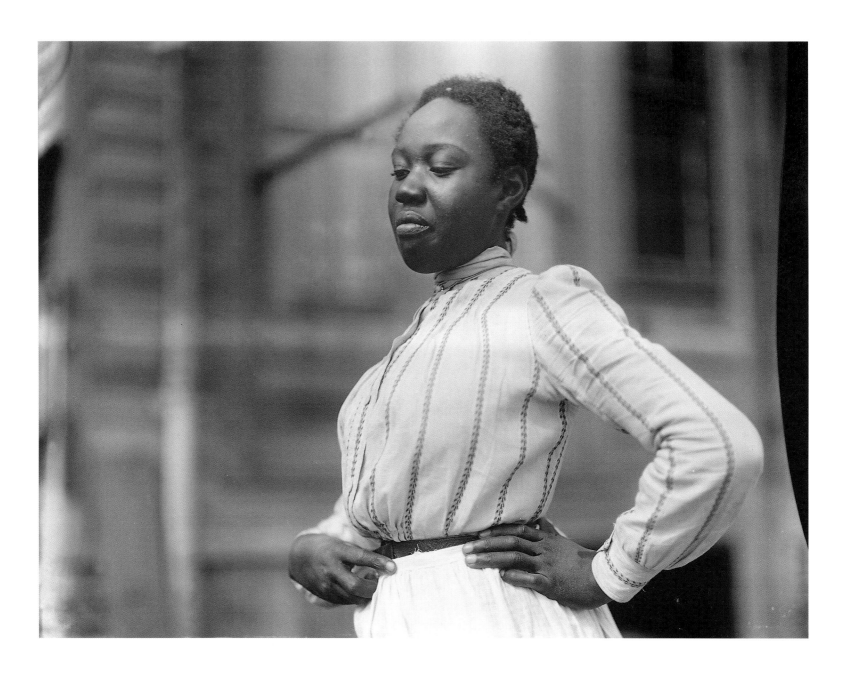

[Young woman]. Beaufort, April 27, 1904. (AMNH 48009)

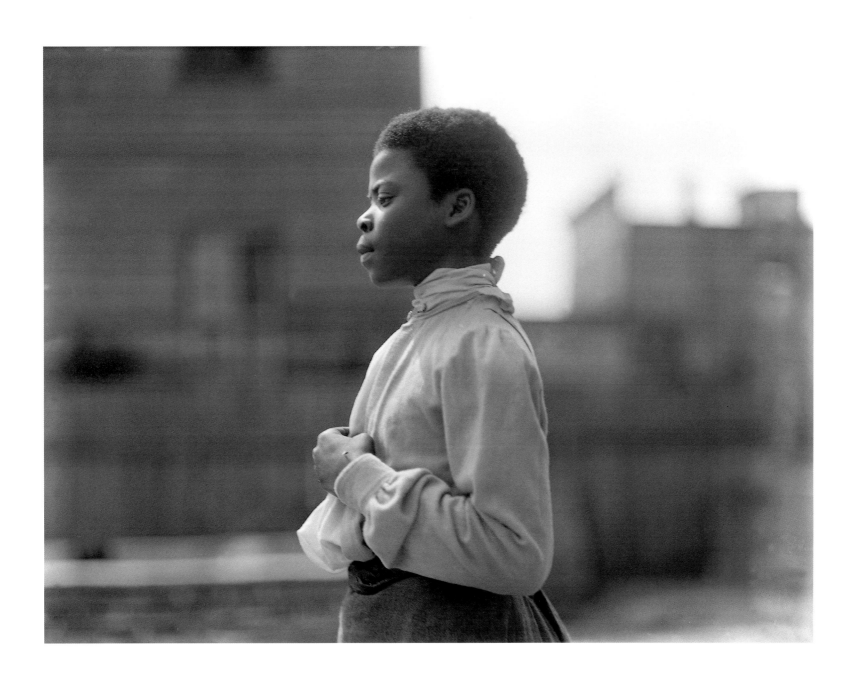

[Young] girl. Beaufort, April 27, 1904. (AMNH 48054)

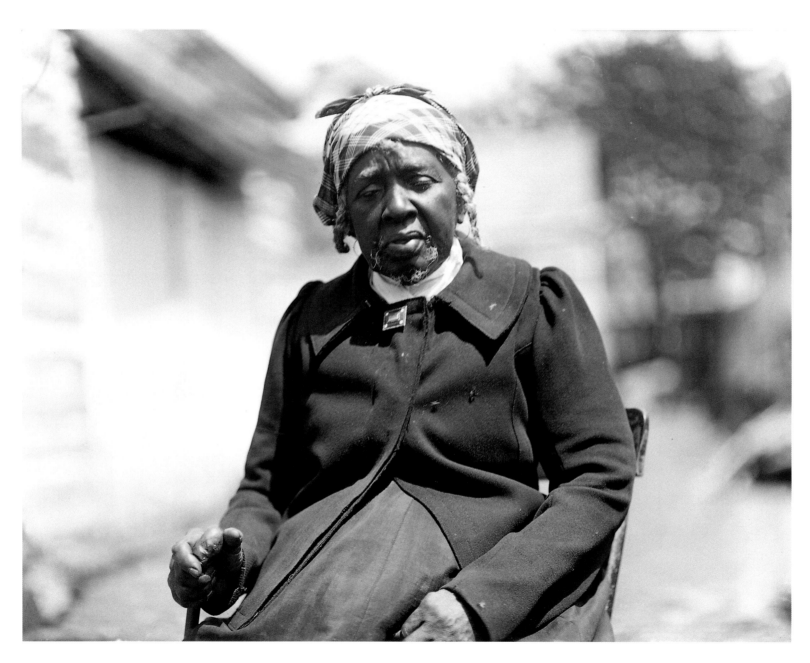

Old [nursemaid] (Mother Margaret). Beaufort, April 28, 1904. (AMNH 48010)

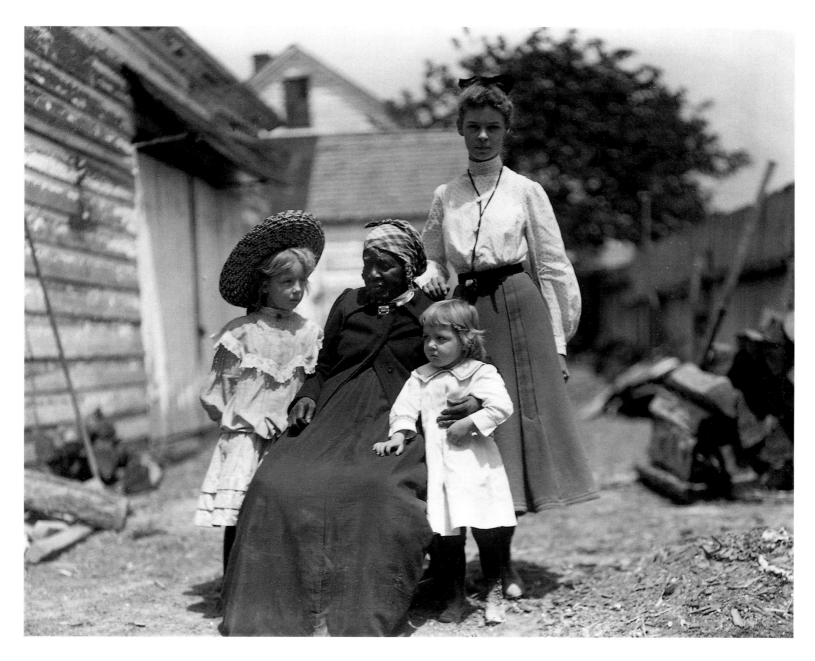

Old woman with 3 girls in front of cabin. [Beaufort, April 1904]. (AMNH 10226)

[Man seated in front of fireplace with book]. [Beaufort, April 29, 1904]. (AMNH 10214)

Old [nursemaid] and baby in front of fire. Beaufort, April 29, 1904. (AMNH 48016)

Rower. Beaufort, April 30, 1904. (AMNH 47900)

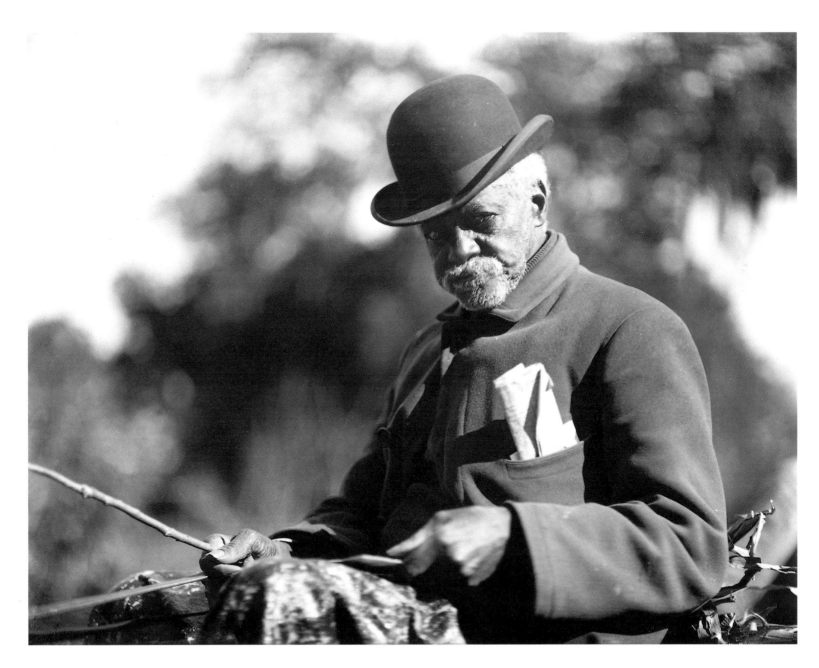

[The Honorable] Hastings [Gantt]. [Beaufort], November 17, 1905. (AMNH 47948)

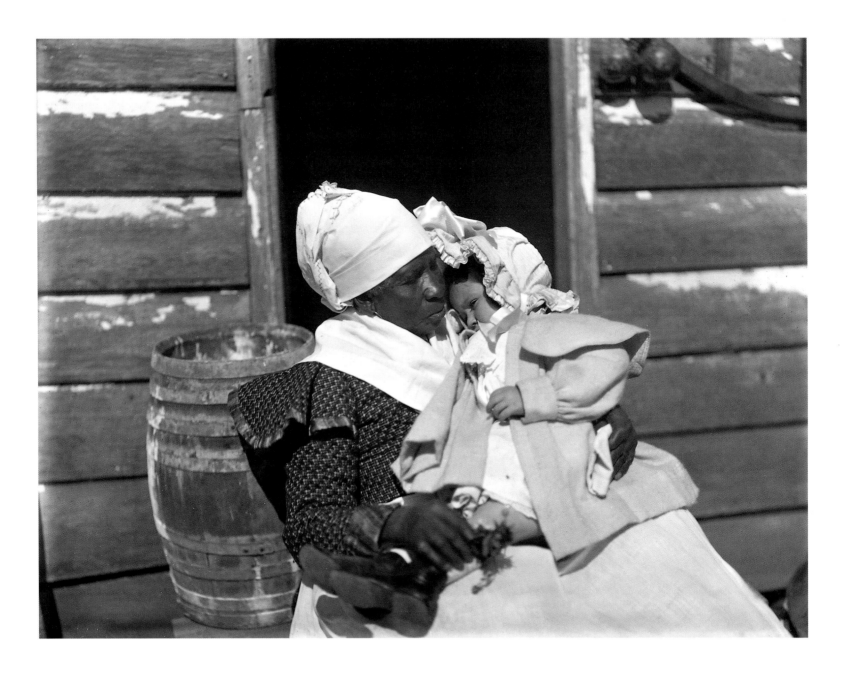

[Old nursemaid] and child in cabin door. [Beaufort], November 15, 1905. (AMNH 48030)

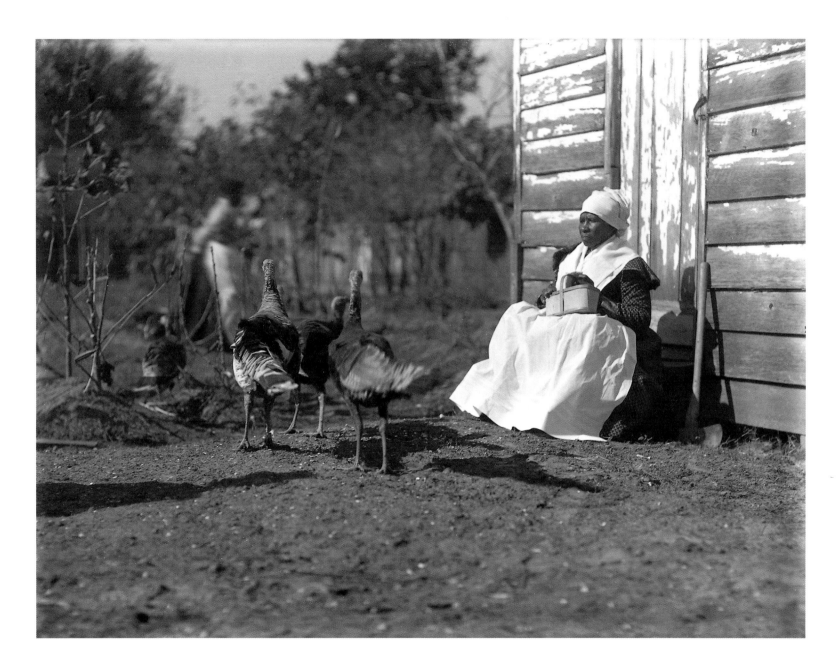

[Woman with basket] and turkeys. [Beaufort], November 15, 1905. (AMNH 48025)

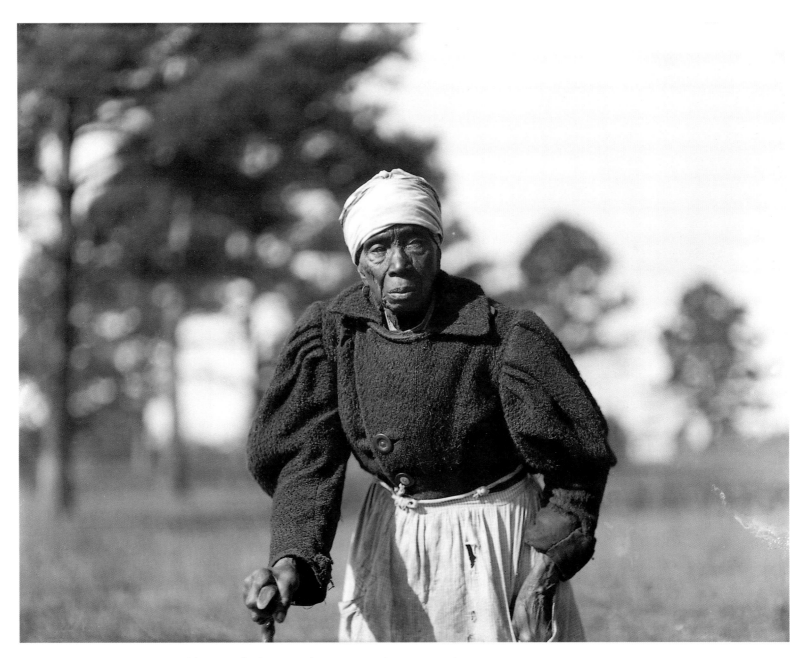

Tamar Blythwood (116 years old). [Beaufort], November 17, 1905. (AMNH 48038)

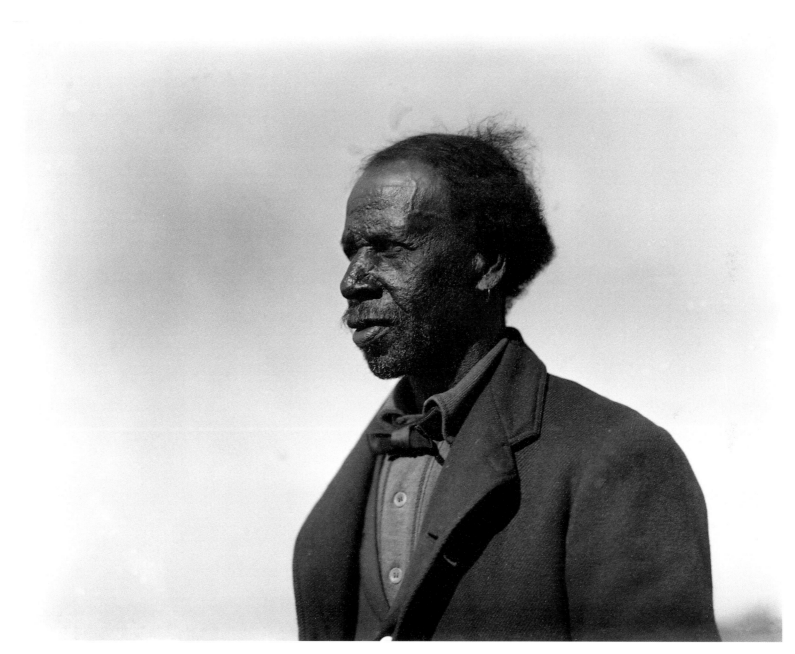

Bailey, age 65. [Beaufort], November 17, 1905. (AMNH 47949)

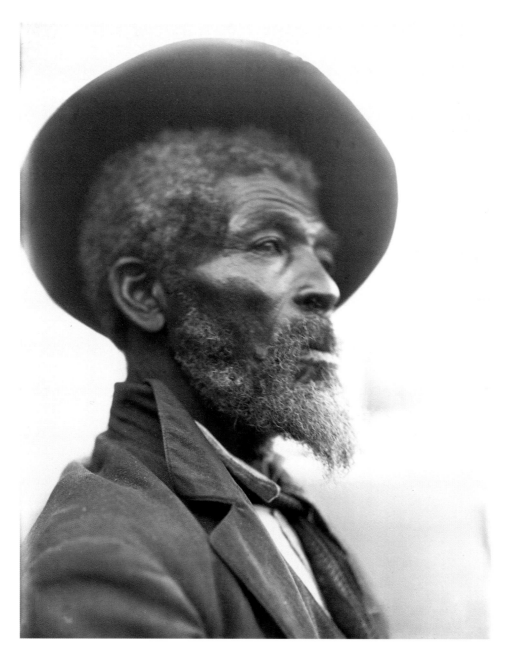

Typical house servant. [Beaufort], November 18, [1905]. (AMNH 47953)

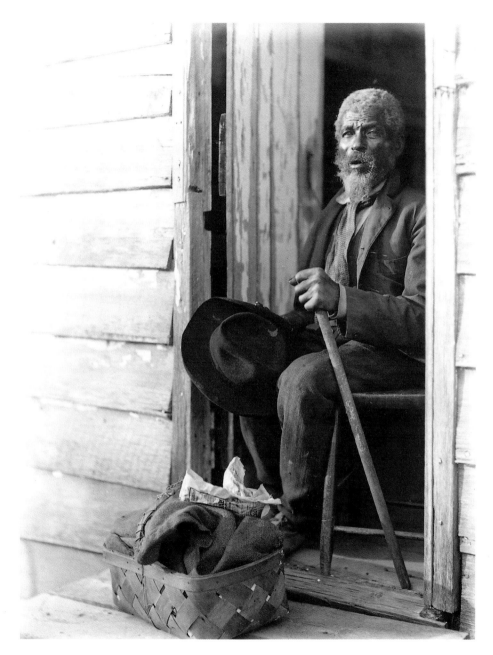

Old [man] in cabin door. [Beaufort], November 18, [1905]. (AMNH 47954)

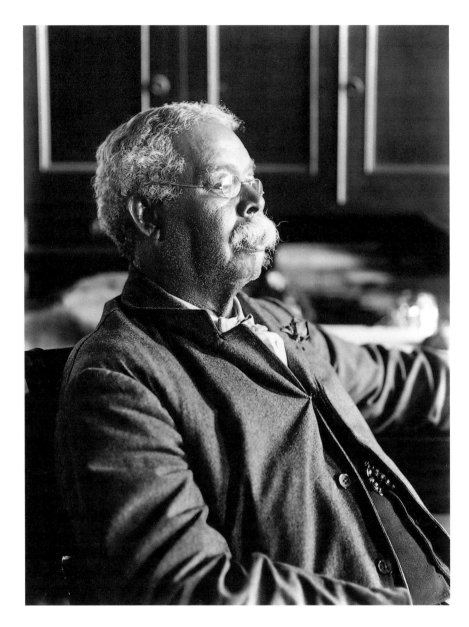

[Portrait of Robert Smalls]. [Beaufort, 1904 or 1905]. (AMNH 10184)

Afterword

LEON F. LITWACK

Few members of the middle class appear in Julian Dimock's remarkable photographic portrayal of black South Carolina in the early twentieth century. That is as it should be, as very few blacks belonged to that class. The photographs depict a hardworking people—men, women, and children, many of them laboring at unrewarding tasks such as tilling the soil, making and gathering crops for the enrichment of others. Most of them would spend their lives in relative obscurity, never sharing equitably in the fruits of their labor or enjoying even a semblance of power. They struggled, worked, tried to educate themselves, and sought ways to temper their accommodation to the racial order. Whatever some of the photographs may suggest of a carefree and contented existence, it was never easy. The prospects for rising out of their condition were bleak, as this bluesman would suggest:

> Can't tell my future, I can't tell my past.
> Lord, it seems like every minute sure gon' be my last.
> Oh, a minute seems like hours, and hours seems like days.
> Yes, minutes seems like hours, hour seems like days.[1]

Although his photographs of black South Carolinians take on an almost timeless quality, Julian Dimock came to the state at a fateful moment in its history, when a new generation of black men and women—the sons and daughters, the grandsons and granddaughters of once enslaved African Americans—was coming to maturity. Responding to growing doubts that this generation, born in freedom, undisciplined by slavery, and unschooled in racial etiquette, could be trusted to stay in its place without legal and extralegal force, South Carolina, along with the rest of the South, denied blacks a political voice, imposed rigid patterns of segregation (Jim Crow), sustained an economic system—sharecropping and tenantry—that left little room for hope or ambition, and refused blacks equal educational resources ("enforced ignorance"). At the same time, popular culture, pseudoscientific theories, and published nostalgic reminiscences of slavery days reinforced and comforted whites in their racial beliefs and practices.

The criminal justice system (the law, the courts, the lawyers and judges) operated with ruthless efficiency in upholding the absolute power of whites to command the subordination and labor of blacks. No wonder blacks came to view the courts as instruments of injustice and those convicted in them as victims, if not martyrs. "Dere ain' no use," a black resident of Richland County reflected. "De courts er dis land is not for niggers. . . . It seems to me when it come to trouble, de law an' a nigger is de white man's sport, an' justice is a stranger in them precincts, an' mercy is unknown." The Bible, he noted, asked people to pray for their enemy, and so he offered up this prayer: "Drap on you' knee, brothers, an' pray to God for all de crackers an' de judges an' de courts an' solicitors, sheriffs an' police in de land."[2]

As this South Carolinian suggested, the perversion of justice had become a lasting legacy of the New South. In the name of law and justice, whites (including those sworn to uphold and

enforce the law) made a mockery of law and justice. The legal system was only one mechanism in the arsenal of white power, but it proved to be a critical and formidable instrument of social control. Unequal justice interacted with disfranchisement, segregation, economic exploitation, inferior schooling, and violence to remind blacks of all ages and classes of where power rested in this society.

How to respond to this repressive apparatus assumed an urgency in black South Carolina. The strategy of hard work, uplift, and accommodation propounded by black ministers, editors, and leaders did little to win for blacks the respect and recognition of white society. No matter how hard they labored, no matter how they conducted themselves, no matter how fervently they prayed, the chances for making it were less than encouraging; the basic rules and controls remained in place.

> *Our father, who is in heaven,*
> *White man owe me eleven and pay me seven,*
> *Thy kingdom come, thy will be done,*
> *And if I hadn't took that, I wouldn't had none.*[3]

From their first days of freedom, black men and women had been forcibly reminded that lofty ambitions and evidence of advancement might be resented rather than welcomed by whites. The obstacles black people faced were exceptional, unlike those faced by any group of immigrants. While maintaining that blacks were incapable of becoming their social, political, or economic equals, the dominant society betrayed the fear that they might. What alarmed white South Carolinians during Reconstruction, when blacks commanded substantial political power, was not evidence of black failure but evidence of black assertion, independence, and advancement: black men in positions of authority; black men learning the uses of political power. The closer the black man got to the ballot box, the more he looked like a rapist.

Black leaders were never able to surmount this paradox. Even as whites scorned black incompetence, many of them feared evidence of black competence and independence. Even as whites derided blacks for their ignorance, they resented educated, literate, ambitious, and successful blacks. The Negro as a buffoon, a menial, or a servant was acceptable; that kind of Negro threatened no one. The historical record is replete with examples of violence and harassment aimed at successful blacks—those in positions of leadership, those who owned farms and stores, those suspected of saving their earnings, those trying to improve themselves, those perceived as "trying to be white."

What happened to Anthony Crawford in Abbeville, South Carolina, in the early twentieth century would be a grim reminder of how whites might respond to black success or ambition. Born of slave parents in 1865, Crawford had become a substantial landowner and farmer in Abbeville; he had twelve sons and four daughters, most of them living nearby. As secretary of the local African Methodist Episcopal Church, he was a pivotal figure in the black community. Few blacks—or whites—had done more in South Carolina to embrace the gospel of self-help. "Anthony Crawford's life and character," one observer noted, "embodied everything that Booker T. Washington held to be virtuous in a Negro." On October 21, 1916, Crawford came to town to sell his cotton. He exchanged harsh words with a local white businessman over the offering price. When a store clerk wielding an ax handle went after Crawford, he backed

away, only to be arrested and placed in jail, securing him initially from a white mob angry over his reported insolence. "When a nigger gets impudent we stretch him out and paddle him a bit," the store manager boasted. The president of the National Bank of Abbeville concurred, "Crawford was insolent to a white man and he deserved a thrashing."

Released on bail, Crawford headed toward the gin where his cotton was waiting. The white mob quickly regrouped and attacked him. Crawford resisted, injuring one of the whites, but the men finally overpowered him and kicked him until he had lost consciousness. The sheriff persuaded the mob to permit him to regain custody of Crawford. From his cell, Crawford was heard to say, while spitting blood where they had kicked out his teeth, "I thought I was a good citizen." But by not displaying "the humility becoming a 'nigger,'" he had become vulnerable. When a false rumor circulated that Crawford might be moved to another jail, the mob mobilized again and easily entered the jail. After shoving Crawford's broken body down three flights of stairs, they mutilated him; dug their heels into his upturned, quivering face; tied a rope around his neck; and dragged him through the streets of the Negro quarter as a warning. Finally, they hung him from a pine tree and emptied their guns into his body. Dutifully, the coroner convened a jury that quickly reached the verdict that Anthony P. Crawford had come to his death at the hands of parties unknown. A subsequent meeting ordered the remainder of the Crawford family to leave town within three weeks.

A leading South Carolina newspaper had little difficulty in ascertaining the principal reason for Crawford's murder. "Crawford was worth around $20,000 and that's more than most white farmers are worth down here. Property ownership always makes the Negro more assertive, more independent, and the cracker can't stand it." But the citizens of Abbeville, regardless of class, demonstrated by their action—and inaction—not only extraordinary cowardice but their own complicity in the crime. Pointing to the tree where Crawford was hanged, a resident remarked, "I reckon the crowd wouldn't have been so bloodthirsty, only its [sic] been three years since they had any fun with the niggers, and it seems though they jest have to have a lynching every so often."

The governor and many of the state's leading newspapers condemned the Crawford murder. Some expressed concern over the migration of blacks to the North. Some even expressed misgivings about civilization and justice in South Carolina.

> If Crawford was a "Bad Negro," if he had been implicated in murders, assaults or barn burnings it has not been reported. If he was a disturbing factor in his community, if he delivered incendiary speeches, if he stirred his race to animosity towards the whites, if he was in any way notorious or criminal or had been guilty of any offense prior to the day that he was killed, it has not been so reported to the press of Abbeville or of the State.
>
> The only defense set up even by implication, as far as the public is informed, for the lynching of Crawford is that a Negro who uses insulting language to a white man and then fights back when attacked is worthy of death and should be forthwith hanged without process of law, though he is in the custody of the law, in jail, and sorely wounded.

The governor, the newspapers in the state capital, and the local businessmen who hurriedly met to dissociate themselves

from the crime did not necessarily speak for the white people of Abbeville—or South Carolina, for that matter. Given the nature of the crime and the absence of any indictments, the sentiments expressed in a local newspaper perhaps came closer to capturing the dominant public mood. "His wealth and coddling from white men desiring his trade, emboldened him to assume an equality that the whites will not tolerate." The "immediate cause" of the lynching was, in fact, irrelevant to the larger issue. "The 'best people' of South Carolina know that when white men cease to whip, or kill negroes who become obnoxious, that they will take advantage of the laxity, and soon make this state untenable for whites of ALL kinds, and that under such conditions the 'best' will be 'like the worst, and the worst like the best.' The point here made is, that no matter who actually killed Crawford, the responsibility for his death rests upon us ALL ALIKE, and because of his own reckless course, due to chest inflation from wealth, it was inevitable and RACIALLY JUSTIFIABLE."[4]

For black Carolinians, the meaning of the Crawford lynching and its consequences were self-evident. "Our people are restless, more so now, than I have ever known them," a black clergyman informed a white editor. "Their property has been taken from them. In some sections of South Carolina and Georgia, the Negroes have been made to leave their property. Those poor, hardworking men, sons of Anthony Crawford of Abbeville, have only the 15th of this month to get away. They will leave 50 bales of cotton in the field; the father left 560 acres of land paid for; $300 would have paid all his debts."[5]

This was the South Carolina Julian Dimock visited briefly and recorded so poignantly with his camera. Based on the photographs alone, the repressive apparatus of white supremacy would hardly be apparent. The photographs depict a people at work and play, going about their daily chores, trying to enjoy the personal and family experiences life has to offer. To survive, they knew, was to veil from whites their inner feelings, to wear the mask. The photographs do not depict the signs ("FOR WHITE ONLY," "FOR COLORED ONLY") that would soon punctuate the South Carolina landscape, that would instruct blacks as to where they could legally walk, sit, rest, eat, drink, and entertain themselves. Five years before Dimock visited Beaufort, a judge presiding over a session of court noted that whites and blacks were sitting together on the courtroom benches and ordered that they be separated. "God Almighty never intended," he declared, "that the two races should be mixed."[6]

The demands made by Jim Crow worked their way into the daily routines and thoughts of black South Carolinians; this is how a new generation would be initiated into the meaning of blackness and freedom. "There wasn't much going for the Negro in the world in which I was born," Benjamin Mays recalled of his childhood in rural South Carolina. "Long before I could visualize them, I knew within my body, my mind, and my spirit that I faced galling restrictions, seemingly insurmountable barriers, dangers and pitfalls. . . . In this perilous world if a black boy wanted to live a halfway normal life and die a natural death he had to learn early the art of how to get along with white folks."[7] For all blacks, whatever their age, education, or social class, Jim Crow was a daily affront, a reminder of the distinctive place "white folks" had marked out for them, a confirmation of their inferiority and baseness in the eyes of the dominant population. What whites insisted on was not so much separation as subordination, a system of controls in which whites prescribed

the rules of racial conduct and contact and meted out the pun-
ishments.

Although Dimock's photographs capture a variety of black
faces and moods, they can provide little insight into how black
people responded to the Jim Crow laws and the spirit in which
they were enforced. One black sighed, "There is no wonder that
we die, the wonder is that we persist in living."[8] What made the
repression so difficult for a new generation of black South
Carolinians was the experience of being forced to watch family
members and friends humiliated and abused with no opportu-
nity to afford them protection or to retaliate. Benjamin Mays
looked on helplessly in 1898 as a crowd of armed white men
rode up to his father, cursed him, drew their guns, and forced
him to remove his hat and bow down to them. "I was not yet
five years old, but I have never forgotten them. That mob is my
earliest memory."[9]

But if Dimock's photographs fail to depict the repression and
violence that circumscribed black life, they do suggest, often
quite eloquently, how black South Carolinians endured, the ex-
traordinary resourcefulness, spirit, and resiliency they displayed.
Under severe constraints, they created a world of their own "be-
hind the veil," as W. E. B. Du Bois described it, and found ways
to respond to their situation. In the face of white hostility, they
drew inward, constructing in their communities a separate
world, a replica of the society that excluded them. Evidence of
this response may be found at all levels, as in the families they
maintained, the institutions they created, the schools they
worked so hard to sustain, the businesses they established, the
churches they attended, the voluntary associations that afforded
them important outlets and support, and their cultural life. The
interior life suggested in these photographs, largely unknown
and incomprehensible to whites, permitted black men and
women not only to survive but to persist. The story of black
South Carolina is the story of how a people confronted and
sought to transcend their plight, and the daily struggles they
waged to wrest some meaning and value out of their working
lives.

Denied access to the political process, limited in what they
could acquire in the schools, and dehumanized in popular cul-
ture, black men and women were compelled to find other ways
to express their deepest feelings and to demonstrate their indi-
vidual and collective integrity. What helped to sustain them was
a rich oral expressive tradition—some of it revealed in these
pages—consisting of folk beliefs, proverbs, humor, sermons,
spirituals, gospel songs, hollers, work songs, and the blues.
Through such expression, black men and women conveyed not
only their disillusionment, alienation, and frustration, but their
joys, aspirations, triumphs, and expectations. "How much his-
tory can be transmitted by pressure on a guitar string?" Robert
Palmer asks in *Deep Blues,* and he answers, "The thought of gen-
erations, the history of every human being who's ever felt the
blues come down like showers of rain."[10]

What white South Carolina lost on the battlefields of the
Civil War and during Reconstruction, it would largely retake in
the late nineteenth and early twentieth centuries. By the time
Julian Dimock arrived, camera in hand, the various components
of white supremacy were already in place, and the results were
readily apparent: a black and white South Carolina, separate and
unequal. If the Civil War was fought over the meaning of free-
dom, the struggle to define that freedom would persist to the

present day. If the flag of the Confederacy was to become a part of South Carolina's heritage, so too were the slave pens, the lynch mobs, the public burnings, the Jim Crow signs, enforced ignorance, and inferior justice.

Since the Civil War, black men and women had viewed movement as a vital expression of their new freedom—away from where they were living and working, if not always toward a clearly defined destination. In South Carolina, as in much of the South, large numbers of blacks grimly considered their prospects and came to view their condition as one of social and economic stagnation. One migrant who left St. Helena Island in 1911 at the age of nineteen put it this way: "Young people is more restless than old people. . . . Young people grow up now and say, 'I want to get 'way from heah. No diggin' in the sile [mud] fo' me. Let other man do the diggin'. I'm through with farmin'.'" Still another migrant, who left at the age of fifteen, testified, "I never could see why the white people in the South want to keep their feet on the necks of the blacks. They want the Negroes to stay down here, but they want them to stay *down*. They won't give a good man a chance. . . . God knows a change is gonna be made, and if the South don't realize it, they gonna wake up n' find all the niggers gone."[11]

After their brief sojourn in 1904 and 1905, the Dimocks returned to their home in the North. Within the next several decades, many of the subjects they had photographed in Columbia and Beaufort would make a similar trek, seeking a new life, a chance to begin again in places where freedom was said to be "freer" and where black men and women could "live with a little less fear." The notion that they might aspire to the American Dream by remaining where they were became far less credible with time and experience. That dream was clearly for white folks only. Perhaps, Benjamin Mays reflected, America would prove to be larger than South Carolina:

> Everything I had seen, and most of what I had heard, should have convinced me that the white man was superior and the Negro inferior. But I was not convinced; I was bothered; I was haunted night and day. I once startled my saintly mother by telling her that if I thought that God had deliberately made me inferior I would pray no more. I did not really believe that God had done this to me, but I knew I could never find out in South Carolina.
>
> I certainly didn't know what, when, how, or where, but before finishing high school I hoped that someday I would be able to do something about a situation that had shadowed my early years and had killed the spirit of all too many of my people.[12]

How, Mays wondered, could he "be somebody" in a society that frowned on blacks aspiring to be anybody? He had come to realize that those who "grinned, cringed, and kowtowed" to whites faced the same dangers as the few who refused to do so. He knew, too, that whites were superior to him only in their ability to wreak violence on his people. By the age of nineteen, Mays chose to act on his feelings, having concluded that he could never be what he hoped to be if he remained in the state depicted in Julian Dimock's photographs. "I had to seek a new world," Mays said. So did tens of thousands of black South Carolinians.[13]

1. Willie Brown, "Future Blues," in *Masters of the Delta Blues: The Friends of Charlie Patton,* Yazoo CD 2002.

2. E. C. L. Adams, *Nigger to Nigger* (New York: Charles Scribner's Sons, 1928), 108–9.

3. Sterling Brown, "Negro Folk Expression: Spirituals, Seculars, Ballads, and Work Songs," *Pylon* 14 (1953): 52.

4. This account is drawn from NAACP Papers, Manuscript Division, C 343,364, Library of Congress. Within this collection, see [Roy Nash], "The Lynching of Anthony Crawford," [1916]; W. T. Andrews, attorney-at-law, to W. E. B. Du Bois, Sumter, S.C., 26 October 1916; *Abbeville (South Carolina) Scimitar,* 1 February and 15 February 1917; and *New York Evening Post,* 23 November 1916.

5. Richard Carroll to W. W. Ball, managing editor, *The State,* Columbia, S.C., 9 November 1916, W. W. Ball Papers, Duke University Library; W. W. Ball, MS Diary 2, 3 November 1916, W. W. Ball Papers. In this diary entry, Ball recounts a visit from one of Crawford's sons to seek advice about leaving and getting protection: "I could only advise him to employ a lawyer of courage and intelligence and to follow the lawyer's direction. I expressed, though, the opinion that the family, failing to leave November 15, would not be molested."

6. George B. Tindall, *South Carolina Negroes,* 1877–1900 (Columbia, S.C.: University of South Carolina Press, 1952), 302.

7. Benjamin E. Mays, *Born to Rebel: An Autobiography* (New York: Charles Scribner's Sons, 1971), 22, 35.

8. "The Negro Problem," *New York Independent,* 18 September 1902.

9. Mays, *Born to Rebel,* 1.

10. Robert Palmer, *Deep Blues* (New York: Viking Press, 1981), 277.

11. Clyde Vernon Kiser, *Sea Island to City: A Study of St. Helena Islanders in Harlem and Other Urban Centers* (New York: Columbia University Press, 1932), 131, 137–38.

12. Mays, *Born to Rebel,* 49.

13. Ibid.

Bibliography

WORKS BY JULIAN A. DIMOCK

"After Tarpon with a Camera." *Country Life* 9 (February 1906): 401–5.

"Capturing the Crocodile." *Scientific American* 66 (September 1903): 156.

"Crocodiling with a Camera." *American Magazine* 61 (January 1906): 269–79.

"A Crusade and What Came of It." *Country Life* 13 (January 1908): 422.

"Double Spin of Crop Rotation." *Country Life in America* 31 (November 1916): 52.

"Egret Murder: A Protest and a Crusade." *Country Life* 11 (February 1907): 418–20.

"Ellis Island as Seen by the Camera-Man." *World To-Day* 14 (April 1908): 394–96.

"The Farm Horse Doesn't Pay." *Independent* 86 (1916): 337.

Florida Enchantments. New York: Macmillan, 1908.

"Following the Winter Road through Vermont." *Travel* 26 (February 1916): 13–15.

"Herons of Florida." *Country Life* 13 (February 1908): 434.

"Hunt for Baby Alligators." *Outlook* 85 (March 23, 1907): 681–86.

"In the Country of the Navaho." *Travel* 25 (October 1915): 29–32.

"In the Everglades—with Camera and Canoe." *Outlook* 86 (May 25, 1907): 181–89.

"In the Land of Railroad Ties." *Travel* 27 (October 1916): 30–32.

"Mangrove as an Island Builder." *Country Life* 9 (November 1905): 40–41.

"New Americans: Photographs." *World To-Day* 14 (April 1908): 337–42.

New Business of Farming. New York: Frederick Stokes, 1918.

"On Runners to Matowan." *Travel* 27 (September 1916): 14–16.

Outdoor Photography. New York: Outing, 1912.

"Sleighing through Vermont." *Travel* 24 (January 1915): 22–24.

"Summer Florida Vacation." *Country Life* 8 (July 1905): 345.

"Three Weeks out of Glo'ster." *Travel* 24 (February 1915): 17–19.

"True Tales of the Northern Frontier." Parts 1–7. *Country Life* 25 (November 1913): 35–38; (December 1913): 46–48; 26 (January 1914): 43–45; (February 1914): 42–43; (March 1914): 45–47; (April 1914): 43–45; (July 1914): 43–45.

"Where Skill Matches Danger; Photographs." *American Magazine* 62 (August 1906): 365–79.

"Where the Tarpon Leaps." *Travel* 23 (June 1914): 9–13.

"Why I Turned Farmer." *New Country Life* 33 (January 1918): 56–57.

"With a Hudson's Bay Dog Team." *Travel* 27 (August 1916): 14–16.

WORKS ILLUSTRATED WITH JULIAN DIMOCK'S PHOTOGRAPHS

Dimock, Anthony W. "Adventures on Skees and Snowshoes." *Country Life* 19 (December 15, 1910): 185–88.

———. "Alligator Hunter in the Making." *Country Life* 16 (September 1909): 487–90.

———. "American Pantheon of the Gods." *Travel* 16 (November 1910): 30–33.

———. "Art of Catching the Manatee." *Century* 73 (April 1907): 848–53.

———. "Baby Moose." *Country Life* 18 (May 1910): 49–50.

———. *Be Prepared: Or Boy Scouts in Florida.* New York: Grosset and Dunlop, 1912.

———. "Bismark." *St. Nicholas* 32 (June 1905): 740–41.

———. *Book of the Tarpon.* New York: Outing, 1911.

———. "Bronco Busting and the Cow-pony." *Country Life* 8 (May 1901): 45–48.

———. "Camera Adventures." *Outing* 59 (December 1911): 365–72.

———. "Chase of the Dolphin." *Country Life* 11 (January 1907): 291–97.

———. "Crossing the Everglades in a Power-Boat." *Harper's* 114 (January 1907): 213–20.

———. "Cruising on the Gulf Coast of Florida." *Harper's* 114 (March 1907): 52–58.

———. "Daily Tragedies of the North Woods." *Country Life* 21 (December 1, 1911): 37–41.

———. "A Despoiled People." *Outlook* 97 (January 28, 1911): 201–6.

———. *Dick among the Lumber Jacks.* New York: Stokes, 1910.

———. *Dick among the Seminole Indians.* New York: Stokes, 1913.

———. *Dick in the Everglades.* New York: Stokes, 1909.

———. "Dolphin's Pedigree." *Country Life* 11 (January 1907): 734.

———. "Harpooning the Tarpon." *Outing* 58 (July 1911): 394–482.

———. "Indians Past and Present." *Outing* 52 (July 1908): 436–47.

———. "In the Depths of the Everglades." *Travel* 16 (January 1911): 116–19.

———. "Intimate Study of the Mangrove in Florida." *Country Life* 9 (November 1903): 92.

———. "King Tarpon, the High Leaper of the Sea." *Outing* 53 (March 1909): 703–17.

———. "Lay of the Loggerhead." *Country Life* 15 (April 1909): 612–14.

———. "Life in a Bird Rockery." *Harper's* 115 (July 1907): 262–69.

———. "Love of Napoleon and Marie Borriere." *Country Life* 17 (February 1910): 398–404.

———. "Man and His Job." *Country Life* 17 (January 1910): 157–60.

———. "New Florida." Parts 1–4. *Country Life* 19 (November 1910): 33–36; (December 1910): 136–42; (January 1911): 219–22; (February 1911): 279–81.

———. "On to Marco Pass." *Outing* 53 (January 1909): 397–412.

———. "Our Lady of the Lakes." *Outing* 55 (December 1909): 370–81.

———. "Overlooked River in Florida." *Travel* 13 (November 1907): 65–67.

———. "Passing of a Wilderness." *Scribner's Magazine* 41 (March 1907): 358–64.

———. "Passing of the Florida Alligator." *Harper's* 116 (April 1908): 669–76.

———. "Professor and the Prairie Schooner." *Outing* 57 (January 1911): 387–97.

———. "Real Wild-West Show." *Harper's Weekly* 50 (December 8, 1906): 1746–48.

———. "River-Driver of Quebec." *Country Life* 17 (April 1910): 683–87.

———. "Salt Water Fly-Fishing." *Country Life* 13 (January 1908): 303–6.

———. "Southern Industrial Experiment." *Harper's* 111 (July 1905): 302–8.

———. "Sport of Tarpon-Fishing." *Harper's Weekly* 50 (November 3, 1906): 1572–74.

———. "A Story of the Sea Islands. *Outlook* 79 (February 1905): 291–98.

———. "Tarpon and the Movies." *Outing* 64 (June 1914): 265–76.

———. "Tarpon of Turner's River." *Outing* 58 (June 1911): 359–61.

———. "The South and Its Problems." *Metropolitan Magazine* 27 (October 1907): 1–11.

———. "Turkey Tracks in the Big Cypress." *Outing* 55 (October 1909): 13–21.

———. *Wall Street and the Wilds.* New York: Outing Publishing Co., 1915.

———. "Wild Life." *Outlook* 92 (May 22, 1909): 184–93.

———. "Winter in the Catskills." *Harper's Weekly* 57 (March 1, 1913): 11–12.

———. "Yachting in a Canoe." *Outing* 57 (September 1908): 721–33.

Dimock, Leila Allen. "The Girl and the Tarpon." *Country Life* 21 (January 15, 1912): 11–14.

Dodd, Helen. "Horses and Cows at Twin-Flower." *Outing* 57 (March 1911): 649–58.

———. "Sugaring at Twin-Flower." *Outing* 57 (February 1911): 515–21.

Hartt, Mary Bronson. "Weather Wisdom." *Country Life* 14 (November 1908): 48-49, 66-68.

McCulloch-Williams, Martha. "Spoiling 'the Little White Men.'" *Country Calendar* (September 1905): 444-47.

Skinner, Alanson. "Notes on the Florida Seminole." *American Anthropologist* 15 (1913): 63–77.

Washington, Booker T. "Twenty-Five Years of Tuskegee." *World's Work* 11 (April 1906): 7433-50.

OTHER

Dimock, Anthony W. "How We Broke into Magazinedom." *The Editor* 32 (July 1920): 4-6.

About the Authors

Thomas L. Johnson has been a field archivist associated for more than twenty-five years with the South Caroliniana Library at the University of South Carolina, where for many years he also taught a course on South Carolina writers. *A True Likeness*, a book he coedited on the work of black photographer Richard Samuel Roberts of Columbia (1880–1936), won a Lillian Smith Award from the Southern Regional Council in 1986. He has won prizes for both his poetry and his short fiction, and he serves as an honorary life member on the board of governors of the South Carolina Academy of Authors.

Leon F. Litwack, the Alexander F. and May T. Morrison Professor of American History at the University of California, Berkeley, has been the recipient of a Guggenheim Fellowship, two Distinguished Teaching Awards, and a National Endowment for the Humanities Film Grant. His book *Been in the Storm So Long* (1979), an account of America's experience with emancipation, won the Pulitzer Prize in history and the Parkman Prize. The late C. Vann Woodward called its 1998 sequel, *Trouble in the Mind*, "the most complete and moving account we have had of what the victims of the Jim Crow South suffered and somehow endured."

Nina J. Root, a native New Yorker, received her bachelor's degree at Hunter College and a master's degree from Pratt Institute. She served as director of Library Services at the American Museum of Natural History for twenty-seven years. Before coming to the museum she was head of Reference, Science and Technology Division, Library of Congress, where she was given a Meritorious Service Award. She is the author of numerous books and articles on the history of natural history and on the Library's collections. Today she holds the title of Director Emerita of the AMNH Library and continues to work with collections, lecture, write, and travel.

Dori Sanders, a peach farmer from York County, South Carolina, saw her first novel, *Clover* (1990), published to immediate critical and popular acclaim. It received a Lillian Smith Award, has gone into ten hardback printings and numerous paperback ones, has been translated into five foreign languages, and was made into a major Walt Disney Film. Another novel, *Her Own Story*, appeared in 1993, and *Dori Sanders' Country Cooking*, in 1995. Her work has been characterized as "Southern writing at its best" and has been compared to that of Alice Walker, Maya Angelou, and Zora Neale Hurston.

Cleveland L. Sellers Jr. is director of the African American Studies Program at the University of South Carolina, where he also teaches in the History Department. *The River of No Return*, published in collaboration with Robert Terrell in 1973 and in a 1990 edition with an afterword by Sellers, is his insider's account of the rise and fall of the Student Non-Violent Coordinating Committee and of his involvement in the 1968 Orangeburg Massacre, including his arrest and subsequent imprisonment. It is considered one of the two or three most important books to have come out of the Civil Rights Movement.